The Ideal
of Rationality

The Ideal of Rationality

A Defense, within Reason

STEPHEN NATHANSON

OPEN ✖ COURT
Chicago and La Salle, Illinois

OPEN COURT and the above logo are registered in the U.S. Patent and Trademark Office.

©1994 by Open Court Publishing Company

This is a revised edition of *The Ideal of Rationality,* published by Humanities Press International in 1985.

First printing 1994

All rights reserved. No part of this publication may be reproduced, stored in a retrieval system, or transmitted, in any form or by any means, electronic, mechanical, photocopying, recording, or otherwise, without the prior written permission of the publisher, Open Court Publishing Company, 315 Fifth Street, P.O. Box 599, Peru, Illinois 61354-0599.

Printed and bound in the United States of America.

Library of Congress Cataloging-in-Publication Data

Nathanson, Stephen, 1943–
 The ideal of rationality / Stephen Nathanson.
 p. cm.
 Includes bibliographical references and index.
 ISBN 0-8126-9261-6 (cloth). — ISBN 0-8126-9262-4 (pbk.)
 1. Rationalism. 2. Reason. I. Title.
B833.N37 1994 94-29318
149′.7—dc20 CIP

In memory of my parents,
Ann and Harry Nathanson

CONTENTS

Preface to the Revised Edition ix

Preface xi

Acknowledgments xiv

Part I: The Life of Reason

 Chapter 1: The Classical Ideal 3
 Chapter 2: John Barth's Critique of Pure Reason 17

Part II: Defects of the Classical Ideal

 Introduction 39
 Chapter 3: Reason and Deliberation 43
 Chapter 4: Reason, Nihilism, and Objectivity 55
 Chapter 5: Reason, Knowledge, and Truth 69
 Chapter 6: The Ethics of Belief: A Jamesian View 81
 Conclusions 93

Part III: Means/End Rationality

 Introduction 97
 Chapter 7: The Means/End Conception of Rationality 99

	Chapter 8: Reasons, Motives, and Morality	111
	Chapter 9: Irrational Desires	123
	Chapter 10: Rational and Irrational Ends	139
Part IV:	**Acting for the Best**	
	Introduction	153
	Chapter 11: Pleasures and Values	155
	Chapter 12: Evaluating Ideals	173
	Chapter 13: Rationality Within Reason	187
Part V:	**Afterwords**	
	Afterword I: Rationality Revisited	197
	Afterword II: An Interview with the Author	203
	Afterword III: Rationality: Doubts and Theories	215
	Afterword IV: Final Thoughts	229
Notes		231
Bibliography		247
Index		253

PREFACE TO THE REVISED EDITION

When the opportunity to revise and improve the original edition of this book first arose, it inspired quite mixed feelings. Authorial pride, bolstered by competing claims on time and energy, first inclined me to leave the original material untouched and to add a brief set of "later reflections." Nonetheless, when I sat down with the original text and looked at actual sentences and paragraphs, the urge to tinker, modify, and improve grew stronger. I have taken advantage of this opportunity both to improve my prose where I saw ways to do so and to bolster my development of the ideas I had previously worked out. So, while rejecting a complete overhaul, I made more extensive changes than I had anticipated in the main body of the text. The most extensive substantive additions occur in chapter 8.

While reworking the original, I also came to think that there were a number of additional issues that needed discussion and whose inclusion would make the book more substantial. In order to incorporate these without disrupting the flow of ideas, I decided to add a number of "afterwords," each of which augments the original in ways that I hope add both depth and breadth.

My chief regret is that I have not been able to pay adequate respect to the many authors who have had important things to say about rationality since I completed the original of this book. In some cases, I have acknowledged later works in brief additional comments, in footnotes, and in the afterwords. Given the pervasiveness of issues concerning rationality, however, it was impossible to discuss many relevant works

without producing something of encyclopedic bulk. While such a work might be more complete, it would lose the virtue of "readability" that I strived for in the original and that has guided my efforts at revision as well.

Recent writings have served only to strengthen my sense that the ideal of rationality is worthy of careful examination. Rationality remains a contested ideal. It is praised by its defenders as an important bastion of civility and scorned by its critics for a wide range of ill effects. In debates such as this, there is likely to be truth and error on both sides. The problem is to find ways of thinking that allow us to understand what is at stake in the debate and to see how we can combine the insights of competing views while discarding their errors and exaggerations. I continue to believe that the original version of this book provided some guidance of this sort, and I hope that this revised version does this even better.

PREFACE

> *I am uneasy to think I approve of one object, and disapprove of another; call one thing beautiful, and another deform'd; decide concerning truth and falsehood, reason and folly, without knowing upon what principles I proceed.*
>
> —David Hume

Rationality is an ideal that has been lacking neither in proponents nor in critics. Many of the greatest thinkers in the Western philosophical tradition have been rationalists. They have placed a special value on the exercise of human reason and have urged that rationality should play a predominant role in human life. Nonetheless, there is a long and powerful tradition of skeptics, romantics, fideists, and irrationalists who either have denied that human beings can live up to rational ideals or argued that the results of being rational are simply undesirable. In their view, striving to be rational detracts from the value of life rather than enhancing it. I believe that the arguments that emerge from the antirationalist tradition are too important to be ignored. Not wanting to take rational ideals on faith, I have tried to examine what can be said on behalf of rationality and what can be said against it. This book is the product of my reflections.

I come to this debate as a philosopher, a teacher of philosophy,

and a person who considers himself a rationalist. My special interest in rationality has several sources. First, I have long been interested in philosophical questions about skepticism and knowledge. Some of these questions are hard for nonphilosophers to take seriously: For example, how can we know that the physical world exists? or, how can we know that persons other than ourselves have minds and conscious experiences? Other such questions are widely recognized as having some point to them: How can we know which, if any, of the various religious beliefs that people hold are true? or, how can we know that particular actions are morally right or wrong? All of these questions raise further questions about the nature and power of reason. They call into question reason's ability to provide a sound basis for our beliefs about the nature of the world and the ways we should act in it.

Second, as a teacher of philosophy, I strive to provide students with an appreciation of rational values. I try to help them develop a concern for truth, a respect for honest inquiry, and a willingness to take seriously positions other than their own. Promoting rational values often involves urging students to question, criticize, and defend their beliefs. This can be a painful process, and it sometimes has the effect of alienating them from familiar traditions or leaving them with no satisfactory perspective. These activities can, of course, be invigorating and liberating as well. Nonetheless, there is no guarantee that encouraging people to engage in philosophical thinking will always have desirable effects, and I have often been troubled by questions about the nature and value of the ideals I recommend to students in my classes.

Finally, many issues about rationality began to crystallize in my mind through my reading of John Barth's novel *The End of the Road* and Philip Slater's psychological and sociological analyses in his book *Earthwalk*. I happened to have read both books at about the same time, and I found in them powerful criticisms of the ideal of rationality. Barth and Slater seemed to be arguing that if we look at rationality in the context of human life, we will see that striving to be rational is a stifling and alienating activity, that rationality is a destructive ideal. While I found this conclusion both shocking and implausible, I felt strongly that both Barth and Slater had important insights, and I resolved to determine whether their antirationalist conclusions were true. This seemed especially worth doing because rational ideals continue to be under attack within our culture, indicating that the issue is neither an eccentric concern of these two writers nor a matter of interest only to professional philosophers.

My approach to these problems, my ways of arguing, and my manner of writing are deeply influenced by my education as an academic philosopher. Concentration in any discipline has the unfortunate tendency of making communication with "outsiders" difficult, and this problem no doubt lies behind the feeling of many that academic philosophy is trivial or irrelevant. In this book I have tried to write not simply for professional philosophers but for thoughtful people in general. I have aimed not only to arrive at true conclusions and to construct plausible arguments but also to express my arguments and results in clear, nontechnical language. The extent of my success remains to be seen, but I hope others will make similar attempts. It would be a great misfortune if the methods of philosophy could not be widely used or appreciated, for these methods are nothing more than the practice of disciplined, sustained thinking and argument. If these methods become the esoteric possession of professionals, rational ideals will have suffered the most serious of defeats.

If we want to assess the views of rationalists and antirationalists, we must first determine what is the *nature* of rationality and thus clarify the ideal that is based on it. A great deal of confusion has arisen because rationalists themselves do not always make clear what they advocate, and antirationalists do not always have the same target in mind when they launch their attacks. If we can clarify what rationality is, we will then be in a position to consider its *value*. In this way, we can decide between the claims of those who champion rational ideals and those who deplore them.

My own thinking has not led me to reject, abandon, or condemn rationality. Nonetheless, it has led me to reject a number of traditional ideas about rationality. For this reason, advocates of rational ideals may view me as an antirationalist in rationalist's clothing. This is not my aim. What I have sought to discover is a reasonable form of rationalism. This has yielded conclusions that have sometimes surprised me and that will disappoint others. Nonethless, I have tried to make clear the reasons that have led me to particular conclusions, and I willingly offer them as fit subjects for the sort of debate and criticism that rationalists cherish.

ACKNOWLEDGMENTS

I wrote a first draft of this book while I was on sabbatical leave in Cambridge, England, in 1979. I would like to thank Northeastern University for granting me the time to reflect and write, and I would like to thank Wolfson College and the philosophy faculty of Cambridge University for the cordiality that helped to make my stay in Cambridge so pleasant and so stimulating. Thanks, too, to John and Janet Toye for urging my wife and me to come to Cambridge and for their wonderful friendship over many years. In addition, my appreciation to E. J. Bond, T. Y. Henderson, and Gerald Paske for many enjoyable philosophical discussions during this period.

Several people read the original manuscript and made comments that helped me to improve it substantially. John Kekes gave me detailed comments and suggestions that led to major improvements in organization. I also profited greatly from the reactions of E. J. Bond, Bernard Gert, John Troyer, and Sanford Thatcher. After a second draft was completed, further changes were prompted by comments by Jack Meiland, whose interest in this project and support of it have been very helpful to me.

As important as the criticisms and suggestions of these people were, perhaps more important was their interest in my work and their encouragement to pursue it. I thank all of them, as well as my other friends and colleagues whose interest has encouraged my thinking about the subject of rationality over the years.

In the final stages of bringing the first edition of the book to

publication, I benefited from the support of Richard Astro, then Dean of the College of Arts and Sciences at Northeastern. For making possible this revised edition, I again thank Northeastern University for a sabbatical leave and express my appreciation to David Ramsay Steele of Open Court.

To Everett Gendler and to Grover Albers, I offer my thanks for ancient inspirations, both philosophical and personal.

My wife, Linda, has endured and supported my preoccupations and has encouraged my efforts to write decent prose. Along with my children, Michael and Sarah, she has helped to keep me attuned to the things of most value.

With great love and deep gratitude, I dedicate this book to the memory of my parents, Ann and Harry Nathanson.

* * * * * * * * * * *

Portions of chapters 2, 3, 4, and 6 are based on articles that first appeared in the following publications: "Nihilism, Reason, and Death: Reflections on John Barth's *Floating Opera*," in *The Philosophical Reflection of Man in Literature*, ed. A. T. Tymieniecka (Dordrecht, Holland: Reidel, 1982), 137–51; "Nihilism, Reason, and the Value of Life," in *Infanticide and the Value of Life*, ed. M. Kohl (Buffalo: Prometheus Books, 1978), 192–205; "Critical Review of John Kekes's *A Justification of Rationality*," *International Philosophical Quarterly* 19 (1979), 227–36; "Non-Evidential Reasons for Belief," *Philosophy and Phenomenological Research* 42 (1982), 572–80; Review of *The Nature of Morality* by Gilbert Harman, *Metaphilosophy* 2 (1980), 96–100.

PART I

THE LIFE OF REASON

1
The Classical Ideal

> *That which is proper to each thing is by nature best and most pleasant for each thing; for man, therefore, the life according to reason is best and pleasantest, since reason more than anything else is man.*
>
> —Aristotle

The ideal of rationality comes to us from the Greeks, particularly from Plato, whose writings contain a record of the character and ideas of Socrates as well as Plato's own development of those ideas. I will call the ideal that emerges in these works the classical ideal of rationality. Although I will later argue that the classical ideal is defective, my aim in this chapter is to describe it and to explain some of the reasons for its powerful appeal.

Central to the classical ideal is the view that reasoning ought to play a preeminent role in the way we live. This view is strikingly expressed in Socrates' famous remark that "an unexamined life is not worth living".[1] In the thought of classical rationalists, this is taken to mean not only that intellectual examination is an effective means to discover how to live a worthwhile life but also that a life in which reason is most fully used and developed is the very best sort of life. That is, using reasoning as a means, we discover that reasoning is the end, the very best activity in which to engage.

The Socratic Model

While there are arguments in Plato's writings for this conclusion, the most persuasive device he uses to support it is his depiction of the character and activities of Socrates. This is most evident in the *Apology, Crito,* and *Phaedo,* very dramatic dialogues in which Socrates courageously confronts prosecution, imprisonment, and death. Even in a less

dramatic dialogue like the *Euthyphro,* however, Plato presents both an abstract discussion about the proper definition of the word "piety" and a vivid contrast between two types of human beings. In that dialogue, the character Euthyphro is engaged in bringing a murder charge against his own father who, he says, was responsible for the death of a slave.

Euthyphro, in defending his action to Socrates, claims that it would be impious not to prosecute a wrongdoer, even if he is a close relative. Socrates has a special interest in discovering the nature of pious and impious actions because he himself is being prosecuted on charges of impiety. He therefore asks Euthyphro to tell him about the nature of piety, assuming that a man who will prosecute his own father must be very confident in his knowledge of what makes this action appropriate.

> *Socrates:* But you by heaven! Euthyphro, you think that you have such an accurate knowledge of things divine and what is holy and unholy that in circumstances such as you describe, you can accuse your father? You are not afraid that you yourself are doing an unholy deed.
> *Euthyphro:* Why, Socrates, if I did not have an accurate knowledge of all that, I should be good for nothing, and Euthyphro would be no different from the general run of men.[2]

The subsequent discussion appears to show that Euthyphro does not know the nature of piety or holiness, and the reader is left to conclude that his confidence is misplaced. Nonetheless, even after questioning by Socrates, Euthyphro remains unshaken in his belief. As the dialogue closes, Socrates is urging that they continue the discussion while Euthyphro is fleeing in haste to carry on his prosecution.

There are many interesting issues raised by this brief dialogue. What I want to focus on is the impression the dialogue conveys to the reader about the characters of Euthyphro and Socrates and the connection between this impression and the ideal of rationality. Plato suggests that although Euthyphro holds strong views and is willing to act on them, he cannot justify either his beliefs or the action based upon them. Even if he is correct that his father ought to be prosecuted, his confidence is misplaced because it lacks a rational basis. Without a rational basis for his belief, Euthyphro has no reliable grounds for thinking that it is true. Once Socrates exposes the lack of a justification for his belief, it is both irrational and irresponsible for Euthyphro to continue to hold it.

The general idea that emerges from the dialogue is that there is an essential connection between *being rational* in one's beliefs and actions and *having reasons that justify* them. This idea gains support from our

language, since we often use words like "rationale" and "reason" as synonyms for "justification." If one wonders why it is good to have reasons for beliefs and actions, part of Plato's reply comes in his portrayal of Euthyphro, for one cannot read the dialogue without feeling that Euthyphro is profoundly irresponsible. While there may be circumstances in which prosecuting a parent is morally required, the action is very serious and ought to be undertaken only if one has the soundest basis for it. Yet it is just this basis that Euthyphro appears to lack, and lacking it, his curtailment of the discussion in order to hurry off to the courts is particularly shocking.

Euthyphro's behavior also reveals a casual attitude toward truth. A person who lacks a justification for a belief has no reason to think that the belief is true. Hence, anyone who is genuinely concerned about having true beliefs will be equally concerned about having rational justification for her beliefs. Euthyphro lacks this concern, and this suggests that he is a dogmatic believer, a person who is more concerned with maintaining favored, personal beliefs than with determining whether they are true or false.

This contrasts sharply with Socrates, who is passionate in his desire to discover the truth and tireless in conducting the inquiries he thinks are necessary to determine what is true or false. After the apparently fruitless discussion with Euthyphro, Socrates urges Euthyphro to remain for more discussion. "And so," he says, "we must go back again, and start from the beginning to find out what the holy is. As for me, I never will give up until I know."[3] There is also a marked contrast between the humility and tentativeness of Socrates (even if it is mixed with irony) and the haughty arrogance and certainty of Euthyphro. The man who begins by claiming that his knowledge makes him superior to the mass of humanity is shown not to possess knowledge at all. By contrast, Socrates' ignorance is no vice precisely because he makes no claim to superior knowledge or status. Socrates at least has the virtue of knowing that he does not know. Knowledge for him is something to be sought after, not something to be claimed for oneself and used as a device for self-glorification.

Rational Values

In writing this dialogue, Plato constructed a miniature morality play in which the values he sought to promote are revealed in the admirable

character of Socrates, while the values he opposes are embodied in the shallow, haughty character of Euthyphro. Underlying the dialogue is a clear conception of the ideal of rationality. The rationalist, as exemplified by Socrates, will strive to discover the truth, to justify all of his beliefs and actions, and to arrive at justified beliefs through inquiry and deliberation. All of these values are taken to be closely related. The activities of inquiry and deliberation yield evidence, and this evidence serves to justify a belief by providing the basis for believing that it is true.

Earlier, I charged that a dogmatic believer like Euthyphro is not genuinely concerned with the truth, but that need not be the case. Nor is it fair to think that rationalists are alone in caring about justifications. What separates rationalists and antirationalists is a disagreement about the proper way to acquire and justify beliefs. It is distinctive of rationalists that they value reasoning as the best method of acquiring truth. In contrast, a mystic, for example, could share with the rationalist a desire to know the truth but would seek it in special experiences of a nonrational sort. Rationalists insist that even if such experiences occur, they are not self-validating and need to be supplemented by some form of argument. It is the value of reasoning, then, that classical rationalists champion and the centrality of reasoning that distinguishes their position. The desire for truth is essential to their position but not distinctive of it.

Though the value of truth is not usually doubted, one may wonder why truth is considered so desirable. One reason is simply that human beings are curious and take great satisfaction from knowing what the world is like. In addition, it is generally very useful to know the truth about matters of concern, since that usually helps us to bring about results we desire. While many thinkers have drawn a sharp distinction between facts and values and have held that the notion of truth applies only to factual claims, Plato regarded discovering the truth as the means to acquiring wisdom. Since wisdom is the knowledge of how to conduct oneself in life, theoretical and practical interests are not divorced in his thinking. It would make no more sense to Plato for a person to ask why he should care about truth than it would for a person to ask why he should care about making the most of his life.

The ideal of rationality, as I have sketched it so far, contains the ideas that truth is worth seeking, that knowing the truth helps us to live worthwhile lives, and that the best way to arrive at truth is through

reasoning. Plato uses the figure of Socrates to portray these ideas in a favorable and attractive way, giving his readers the same impressive model by which he himself was so decisively influenced.

A model, however, is not an argument, and we need to reflect further to see what argumentative support a rationalist can give to this ideal. One strategy is to show that the ideal of rationality is closely tied to other valuable ideals or goals, and in this vein, rationalists have tried to link rationality to other values, such as personal autonomy and respect for other persons. In setting out their arguments, another central component of classical rationalism makes its appearance, the ideal of objectivity.

Objectivity

In order to clarify the role of objectivity and its value, it will be useful to return to the *Euthyphro*. As we have seen, while the dialogue appears to reveal that Euthyphro's views about prosecuting his father are unfounded, Euthyphro himself is impervious to this result. Since he assumes that he has knowledge of a special sort, he does not allow himself to be influenced by what Socrates has to say. In this way, Euthyphro shows a certain lack of respect for Socrates; he does not really consider Socrates as an equal whose different perspective might provide insights into the situation. Euthyphro is too fond of his own views to consider anyone else's.

The very idea of a rational discussion, however, presupposes some element of impersonality. Since beliefs are in themselves true or false and arguments are in themselves valid or invalid, the worth of a belief or an argument is something it possesses independently of any person. Thus, especially in abstract or theoretical discussions, the fact that a particular person asserts an idea is not generally a good reason for thinking it true. Consequently, if I engage in a rational discussion with someone with whom I disagree, I must acknowledge that she may be correct and that I may be mistaken. The fact that one view is mine does not make it superior. If it is superior, that is because of the evidence I can adduce in its favor and is not a result of my personal connection to the view in question. If, however, the strength of my ideas derives from the arguments in their favor, the same is true of the views of the other person.

To be a genuine participant in a rational discussion, I must try to detach myself from my own ideas and view them as I view the ideas of the other person. Otherwise, I am not really participating in a joint activity of reasoning; I am simply making a speech, talking *at* someone rather than *with* her. To engage in a joint effort of reasoning requires a respect for the other person as someone from whom I can learn and as an equal in the quest for truth.

This idea has been expressed by a number of recent philosophers. Max Black has written that there are "quasi-moral implications" of being reasonable. To be reasonable, he writes,

> demands a sustained effort to suppress bias and, in striving for impartiality and objectivity, to pay a decent respect to the opinions of others. To act reasonably is to be willing to reason and thereby to submit to impersonal judgment.[4]

Similarly, Karl Popper makes the claim that rationalism

> is bound up with the idea that everybody is liable to make mistakes, which may be found out by himself, or by others, or by himself with the assistance of the criticism of others. It therefore suggests the idea that nobody should be his own judge, and it suggests the idea of impartiality.[5]

Popper goes on to discuss the political implications of rational ideals. He claims that there are important connections between rationality, egalitarianism, and democracy, and he explicitly states his indebtedness to Socrates for these points.

Impartiality, then, can be understood as a social concept, an idea about how we ought to treat other people's ideas in relation to our own. It is one aspect of the broader idea of objectivity. Impartiality requires us to ignore *who* an idea belongs to when we consider it. Objectivity requires us to be aware of *any* irrelevant factors that might influence us in forming beliefs and to strive to give no weight to these factors in making judgments.

Socrates emphasizes objectivity as an aspect of rationality in another dialogue, the *Crito*. After Socrates was tried, convicted, and sentenced to death, his friend Crito attempted to arrange an escape. The dialogue focuses on the question of whether Socrates ought to escape or whether he is morally obligated to remain in prison and accept his punishment. While it would be understandable for a person facing death to allow himself to be swayed by any argument that could save him, Socrates

dismisses his present situation as irrelevant to the truth of the moral principles being discussed. "My dear Crito," he says,

> it has always been my nature never to accept advice from any of my friends unless reflection shows that it is the best course that reason offers. I cannot abandon the principles which I used to hold in the past simply because this accident has happened to me. . . . I respect and regard the same principles now as before. So unless we can find better principles on this occasion, you can be quite sure that I shall not agree with you.[6]

Socrates' point is that the discussion should focus only on the truth of the principles on which he bases his actions. While he would reject these principles if they could be shown to be wrong, he denies that his present circumstance should alter his assessment of them. The "accident" of his present predicament is not a relevant consideration, as it has no bearing on the truth of the principles in question.

> *Socrates:* Of course one might object, all the same, the people have the power to put us to death.
> *Crito:* No doubt about that! Quite true, Socrates. It is a possible objection.
> *Socrates:* But so far as I can see, my dear fellow, the argument which we have just been through is quite unaffected by it.[7]

Even if one thinks that Socrates' impending execution is relevant to the question of his escape, his general methodological point seems sound: features of a situation that do not bear on the truth or falsity of a matter under discussion should be ignored.[8]

Autonomy

Classical rationalists have linked the ideal of rationality not only to objectivity but to personal autonomy as well. By autonomy I mean the ability to control one's life, to determine one's actions for oneself rather than submitting to external forces. Autonomy, of course, is not an all-or-nothing condition, and the degree to which people possesses it depends both on the power of the forces impinging on them and on their own character.

Socrates exemplifies two kinds of autonomy in the *Crito*. One is shown in his determination not to be swayed by popular opinion, the second in his intention to judge his situation in a clear, unemotional

manner. Socrates sees the emotions as an obstacle both to objectivity and to autonomy. He is determined not to consider anything other than relevant arguments,

> even if the power of the people conjures up fresh hordes of bogies to terrify our childish minds, by subjecting us to chains and executions and confiscations of our property.[9]

To give way to fear in this situation is to allow oneself to be manipulated by others. It is to return to a childish condition in which one lacks self-control and personal freedom.

For Socrates, what we need to do is to free ourselves from the influence of the emotions. This requires recognizing these emotions, seeing how they affect our judgment, and then trying to discount this influence. We should do this because the emotions one happens to feel about a situation are irrelevant to the truth or falsity of claims about that situation. If our emotions tend to make us act unthinkingly, our ability to check this influence allows us to approach matters objectively and rationally. It thus increases our control over our actions. This is not to say that the emotions always lead us to act wrongly or adopt mistaken views. However, we ought only to act in accord with them when reason shows this to be appropriate. Reason alone should rule our actions and beliefs.

While this kind of control may be difficult to attain, even more is required to reach genuine objectivity and autonomy. If we reflect on the origins of our beliefs, we will see that many of them were acquired long before we could reason and weigh evidence. Descartes, a later champion of reason, lamented this, calling the "prejudices of childhood" the "principle cause of error" in human beings.[10] In addition, the beliefs that each of us holds are very much a function of the particular setting in which we have grown up and in which we have been taught. We know, however, that people in other cultures, societies, and eras of history have held beliefs different from our own. Had we been brought up in some other setting, our beliefs would have been quite different. They would have reflected that other setting, just as our current beliefs reflect our present environments.[11]

It is easy to see, however, that the time and place of one's birth and education are not relevant items of evidence in support of particular views. If they were, contradictory beliefs would be true. Therefore, if we want to have rational confidence in our beliefs, we need to consider the

evidence for them and not rest content with the fact that we happen to have "inherited" those particular beliefs. This activity of reflection will increase our autonomy because the view of the world that emerges from it will be one that we choose, not one that we absorb unthinkingly.

Rationality, then, involves a striving to be objective.[12] The more rational we become, the freer we can be of our surroundings and the more control we have over ourselves. Rational deliberation gives us this control by, so to speak, breaking the circuits between desires and actions or between inclinations to believe and believing itself. It allows us to step back and view a situation from a broader perspective before deciding what to believe.

Rational inquiry, then, is an impersonal search for truth. It is impersonal in a number of respects. First, its methods can be used by anyone. Second, the evidence produced by inquiry, if it is adequate to establish a belief, should convince any rational person of the truth of that belief. Finally, the product of applying this method is a true theory that describes things as they really are. By discounting the influence of any particular being's contingent perspective, successful rational inquiry furnishes a picture of the universe from a purely impersonal and objective perspective, a cosmic or "God's eye" point of view.

Rationalists hold analogous ideas about applying objectivity to the sphere of action. A rational person will be prudent, in the sense that she will not view her actions and choices only from the perspective of present feelings and desires. Rather, she will keep in mind other interests and desires that may be affected by what she does now. She will not allow herself to be unduly influenced by the "present-ness" of desires she now feels because she knows that the present will pass and that giving undue weight to what happens to be occurring now will lead to regret. Thus arises the idea of a person's overall good, and it is this which a rational person will keep in mind in making decisions that primarily affect herself. She will weigh the long-term value of actions rather than being guided by momentary impulses.

A virtue of this account of rational decision-making is that it can plausibly be extended from matters of self-interest to moral questions. In making moral decisions, we eliminate the egocentricity of prudential reasoning and substitute a broader perspective, one that gives weight to the desires and interests of all persons affected by the proposed actions. While the prudent person discounts the fact that certain desires are present now, the moral person must sometimes discount the fact that

certain desires or interests are his own. In this way, he can make a fair and impartial judgment of the legitimacy of different people's rights or needs. Moral reflection gives rise to the concept of an ideal observer or benevolent spectator, someone who is equally concerned about all persons.[13] The conscientious person will attempt to make his moral judgments from the perspective of such an impartial being, rather than from the point of view of his own interests or the interests of his class, race, or state.

Rational ideals, then, are closely tied to ideals of objectivity, autonomy, prudence, and morality. In Plato we find the most optimistic version of the rationalist ideal. Beginning with Socrates' belief that virtue is knowledge, Plato concluded that people whose lives are ruled by reason will possess knowledge of the truth, will be perfectly just and moral in their behavior, and will live the happiest and most fortunate of lives. These are the benefits of the life of reason as he saw it.

The Problem of Egoism

There is a problem lurking here, however, and it is one that Plato was acutely aware of. For Plato, the rational person promotes his own well-being and at the same time acts morally toward others. The problem, however, is that while the demands of self-interest and morality can both be satisfied in many circumstances, they also frequently conflict. Moreover, if a person takes his own interests very seriously, as it appears rational to do, it is difficult to see why he would take morality seriously on those occasions when it conflicts with self-interest. Why wouldn't a rational person be an egoist, someone who cares only about his own well-being and strives always to act in ways that promote his own interests?

Plato raises this problem himself in book 2 of the *Republic,* and much of the theory he develops there is motivated by his desire to reconcile morality and self-interest. Egoists, of course, do not deny that it is rational for people to behave justly when failing to do so will lead them to suffer. For example, if a person is dishonest, this might cause her to lose the goodwill of people whose cooperation she needs. Or the state may impose legal punishments on her if she has conducted business dishonestly. Nonetheless, egoists argue, if one could behave unjustly in ways that no one would discover, there would be no reason to comply with rules of moral behavior. Hence, they say, the only value of moral

behavior is instrumental, and people are rational to behave morally only when this coincides with their interests.

This argument suggests a less attractive image of what a rational person would be like. Rational people, calculating their own long-term interests and acting simply to satisfy them, will be far from admirable. They will view other people as means to their own ends and will recognize no constraints that are not forced upon them. If possible, they will follow the model of the shepherd Gyges, who, according to a fable that Plato relates, took advantage of the power of making himself invisible to kill the king and set himself up as a tyrant.[14] If rationality requires the intelligent pursuit of one's own interests, then wouldn't any rational person do the same? And if this is the way rational people will behave, is rationality such an admirable ideal after all?

Plato's answer to the challenge of egoism (which I will only sketch here) is instructive in a number of ways. Essentially, he tries to show that people who seek unlimited power and riches for themselves are making a mistake about the nature of their own self-interest. Had they a better understanding of their true interests, they would not strive for power and wealth. They would strive for a state of harmony among the various elements of the soul, for this state is the true good for human beings. In such a harmonious state, the rational element of a person's nature will rule. The grasping egoist who seeks money, power, or limitless sensual pleasure is not ruled by reason. He is dominated by his passions. The person who lives by reason will not desire to live in the lawless fashion that requires subjugating others in the name of his own apparent good.

It is a mistake, Plato argues, to believe that living justly requires great sacrifices that no rational person would be willing to make. Rather, the life of reason and the life of morality coincide, since both require us to establish control over our passions and desires. People mistakenly believe that the moral life requires a sacrifice of personal goods because they have false beliefs about what is really valuable for human beings. Those who follow reason and know what is genuinely good will not find the life of Gyges attractive. Nor, more generally, will they seek their own good at the expense of others.[15]

While I do not think that Plato succeeds in showing that the moral life and the self-interested life coincide, I have described this problem and his response to it for two reasons. First, it shows that rationalists have been aware that descriptions of the life of reason might have implications that make that life appear morally unattractive. Second, Plato cleverly tries to resolve this problem in a way that further

strengthens his rationalism, for on his account, it is the passions rather than reason that lead to immorality. Hence, far from there being a conflict between reason and morality, the cultivation of reason will lead to a strengthening of the bases of moral behavior.

In Plato's answer to the challenge of egoism, we can see at work many of the elements that make up the ideal of rationality. There is an emphasis on the use of reason to discover both what has real value for human beings and how to attain it. There is an emphasis on controlling our emotional reactions to things in order that our beliefs and actions be based on deliberation rather than impulse. In assessing how we ought to behave or what we ought to believe, we are to strive for objectivity, and if we are successful, we will be able to justify our beliefs and actions by appeal to reasons that other rational persons can accept. In addition, by proceeding in this manner, we can attain the highest possible degree of self-control and personal autonomy, since we will be dominated neither by other persons nor by our own nonrational natures.

There is finally another influential suggestion in Plato, the idea that in living the life of reason, we develop most fully those aspects of our nature that are distinctively human. Plato summarizes his discussion of the value of a just life by suggesting that we think of a human being as composed of three elements: a many-headed beast, a lion, and a man, these corresponding respectively to the desires, the will, and reason. A person who praises the life of injustice is, Plato says,

> affirming nothing else than that it profits him to feast and make strong the multifarious beast and the lion and all that pertains to the lion, but to starve the man and so enfeeble him that he can be pulled about whithersoever either of the others drag him. . . . And on the other hand, he who says that justice is the more profitable affirms that all our actions and words should tend to give the man within us complete domination over the entire man and make him take charge of the many-headed beast, like a farmer who cherishes and trains the cultivated plants but checks the growth of the wild.[16]

According to Plato, success in living the life of reason constitutes the fullest realization of our humanity.

Summing Up

Plato's portrayal of Socrates provides us with a powerful and attractive model of rationality. The classical ideal that emerges from this portrayal

stresses the value of truth, justified beliefs, inquiry, deliberation, and objectivity. It ties these components of rationality to the pursuit of personal autonomy and respect for others. For Plato, the life in which reason plays a dominant role is the very best sort of life, as one who follows it will be just to others and will enjoy a state of internal psychic harmony. The good life is the life of reason.

2
John Barth's Critique of Pure Reason

> *Reason is, and ought only to be, the slave of the passions.*
> —David Hume

In chapter 1, I described the main features of the classical ideal of rationality and explained some of the reasons that make it attractive. In this chapter, I want to raise some doubts about the classical ideal. I will do this by discussing two novels by John Barth, *The Floating Opera* and *The End of the Road*.

To many philosophers, a discussion of a novel at this point may appear to be a needless digression. After all, premises and conclusions are the stuff of philosophy, and if there is anything we know about fiction, it is that the premises are false. Moreover, it might be said, if a novel contains cogent arguments, they can simply be lifted out for logical analysis, without considering the context in which they are raised. On with the argument, then, and forget about stories!

I record this objection because I have some sympathy with it. Philosophy should be as direct and explicit as possible, and good novels often work by indirection, insinuation, and suggestion.[1] Nonetheless, literature is philosophically important, especially if we are concerned with assessing ideals and ways of life. A good novel, story, or play can make the implications of adopting particular ideals vividly clear by portraying the ways in which ideals are expressed in life. Just as we can learn from our own personal experiences and from the lives of historical persons, so too we can learn from the "lives" of fictional persons. I have already stressed how important a role is played by the character of Socrates in Plato's philosophical dramas, providing us with an embodiment of a set of ideas in addition to a verbal formulation of them.[2] If Socrates' character matters, in addition to his arguments, then it is hard

to see how one could dismiss the relevance of other characters in the made-up stories that novelists produce.

In the two novels I will discuss, John Barth provide us with three striking exemplars of the life of reason: Todd Andrews, Jacob Horner, and Joe Morgan. Like the fabled shepherd Gyges, none of these men has ever walked the earth. Nonetheless, we can learn important lessons about rationality from the ways in which these characters confront the problems of life.

The Rational Man as Nihilist

Todd Andrews, the narrator and central character of *The Floating Opera,* embodies many of the features associated with rationality and takes great pride in these aspects of himself. On the very first page of the novel, he tells us,

> If other people . . . think I'm eccentric and unpredictable, it is because my actions and opinions are inconsistent with their principles, if they have any; I assure you that they're quite consistent with mine. And although my principles might change now and then . . . I always have them aplenty, . . . and they usually all hang in a piece, so that my life is never less logical simply for its being unorthodox.[3]

Todd's rationality is shown by the serious efforts he makes to find answers to questions about life and its value. For many years, he has been writing an "Inquiry" into the cause of his father's suicide and the defective communication that had existed between his father and himself. The narrative of *The Floating Opera* is itself an offshoot of this "Inquiry," and the entire project amounts finally to a classic quest for self-knowledge. The thoroughness and duration of Todd's examination would appear to assure that he meets the most stringent Socratic criteria for the life worth living.

Todd takes his reflections seriously and lives by their results. "I tend, I'm afraid, to attribute to abstract ideas a life-or-death significance," he tells us (15). On a fateful day in June of 1937, Todd's reflections lead him to the conclusion that nothing matters. As a result of this realization, he decides to commit suicide, and he chooses to accomplish this by setting off an explosion on the showboat *Floating Opera* at a time when it will be occupied by about seven hundred people. Among those on the boat will be Todd's friend Harrison Mack, his mistress Jane

Mack, and little Jeannine Mack, who may well be Todd's own daughter. Here is Todd's description of himself as he watches the show and waits for the blast.

> My heart, to be sure, pounded violently, but my mind was calm. . . . Calmly I thought of Harrison and Jane; of perfect breasts and thighs scorched and charred; of certain soft, sun-smelling hair crisped to ash. I heard somewhere the squeal of an overexcited child, too young to be up so late: not impossibly Jeannine. I considered a small body, formed perhaps from my own, and flawless Jane's, black, cracked, smoking. . . . [I]t made no difference, absolutely. . . . From high on his chair Capt. Adam regarded his brood with an olympian smile—calmly, more godlike than he, I too smiled. (23)

However ghastly we may find this, Todd's reactions are certainly consistent with his beliefs. If nothing matters, then the impending explosion and the deaths and injuries he expects do not matter. If none of these things matters, there is no reason to be upset by their expected occurrence.

As things turn out, the explosion never goes off. Afterward, Todd realizes that he had made a mistaken inference from his new belief. If nothing mattered, he later saw, there was no reason to live, but neither was there any reason to kill himself. As he notes in the final chapter:

> To realize that nothing makes any final difference is overwhelming; but if one goes no farther and becomes a saint, a cynic, or a suicide on principle, one hasn't reasoned completely. The truth is that nothing makes any difference, including that truth. (246)

Though Todd decides against reattempting suicide, this is not because he finds that life is after all worth living. Instead, it is a reflection of a deeper, more consistent nihilism. Todd continues living, he tells us, much "as a rabbit shot on the run keeps running in the same direction until death overtakes him" (246).

An Argument for Nihilism

Todd's credentials as a rational model emerge most directly in his reflections on the nature of value. Though he says he is no philosopher, he manages to construct an abstract argument for nihilism, the view that nothing is of value. Here is the argument he records in his journal:

> I. Nothing has intrinsic value.
> II. The reasons for which people attribute value to things are always ultimately irrational.
> III. There is, therefore, no ultimate reason for valuing anything. (218)

He later adds the words "including life" to proposition III and concludes that there is no "final reason for living" (223).

Todd's nihilistic insight comes to him during a conversation about suicide with Mr. Haecker, one of the aged residents of the hotel in which Todd lives. Reflecting afterwards, he is surprised that it did not occur to him earlier.

> All my life I'd been deciding that specific things had no intrinsic value—that things like money, honesty, strength, love, information, wisdom, even life, are not valuable in themselves, but only with reference to certain ends—and yet I'd never considered generalizing from those specific instances. But one instance was added to another, and another to that, and suddenly the total realization was effected—*nothing* is intrinsically valuable, the value of everything is attributed to it, assigned to it, from outside, by people. (166-67)

While Todd's argument for nihilism should certainly be looked at closely before we accept such a radical conclusion, his rationale for this belief has both power and plausibility. His realization that many things to which people attribute value are not valuable in themselves leads him inductively to a nihilistic view. His conclusion is bolstered by reflection on the language in which we usually discuss value, for most expressions about value do have a relational element. We say that something is valuable *to* someone or valuable *for* something.

When Todd says that there is "no ultimate reason for valuing anything," his use of the word "ultimate" suggests that his judgment is being made from a cosmic, impersonal point of view, rather than from the usual personal perspective that people adopt. This cosmic point of view is related to the classical ideal of rationality because it incorporates the most perfect form of objectivity. Todd's argument suggests that if we want to make sense of the idea of absolute values, we need to think of things whose value would be recognized by a purely rational being, a being that had no particular desires, goals, or interests. But, he believes, when things are viewed in this purely rational way, they are seen to be without value. It is only because we are influenced by irrational desires and illusions that we believe that things possess value. The rational person will be a nihilist.

Todd's nihilism receives further support from his skepticism about the possibility of giving rational justifications for our beliefs, actions, and desires. After urging the aged Mr. Haecker to think about committing suicide, Todd defends himself, saying, "Don't think I'm an indiscriminating promoter of suicides; I merely hold that those who would live reasonably should have reasons for remaining alive. Reasonable enough?" (169) Todd believes, of course, that no such reason can be given, that all alleged reasons terminate in something arbitrary and nonrational. This emerges most clearly in an exchange with little Jeannine. As they approach the showboat, she begins to question him about it.

> "What's it for, Toddy honey?" she shouted, awed at the Opera's size. "It's a showboat, hon. People go on it and listen to music and watch the actors dance and act funny." "Why?". . . . "The people like to go to the show because it makes them laugh. They like to laugh at the actors." "Why?" "They like to laugh, because laughing makes them happy. They like being happy, just like you." "Why?". . . . "Why do they like being happy? That's the end of the line." (194–95)

A few moments later, Jeannine asks for an ice cream, and when Todd repeatedly asks "Why?" she continues to say "I want one." The justification in both cases ends not with a reason but with a desire, a nonrational psychological urge. For Todd, since justifications end in something nonrational, they fail to be rational justifications. They would only succeed if one could establish—as he thinks one cannot—that the thing desired has some intrinsic or absolute value, some value that would be recognized from a totally objective point of view.

The Significance of Todd's Nihilism

Armed though he is with rational arguments, Todd Andrews is not a mind in a vacuum who simply happens to light on the propositions he presents to us in the novel. The novel reveals enough of Todd's history to suggest that his bleak views result more from his own personal suffering and deficiencies than from his reasoning. Having undergone several severe traumas in his life, Todd suffers from a deep sense of indignity and self-hatred.[4]

My point in drawing attention to Todd's personal flaws is not to refute nihilism, which could presumably be held by a healthier, less obsessive person. It is important to see, however, that the novel does not

endorse Todd's nihilism. Instead, it undermines the view that Todd's views arise simply from his arguments. He himself suggests at one point that his arguments are "rationalisings . . . the *post facto* justification, on logical grounds, of what had been an entirely personal, unlogical resolve" (219). At the end of the book, he even wonders whether he hadn't simply reasoned mistakenly about life and its value. "I considered whether in the real absence of absolutes, values less than absolute mightn't be regarded as in no way inferior and even lived by. But that's another inquiry, and another story" (246–47).

Given this inconclusive ending, we might wonder why Todd's story matters. I believe that it matters because it raises serious doubts about the possibility and the desirability of the rationalist ideal. The novel presents us with an alternative vision of the "examined life." It shows us, first, that an examined life of the sort that rationalists have advocated is consistent with cruelty and indifference to others, as well as deep personal unhappiness. Second, it shows that reasoning may lead not to a discovery of what is genuinely valuable in life but to the discovery that nothing is of value, including the life of reason. Finally, the full story of Todd suggests that even strenuous efforts to live according to reason may be illusory, that the shape of our lives may be determined by our emotions and the events that befall us. Reasoning may be no more than a cover for emotional forces rather than an autonomous part of us that can guide and control the other elements of our nature.

As both novel and philosophical stimulus, *The Floating Opera* more than stands on its own. Nonetheless, Barth must have felt that he had not fully explored these questions about reason, value, and the examined life, since they remain the central issues in his second novel, *The End of the Road*.

Jacob Horner: Reason and Inertia

Jacob Horner, the narrator and main character of *The End of the Road*, shares with Todd Andrews the characteristic marks of the rational man. Although first introduced as a person undergoing some form of psychiatric therapy, Jacob is certainly a highly competent reasoner, someone who can construct elaborate justifications even for simple actions. Early in the novel, he describes his solution to the problem of how to sit when visiting the Doctor. There are many possible positions for his arms, and Jacob moves them continuously

as a recognition of the fact that when one is faced with such a multitude of desirable choices, no one choice seems satisfactory for very long by comparison with the aggregate desirability of all the rest, though compared to any one of the others it would not be found inferior.[5]

This kind of reflection is typical of the way he approaches things. It is, he says, "the story of my life in a sentence."

Jacob's reasoning ability again reveals itself in his reaction to the Doctor's asking if there is any reason he should not apply for a teaching job. Here is his reaction, which he again describes as "in a sense the story of my life":

> Instantly a host of arguments against applying for a job . . . presented themselves for my use, and as instantly a corresponding number of refutations lined up opposite them, one for one, so that the question of my application was held static like the rope marker in a tug-o-war where the opposing teams are perfectly matched. (4–5)

Jacob's problem is that all of this consideration of pros and cons leads him to inertia and inaction. He finds it difficult to decide, to choose, or to act. His reaction, however, does not seem irrational, for acting rationally seems to require having a reason for choosing one of a number of options, and if there are too many good options, a rational choice among them may not be possible. Moreover, if there are equally strong reasons for and against every option, reason may provide no basis for choice.

On the day of his twenty-eighth birthday, Jacob suffers a severe attack of motivational paralysis at the Baltimore railroad station. Though the immediate cause of this paralysis is his inability to choose from a number of equally valuable (or valueless) destinations for a train trip, Jacob's affliction has deeper, more metaphysical roots. As he tells us,

> There was no reason to do anything. My eyes . . . were sightless, gazing on eternity, fixed on ultimacy, and when that is the case there is no reason to do anything—even to change the focus of one's eyes. . . . It is the malady *cosmopsis,* the cosmic view, that afflicted me. (74)

After sitting immobilized for more than twelve hours, Jacob is brought out of his trance by the Doctor, a distinguished-looking black man, who claims to specialize in "various forms of physical immobility" (76).[6]

From this point on, Jacob struggles against a relapse into paralysis. Even after the Doctor revives him, he is still stymied by elementary choices. Returning to the Doctor with coffee he had purchased, he finds

himself standing in front of the waiting room bench. "'Good,' the Doctor said. 'Sit down.' I hesitated. I was standing directly in front of him. 'Here!' he laughed. 'On this side! You're like the donkey between two piles of straw!'" (77) The allusion here is to the parable of Buridan's ass, a story in which a purely rational donkey starves to death because it is faced with two identical piles of straw and has no reason to eat one rather than the other.

Jacob's awareness of the many alternatives to any given action, his knowledge of equally good reasons in favor of and against particular choices, his ability to see his situation from a totally objective, cosmic point of view—all of these reflect his rationality, but together, they make choice and action impossible for him. For this reason, the Doctor urges him to act on any principles whatsoever, and his prescriptions sound like rejections of rational standards. What matters, the Doctor says, is that Jacob act. Whether he acts reasonably and consistently or impulsively and arbitrarily makes no difference. Here are his guidelines for choice:

> If the alternatives are side by side, choose the one on the left; if they're consecutive in time, choose the earlier. If neither of these applies, choose the alternative whose name begins with the earlier letter of the alphabet. These are the principles of Sinistrality, Antecedence, and Alphabetical Priority—there are others, and they're arbitrary, but useful. (85)

Although Jacob is suspicious that the Doctor is a quack, he tries to follow his advice. Characteristically, he often has difficulty deciding which of the three principles to apply to a given situation.

For much of the novel, we see Jacob as a person without a sense of identity, shifting among various roles, imitating other people, not identifying with the being who performs "his" actions, and frequently sinking into "weatherless" frames of mind in which he simply remains inert, rocking in his chair.

Joe Morgan: Reason in Action

Like Todd Andrews and Jacob Horner, Joe Morgan had seen reality from the cosmic point of view and had likewise concluded, "Nothing matters one way or the other ultimately" (42). Unlike Jacob, however, Morgan is not immobilized by this vision. He is active and decisive and impresses Jacob with "his drive, his tough intellectuality, and his deliberateness."

> Joe Morgan would never make a move or utter a statement, if he could help it, that he hadn't considered deliberately and penetratingly beforehand, and he had, therefore, the strength not to be much bothered if his move proved unfortunate. . . . Indecision . . . was apparently foreign to him: he was always sure of his ground; he acted quickly, explained his actions lucidly if questioned, and would have regarded apologies for missteps as superfluous. (32–33)

Joe thought hard and translated his conclusions into practice. Philosophizing, Jacob tells us, "was no game for Mr. Morgan. . . . [H]e lived his conclusions down to the fine print" (48). Joe's commitment to rational deliberation and objectivity is apparent in his views about his marriage, which he sees as an unsentimental but respectful partnership between equals. At Joe's insistence, he and his wife Rennie had "agreed that on every single subject, no matter how small or apparently trivial, we'd compare our ideas absolutely and impersonally and examine them as sharply as we could" (61). Summing up his own ideals at one point, Joe tells Jacob, "Nothing is ultimately defensible. But a man can act coherently. He can act in ways that he can explain, if he wants to. This is important to me" (47).

In Joe Morgan, we seem to see a more successful version of a rational person than we find in Jacob Horner. Although he does not find that reason alone reveals objective values on which to base his life, the process of rational deliberation remains supremely important to him. He accepts it as the means of shaping his life, even though it is not easy living by these standards. As he says to Jacob,

> The more sophisticated your ethics get, the stronger you have to be to stay afloat. And when you say good-by to objective values, you really have to flex your muscles and keep your eyes open, because you're on your own. It takes energy. (47)

Joe apparently has the energy Jacob lacks, and this allows him to live actively in spite of his uncomforting vision of reality.

A Disaster for Reason

While Joe appears to be a successful example of someone committed to rational living, the novel shows both Joe and Jacob to be failures, and it is their rationality that lies at the root of their defects.

That Jacob is a failure is clear. His rational tendencies lead him to

skepticism and immobility. Even with Joe as a model and the Doctor's attention, his sense of the ultimate arbitrariness of all choice robs him of the ability to act. Jacob's rationality is an obvious dead end, the source of his sickness and his suffering. Lacking reasons for conviction, Jacob usually follows the path of least resistance, and where external prods are lacking, he slips toward inertia and paralysis. His story is a set of variations on the Buridan's ass theme, and in it we see that rationality need not be a liberating ideal for a person. Instead, it can be a burden and an obstacle to living well.

Joe's case is more complex, for he appears at first to be successful in living according to rational ideals. He is strong, energetic, and abundantly supplied with justifications for what he does. As the novel progresses, however, his weaknesses are revealed, and Barth makes it clear that Joe's weaknesses are strikes against the ideal of rationality. As Jacob says to Rennie, "A disaster for him is a disaster for reason, intelligence, and civilization, because he's the quintessence of these things" (123). Though granting that he sometimes finds Joe "noble, strong, and brave," Jacob also provides an alternative view: "Or you could say he's just insane, a monomaniac: he's fixed in the delusion that intelligence will solve all problems" (123).

Joe's limitations are brought out in a number of ways. First, there is Jacob's cynical humor, which casts a harsh light on Joe's earnest deliberateness, making him look foolish rather than heroic. He infuriates Joe by treating the process of rational discussion and argument so casually. When Joe asks whether he had changed his mind about a particular argument, Jacob replies:

> 'The fact is that I can never remember arguments, my own or anybody else's. I can remember conclusions but not arguments.' This observation, which I thought arresting enough, seemed to disgust Joe. (41)

Jacob's mockery is a deadly weapon which the Morgan system cannot tolerate, and the book is full of Rennie's anguished wincings as she sees Jacob's humor applied to things she and Joe had considered sacred. Joe could answer arguments and withstand disapproval, but he had no defense when Jacob mocked these very capacities. "Kind of silly and awfully naive. That's our Joseph. Not a man to take too seriously," Jacob tells Rennie (123).

The novel also undermines Joe by revealing the degree to which he is deceived about himself, Rennie, and their marriage. This is an especially

serious charge because of Joe's insistence on facing the facts and avoiding comfortable illusions. But how clearsighted had he really been? How honest and open was he with Rennie and about himself? Jacob reveals Joe in a new light and shows him to be something of a hoax. In one of the book's most devastating scenes, Jacob urges Rennie to peek in at Joe when he believes himself to be alone and unobserved. Rennie, expecting to see the usual deliberate, self-controlled Joe, says, "Real people aren't any different when they're alone. No masks. What you see of them is authentic" (70). The Joe she sees in the room, however, is not the familiar one. This Joe prances around in Boy Scout marching steps, yells orders and nonsense at his mirror image, and then settles down to read a book, while at the same time masturbating and picking his nose. Commenting on this scene in a later discussion of consistency and self-identity, Jacob says,

> In my cosmos everybody is part chimpanzee, especially when he's by himself. . . . Maybe the guy who fools himself least is the one who admits that we're all just kidding. (138)

Joe Morgan is apparently not to be classed among those who fool themselves least.

Moreover, he could not be more wrong about Rennie. Though he tells Jacob that Rennie is strong and self-sufficient, we are made aware of her suffering, her inability to live by Joe's standards, and the ways in which their marriage suppresses her nature. Rennie, describing their premarital agreement to discuss all subjects impersonally, tells Jacob,

> [H]e warned me that until I got into the habit of articulating very clearly all the time . . . most of the more reasonable-sounding ideas would be his. We would just forget about my ideas. (61)

As a result, she says,

> I threw out every opinion I owned, because I couldn't defend them. I think I completely erased myself, Jake, right down to nothing, so I could start over. (61–62)

The unhealthy denial of Rennie, who knows she will never be able to match Joe's argumentative skills, could not be clearer, yet they both strive to retain the illusion of equal and mutually respecting partners.

None of these important facts has any impact on Joe until the pivotal

event of the novel: Rennie's adultery with Jacob. Even then, though aware that something is wrong, he cannot see what the problem has been. In spite of his commitment to truth and facing harsh realities, Joe had been blind to central facts about his life. Like other less rational people, he was simply caught up in a set of flattering illusions.

Finally, and most dramatically, Joe Morgan's commitment to the life of reason is discredited by his callous insensitivity toward Rennie. After Rennie and Jacob's adultery, Joe forces her back to Jacob because he thinks that continuing the affair is the only way to understand why it happened in the first place. He told Rennie

> that if we were ever going to end our trouble we'd have to be extra careful not to make up any versions of things that would keep us from facing the facts squarely. If anything, we had to do all we could to throw ourselves as hard as possible against the facts, . . . no matter how much it hurt. (122)

Neither Rennie's loathing of Jacob nor her anguished talk of suicide shakes Joe's determination to understand. Even after Rennie becomes pregnant and makes clear that she desperately wants an (illegal) abortion, Joe offers her no support. His belated quest for real understanding takes precedence over everything.

Rennie's despair, though it leaves Joe unmoved, is so great that it penetrates the pathological passivity and detachment of Jacob. It is Horner, the cynic and arch-skeptic, who is moved to act on Rennie's behalf and who asserts the values of compassion and benevolence. He asks Joe,

> "Don't you think you're just keeping the wounds open?" "I guess so [Joe replies]. In fact, that's exactly what I'm doing. But in this case we've got to keep the wound open until we know just what kind of wound it is and how deep it goes." "It seems to me [Jacob answers] that the important thing about wounds is healing them, no matter how." (146)

The extremity of Morgan's insensitivity and his overintellectualizing of the problems of life are finally and perhaps most grotesquely brought out when, speaking to Jacob, the man who in his view has ruined his marriage and brought his wife to the verge of total breakdown, Joe says: "If there's one thing I'd kill you for, Horner, it's for screwing up the issues so that we have to act before we've thought" (154). The final effect of Joe's rationalistic "monomania" (to use Jacob's term) is to stifle his humane instincts and blind him to what is of first importance.

Rennie and the Doctor

Rennie, as we have already seen, is the victim of Joe's rationalism. It is painful to see her granting such dominance to him and losing any sense of her own nature. Nonetheless, there is a certain rationality to her deference. In fact, she exemplifies the kind of response that one implicitly wants from Euthyphro after his conversation with Socrates. We expect him to back down from a decision that he cannot rationally justify. Yet this is just what Rennie does, acting just as a certain rational ideal would seem to require: the ideal of giving up those beliefs that one cannot justify. Rennie does this, and we see the great costs to her. She loses all sense of self-confidence and self-direction as a result of attempting a rational reconstruction of her life.

Finally, there is the Doctor, whom Barth uses to drive home his antirationalistic conclusions. Classical rationalists have emphasized the great value of reasoning and the discovery of correct principles as means to deciding how to live. In opposition to this view, the Doctor urges Jacob to cease his deliberations. "It doesn't matter," he says, "whether you act constructively or even consistently, so long as you act" (3). While the actual principles (sinistrality, antecedence, etc.) that the Doctor recommends to help Jacob make choices are totally absurd, they seem oddly appropriate to Jacob's case.

Often, the Doctor's advice makes a mockery of traditional rational ideals. He rejects, for example, any commitment to truth-seeking, substituting for it the treatment he calls "mythotherapy." Since Jacob lacks a sense of identity, the Doctor urges him simply to create roles for himself and the people he deals with. Such fictionalizing plays an important part in everyone's life, he says, and Jacob's paralysis was partly caused by his failure to participate in this universal myth-making. The road to recovery is through fiction rather than truth (88–90). Nor is the Doctor afraid to apply his indifference to truth to his own views. Commenting on his own remarks to Jacob, he says,

> You've no way of knowing whether anything I've said or will say is the truth, or just part of my general therapy for you. . . . Access to the truth, Jacob, even belief that there is such a thing, is itself therapeutic or antitherapeutic, depending on the problem. (80)

Indeed, as Jacob notes, this comment reflects the Doctor's entire orientation toward the world. The Doctor, Jacob tells us, is "a kind of

super-pragmatist." For him, "Everything . . . is either therapeutic, antitherapeutic, or irrelevant" (84).

For the Doctor, the great Socratic quest to discover the true nature of things and the best way to live is totally subordinated to therapeutic needs. Ideals that people have taken to possess supreme, intrinsic value are reduced by the Doctor to instruments for treatment. Thus, among the Doctor's available treatments are such things as Virtue and Vice Therapy, Theotherapy and Atheotherapy, Mythotherapy and Philosophical Therapy. He tells Jacob,

> It would not be well in your particular case to believe in God. . . . Religion will only make you despondent. But until we work out something for you it will be useful to subscribe to some philosophy. Why don't you read Sartre and become an existentialist? It will keep you moving until we find something more suitable for you. (84–5)

The message is clear. The rational pursuit of truth has no intrinsic importance. Like all else, it may or may not prove useful.

While the Doctor is an effective spokesman for Barth's skepticism, he does not escape unblemished by the events of the novel. He condemns Jacob's heroic efforts on Rennie's behalf as antitherapeutic, accusing Jacob of ruining his "most interesting case"—Jacob himself. Moreover, it is finally at the Doctor's hands that Rennie meets her death, since he performs the fatal abortion.

There is, thus, nothing left intact at the bleak end of the novel, when Jacob gets into a taxi and utters the book's final word, "Terminal."

Is Barth's Argument Valid?

To this point, I have been trying to substantiate my claim that *The End of the Road* contains an attack on the classical ideal of rationality. The basic strategy underlying this attack consists of identifying the main characters as models of rational behavior and reducing each to absurdity. Jacob's ideas lead him to apathy and paralysis, while Joe's lead to foolish singlemindedness, self-deception, and insensitivity.

We may wonder, however, whether there is really anything here that should worry a rationalist. Does the novel prove its point? Or can it be dismissed as "just a story"? Rationalists might object that the strategy of identifying characters with theories or positions is unfair and fallacious. While we are supposed to infer from the defects of the characters that

their ideas are defective, a moment's reflection shows this to be a blatantly *ad hominem* argument. It is surely illegitimate, one might argue, to reject Joe's ideas because they produce self-deception and cruelty in him, and it is equally illegitimate to reject Jacob's principles because they lead him to paralysis.

Surely, the objection would continue, true ideas and worthy ideals may sometimes lead to unfortunate consequences, but there is no necessary connection between these misfortunes and the worth of the ideas in question. It is not necessary that anyone with Joe's or Jacob's ideas would behave just as they do. Surely, we could write stories in which persons having precisely their ideas show themselves to be healthy and admirable in every way, thus crediting these ideas in the same way that Barth's novel seeks to discredit them.

Or could we? This is the crucial question we must answer in order to assess the ideas expressed by the novel.

The question suggests a general test (though not the only one) for evaluating the philosophical value of ideas in literature. If a book's argument is "valid," it will be because the facts showing a character and his beliefs in a good or bad light are inevitable consequences of that character's nature and beliefs. If, however, we can readily imagine things happening in quite different ways, this will suggest that the relationship between the ideas and the events of the novel is quite loose and that no valid inference can be drawn about the ideas from the events of the novel.

Looking at Barth's novel with this test in mind, I think that it stands up quite well. In the cases of both Jacob and Joe, the defects attributed to them are essentially related to their natures, not merely incidental to them.

A Dilemma for Rationalists

In trying to show the power of the novel's argument, I want to reemphasize a point made earlier—that Joe and Jacob are, for all their differences, similar in important ways. As Rennie tells Jacob,

> What scares me sometimes is that in a lot of ways you're *not* totally different from Joe: you're just like him. I've even heard the same sentences from each of you at different times. You work from a lot of the same premises. (64)

The central premise they both share is a commitment to the classical rationalist paradigm. Both believe that rationality involves maximizing the role of deliberation and knowledge in one's life. The book presents its challenge to classical rationalist ideals in the form of a dilemma. Either the attempt to adhere to rational ideals leads to paralysis, or it leads to self-deception.

To see this, consider Joe. He first appears to be a successful embodiment of rational ideals, a person who strives to fashion a coherent life for himself based on knowledge and deliberation. The novel, however, provides two important insights about Joe Morgan. First, he is self-deceived. Second, and even more important, it is only because he is self-deceived that he can be the vigorous person that he is. If he were true to his ideals, he would be another Jacob Horner, for it is Jacob who actually embodies the ideals espoused by Joe. What we see in Jacob, however, is that these ideals are not ideal. They are a disease that renders life and action impossible.

In presenting his ideals to Rennie, Joe had warned her that "one of the hardest and most essential things is to be aware of all the possible alternatives to your position" (62). Only by doing so can one have reason to believe that one's own choices are justified. Both Rennie and Joe are convinced that Joe meets this image of perfection. Barth, however, presents the reader with the image of Jacob's life as a criterion for seeing how well Joe really meets his ideal and what the value of success might be. A person who envisaged all the alternatives to his own position would not be the decisive Joe Morgan. He would be Jacob Horner in the Progress and Advice Room, trying to decide the best way to sit opposite the Doctor.

> The Doctor sits facing you, his legs slightly spread, his hands on his knees, and leans a little toward you. You would not slouch down, because to do so would thrust your knees virtually against his. Neither would you be inclined to cross your legs in either the masculine or the feminine manner; the masculine manner, with your left ankle resting on your right knee, would cause your left shoe to rub against the Doctor's left trouser leg, up by his knee, and possibly dirty his white trousers; the feminine manner, with your left knee crooked over your right knee, would thrust the toe of your shoe against the same trouser leg, lower down on his shin. To sit sideways, of course, would be unthinkable, and spreading your knees in the manner of the Doctor makes you acutely conscious of aping his position, as if you hadn't a personality of your own. (2)

It is here in Jacob that the ideal of self-conscious reflectiveness finds its true expression rather than in the life of Joe Morgan. No person could live anything like a normal life if he were committed to an awareness and evaluation of all positions on matters large and small. Horner, not Morgan, is the more consistent rationalist in the novel, and it is he who reveals what can only be called the pathological implications of the position.

We can approach this point from a different perspective by recalling the surreptitious viewing of Joe's uncharacteristic self by Rennie and Jacob. Jacob's comment was that everyone is part chimpanzee, and the animal comparison is unflattering to Joe, who views himself as determined by reason. In comparison with the paralyzed Jacob, however, the animal energy generating Joe's activity may seem more positive. While thought leads to immobility, it is the passions and impulses that are life-giving and activity-generating. While Jacob, paralyzed by cosmopsis, had sat frozen in the railroad station,

> shortsighted animals all around . . . hurried in and out of doors leading to tracks. . . . Women, children, salesmen, soldiers, and redcaps hurried across the concourse toward immediate destinations. (74)

Unbeknownst to himself, Joe Morgan is one of these "shortsighted animals." That is both his weakness and his strength. It both permits him to live actively and makes him a failure by his own standards.

I conclude, then, that Jacob's paralysis and Joe's self-deception are not accidental features, that they flow directly from the ideal of rationality and the extent to which each character approximates that ideal. If we were to try to write another story in which this ideal emerged more positively, we could not do so without changing the ideal. Any character that we might portray who was committed to the traditional ideal would be either paralyzed or self-deceived.

Much of the force of Barth's book is captured by David Hume's famous remark: "Reason is, and ought only to be, the slave of the passions."[7] Reason *ought* to be the slave of the passions because too much thinking interferes with successful living. It either halts activity, as in Jacob, or leads to a subordination of more important values, as in Joe. Rennie makes this point when she comments, "All our trouble comes from thinking too much and talking too much." (131)

Reason *is* the slave of the passions, the novel suggests, because it is not the real cause of our actions. If Joe and Jacob share so many premises and yet act so differently, their behavior must derive from nonrational

passions or impulses. Their ideas are no more than an epiphenomenal cover that obscures the power of these nonrational causes. Jacob reflects half-seriously at one point that all behavior derives from a sexual motivation.

> If one had no other reason for choosing to subscribe to Freud, what could be more charming than to believe that the whole vaudeville of the world, the entire dizzy circus of history, is but a fancy mating dance? . . . When the synthesizing mood is upon one, what is more soothing than to assert that this one simple yen of humankind, poor little coitus, alone gives rise to cities and monasteries, paragraphs and poems, foot races and battle tactics, metaphysics and hydroponics, trade unions and universities? Who would not delight in telling some extragalactic tourist, "On our planet, sir, males and females copulate. Moreover, they enjoy copulating. But for various reasons they cannot do this whenever, wherever and with whomever they choose. Hence, all this running around that you observe. Hence the world"? (93)

For most of the book, Jacob refrains from causal hypotheses and is stingy with facts about the past. We are in no position to speculate about the deeper causes of the actions and events we witness. Nonetheless, as in Hume, there is a two-pronged attack on reason. Because Reason is not the fundamental cause of human behavior, the ideal of rational self-direction is unattainable. Moreover, if this ideal could be attained, it would not be desirable to do so. Contrary to Socrates, it is the *examined* life that is not worth living.

Summing Up

I hope that my discussion has made it clear that Barth's novels raise serious doubts about the classical ideal of rationality.[8] Key components of that ideal—deliberation, objectivity, knowledge, and truth—all come under attack, and the criticisms are far from superficial. Nonetheless, one may be tempted to reply to Barth's assessment of rationality as Rennie Morgan does to Jacob's assessment of her husband, Joe. "Jake," she says, "You know he could answer all those charges" (123).

Can defenders of classical rationality "answer all those charges"? I think not, and in the next chapters, I want to consider the classical ideal and its defects in more detail. This consideration will not be entirely negative in its results. While I will try to show that the defects of the

classical ideal are sufficient to undermine it, my hope is that the pattern of criticisms will suggest ways to defend the value of rationality by formulating an alternative to the classical conception.

PART II

DEFECTS OF THE CLASSICAL IDEAL

Introduction

> *Every human virtue contains an evil, and we need to understand the price paid for the qualities we hold dear and deem essential.*
> —Philip Slater

At this point, we have before us two images of the same ideal, one that portrays rational ideals as ennobling and eminently valuable, another that presents them as debilitating and destructive. While I have claimed that the criticisms of rationality in Barth's novels are cogent, a bit of reflection may lead one to feel that a condemnation of rationality is extremely paradoxical, perhaps even self-contradictory. This is because we ordinarily use words like "rational" and "reasonable" to express our approval or commendation. Likewise, we label someone's beliefs, actions, or desires "irrational" or "unreasonable" when we want to expresses disapproval or impatience. On occasion, these words denote the presence of pathological conditions. Max Black claims that these evaluative components are part of the meaning of these terms. He writes:

> To call an action reasonable is to approve it, and to call it unreasonable is to censure it. This point has been implicit . . . in my frequent reference to 'reasonable' as a term of *appraisal*. It is worth making explicit, however, that the praise is part of the standard meaning of the word (as also in the cases of 'fine', 'good', 'splendid', and the like) and can be overridden in speech only by using irony, paradox or some other *ad hoc* rhetorical device.[1]

If Black is correct about these words, it should make no more sense to censure an action for its being rational than it does to condemn a work of art for its being splendid. How then can rationality be a bad thing?

While Black's claim about the meaning of "rational" contains an important truth, it cannot be the whole story. If he were correct, any

discussion of whether rationality is a good quality would be impossible; there would be nothing to discuss. Such discussions, however, are clearly possible and are acknowledged in the intriguing opening words of Black's essay itself. He writes:

> Many say and some believe that it is a good thing to be reasonable. Yet it would be heroic folly to aspire to be reasonable in all situations: those who wish to be as reasonable as it is reasonable to be may feel uncomfortable with Reason's traditional status as a supreme value.[2]

These words have a paradoxical air about them. It is hard to see how it could be true both that "reasonable" is always a term of positive appraisal and that being reasonable could sometimes be "heroic folly." To call the aspiration to be reasonable in all situations "folly" is to suggest that it is foolish and unreasonable. This further suggests that it could be unreasonable to be reasonable, but Black provides no guidance on how that could be. How can it be that "rational" is a term of positive endorsement and yet that we can meaningfully ask whether it is good to be rational?

We can resolve this paradox by seeing that it is possible for two people to agree that being rational is a good thing while disagreeing about what it is to be rational. Likewise, if the *general concept* of rationality becomes identified with some *specific conception or interpretation* of rationality, people who want to reject a specific conception may express their position by claiming that rationality itself is not valuable. What they really mean, however, is that some specific conception of rationality ought to be rejected, and they might even have good reasons to support this claim. Because they mistakenly identify the concept of rationality with the specific conception being rejected, they believe themselves to be rejecting rationality itself.

This point can be illustrated by reference to debates about science and technology. It frequently happens that both advocates and critics of technological change identify rationality with the methods of technological analysis and problem-solving. Critics of these methods and their results sometimes unwittingly become critics of rationality. They think that the only way to reject the evils of technological analysis or their inappropriate extension to nontechnical domains is to reject rationality. Their mistake is in conceding that those who advocate unlimited application of technological models of thought are themselves rational.[3]

If it turns out that technological approaches to human problems are themselves destructive of what is valuable in human life, then it is

irrational for human beings to employ these techniques. Rationality (in the broader sense) is not identical with the specific interpretation of it that the participants in this debate accept. Critics think they are rejecting rationality, but they are in many cases only rejecting a narrowly scientific or technological interpretation of rationality, an interpretation that need not be accepted.

The same is true, I think, of some criticisms of rationality made by feminists. Because rational ideals are often modeled on traits associated with men and are then used to denigrate the nature and status of women, feminists sometimes argue that rationality should be rejected.[4] Here again, if their arguments are correct and if genuinely valuable traits have been devalued by rationalists, that shows that these rationalists have gone astray. Since it can never be rational to denigrate something that is genuinely good, any criterion of rationality that denigrates valuable traits associated with women is a defective conception of rationality.

My key point here is that we must avoid mistaking a particular conception of rationality for the general concept of rationality itself. Once we see this, we can understand how it is possible to question or criticize any particular ideal of rationality, whether it be the classical ideal or an ideal that is rooted in technological methods or in ideals of masculine and feminine behavior.

Here I want to focus on the classical ideal because it is historically the most powerful and pervasive conception of rationality. It expresses a specific interpretation of what it is to be rational and proposes that interpretation as an ideal. People who reject the classical version of rationality because they believe it is defective may easily come to believe that they are rejecting rationality itself. Likewise, people who value rationality may mistakenly find themselves defending an untenable ideal. They believe (rightly, I think) that rationality is genuinely valuable and worth defending, but because they identify rationality with the classical ideal, they mistakenly defend the classical ideal.

It is a mistake for people who value rationality to defend the classical ideal or to assume that if it fails, rationality itself must be forsaken. What is necessary is to examine the classical ideal, understand its defects, and formulate an interpretation of rationality that shows why rationality is desirable and thus explains why the word "rational" carries a positive connotation.

This, at any rate, is my strategy. In the following four chapters, I will focus on the place of deliberation, objectivity, knowledge, and truth in the classical ideal. I will show why the classical conception of these ideals

is misguided and will describe the proper role that a reasonable rationalist will accord to them.

Before considering these, however, it is necessary to begin to clarify the meaning of the word "rational." In one sense, to be rational is simply to have a capacity to reason. When the expression "human being" is defined as "rational animal," this is meant to emphasize that human beings possess a capacity that other animals lack. The definition does not imply that humans always use that capacity or that our behavior is always rational. The contrasting term to this sense of "rational" is "nonrational" rather than "irrational." Things that lack a capacity to reason, such as inanimate objects and simple forms of animal life, are nonrational, not irrational.

The second sense of the word "rational" is evaluative or normative. To say that something is rational in this sense means that it meets certain standards of rationality, and this obviously requires more than the mere possession of a capacity. One can fail to live up to standards of rationality, and when one does, he can be said to be irrational to some degree or in some respect.

This evaluative sense of "rational" can apply either to specific features of persons (their beliefs, actions, desires, etc.) or to persons themselves. We can call a person's individual acts or beliefs irrational without implying that he is an irrational person. What we would be saying is that he is irrational with respect to that particular belief or action, but this need not imply that he is on the whole an irrational person. To call a person "rational" or "irrational" is to make an overall appraisal of how far he or she conforms to standards of rationality. I may be a rational person and yet have, for example, an irrational fear of heights or an inability to evaluate objectively the talents of people I love. These features by themselves would not justify calling me an irrational person.

We need, then, to keep a number of distinctions in mind when we think about rationality. We need to distinguish the general concept of rationality from specific conceptions. We need to distinguish the nonevaluative sense of "rational" that contrasts with nonrational from the evaluative sense that contrasts with "irrational." Finally, we need to distinguish judgments that a particular feature or act of a person is rational from overall judgments about that person.

3
Reason and Deliberation

> *Life has to be lived, and there is no time to test rationally all the beliefs by which our conduct is regulated. Without a certain wholesome rashness, no one could long survive.*
> —Bertrand Russell

Classical rationalists have been distinguished by their urging that we use our reasoning capacity to make judgments and decisions, that we live by the dictates of reason. They hold that people are rational to the degree that they base their beliefs and actions on rational deliberations. For them, two factors seem to be involved in the overall rationality of a person: the extent to which she engages in deliberation and the quality of her reasoning. How rational a person is depends on how much and how well she deliberates about matters of belief and action.

The spirit of the classical ideal is nicely captured in Jonathan Barnes's description of Aristotle's view of the ideal human being. For Aristotle, Barnes writes,

> The good man, or expert human, is . . . an ace rationalist, either in that his actions are as a rule soundly based on excellent reasoning, or in that he indulges fairly often in fine excogitations.[1]

Max Black also stresses the nature of people's deliberations as central to the rationality of their actions. He writes,

> A man will be acting reasonably to the extent that he tries to form a clear view of the end to be achieved and its probable value to him, assembles the best information about available means, their probable efficacy and the price of failure, and in the light of all this chooses the course of action most strongly recommended by reason.[2]

While neither of these quotations provides a full account of the criteria of rationality, the overall idea is clear. Being rational requires using some

method of deliberation and basing one's choices on the results of employing that method. Striving to live according to the ideal of rationality involves striving to maximize the influence of deliberation in one's life. The more a person bases his actions on the kinds of deliberation Black describes, the more rational he will be.

For Aristotle, thinking is valuable not simply because it helps our actions to succeed but because thinking is simply the highest form of activity in which humans can engage, and an ideal life would apparently consist of nothing but contemplation. "Happiness," Aristotle writes,

> is co-extensive with contemplation, and the more people contemplate, the happier they are; not incidentally, but in virtue of their contemplation, because it is in itself precious.[3]

While it is no doubt important that Aristotle is discussing contemplation rather than practical deliberation in this passage, it is more important that thinking itself is elevated to such an exalted position. In both Aristotle's account and Black's more down-to-earth discussion, thinking appears to be something there cannot be too much of.[4]

That thinking and deliberation can be excessive, however, is one of the key points shown by *The End of the Road*. Through the character of Jacob Horner, Barth shows that it would not be desirable to maximize the role of deliberation in life. William James had the same insight. Discussing the nature and value of habits, James wrote,

> There is no more miserable human being than one in whom nothing is habitual but indecision, and for whom the lighting of every cigar, the drinking of every cup, the time of rising and going to bed every day, and the beginning of every bit of work, are subjects of express volitional deliberation.[5]

James's comment helps to clarify Black's paradoxical remark that it would be folly to strive to be reasonable in all situations. If by "being reasonable" we mean "engaging in deliberation," then being reasonable would be foolish because it would result in a life of constant hesitation and indecision. Someone who tried to base every action on deliberations that conform to the conditions described by Black and other traditional rationalists, would lead a miserable life. Because we can predict that such a life would be miserable, it would be irrational to choose it. Hence, it is irrational to aspire to the deliberative ideal that rationalists have advocated.

What James's point makes clear is that an account of rationality must

focus not only on the *method* by which decisions and judgments are made but also on the *results* of the actions being considered. Because of his pragmatic perspective, James saw that deliberation itself is an action and thus that the results of engaging in deliberation (that is, the results of using "rational" methods in any given situation) could be bad. In such cases, the rational thing to do—the action with the best foreseeable results—would be to refrain from reasoning.

The strong associations between rationality and deliberation make it easy to overlook the fact that they are not identical, but the point has not gone unnoticed by other philosophers. John Rawls takes note of it in his striking statement that "there is even nothing irrational in an aversion to deliberation itself provided that one is prepared to accept the consequences."[6] Henry Sidgwick also emphasized that rational processes must be evaluated by looking at the role they play in a person's life as a whole and that one should not simply assume that rational powers ought to be developed and exercised to the greatest degree possible. In his words,

> The question is . . . whether any degree of predominance of Reason over mere impulse must necessarily tend to the perfection of the conscious self of which both are elements. And it is surely not self-evident that this predominance cannot be carried too far; and that Reason is not rather self-limiting, in the knowledge that rational ends are some times better attained by those who do not directly aim at them as rational.[7]

The proper conclusion to draw is that reasonable rationalists will not adopt the ideal of engaging in "express volitional deliberation" on all matters. This is not a rational goal to adopt because it would diminish the well-being of those who try to achieve it.

Once we see this, it is easy to think of instances in which people behave rationally, even though their action does not result from deliberation. Deliberation is not a necessary condition of rational action. For example, it can be rational for me to stop at the curb of a busy street prior to crossing, even though I have not evaluated this action with respect to my goals, assessed its efficacy as a means, made unbiased and objective judgments, and so on. While this kind of evaluation would yield the conclusion that my action is rational, I need not consciously carry out the evaluation myself in order for my stopping to be rational. The probable results of my stopping or not stopping are the measure of the rationality of my action, and we can judge my action without referring to a "method criterion" of rationality.

These points seem so elementary that one may be tempted to doubt that anyone has ever denied them. Isn't my criticism an attack on a straw man, a view that no one has ever held? This reaction overlooks several points.

First, it is important to realize the degree to which views gain power by virtue of their generality. The appeal to the ideal of rationality is most powerful when the domain of reason is presented as unlimited and rationality is championed as the supreme value. Philosophers, in fact, are often drawn to extreme views because we tend to value both simplicity and logical consistency. It is the murky and complex that philosophers generally dislike, and this leads to a fascination with theories that reduce all judgments, rules, or values to one or two fundamental kinds. Socrates' famous dictum—"the unexamined life is not worth living"—is just one example of this type of philosophical extreme. He is not content to say that philosophizing is one of many valuable activities or that it makes some contribution toward a worthwhile life for some people. Instead, he claims that it is absolutely necessary to any worthwhile life. Had he said that the unexamined life is *usually* not worth living and described several types of lives that were unexamined but nonetheless worthwhile, he might have been less likely to have his words recorded and passed down through the ages.[8]

Extreme views have a special power to attract and have been common in the history of thought. John Passmore, after a scholarly survey of ideals of human perfection prior to the Renaissance, seems compelled to comment on just this extremity. He writes:

> Contemplating in retrospect the long history of Graeco-Christian thought, to say nothing of the Eastern religions, what strikes us most of all is the extravagant nature of the objectives it sets before men, and what goes with this, the severity of the conditions it lays down for their perfection.[9]

Passmore's history makes clear that the extravagance of the deliberative ideal does not mean that people have not held it or advocated views that implied it.

There is a second reason why rationalists may have shied away from noting that the value of deliberation is not unlimited. Once we recognize limits on the range of things about which it is desirable to deliberate, we must face the difficult task of saying what these limits are. The need to do this may put rationalists on the defensive, for their

demand that a particular belief or policy be rationally justified may provoke the counterdemand that they first demonstrate the appropriateness of reasoning in this kind of case. For all its unattractive implications, the extreme ideal of rationality has its charms, and many new problems arise when it is given up.

When Reasoning Is Irrational

I would like to make a start toward facing these difficulties by describing several kinds of circumstances in which deliberation would be irrational. These cases will be further evidence for the main point of this section: that there is a *result* criterion of rationality and that this criterion often dominates over the *method* criterion.[10]

The cases I will discuss come from debates about utilitarian ethics. While utilitarians have urged that we determine whether actions are morally right by calculating how much good they produce, their critics have tried to describe cases in which the process of calculating benefits and losses would itself be undesirable. Utilitarians have responded by noting that their aim is to achieve the best results and that they can acknowledge that there are situations in which we get better results by not engaging in explicit calculations. Their reply parallels the view that I think will be held by reasonable rationalists.[11]

Deliberation, then, is irrational when it is:

Harmful. In some cases, there is an urgent need to act and no time to deliberate. People will do better by trusting their instincts than by spending time in thought. A person in a burning building, for example, ought not to spend too much time considering which of several possible exits to use. Too much deliberation will actually decrease the chances of escaping safely. Here, deliberation is best left undone because it is likely to be harmful.

Unproductive. In other cases, though no harm would be done by deliberating, deliberation would be unreasonable because no good is likely to result. These are the kinds of cases suggested by William James. If someone is faced with a range of choices on a trivial matter, deliberation is unlikely to yield any benefits. Moreover, if the deliberations are carried out in an extremely thorough manner, this only makes them more irrational, not less so. Jacob Horner's reflections on how to sit at the Doctor's office provide a clear instance of this. When a question

is trivial, a person is best served by simply choosing. Likewise, the best choice may be so obvious that deliberation would be unproductive.

Baseless. Deliberation may not be harmful but may promise no benefits in cases where there is no basis for selecting from a number of options. If one is ignorant of the likely effects of action or if the result will depend entirely on matters of chance, deliberation would be fruitless.

Redundant. Deliberation may be unproductive because it has already been carried out. If I face a choice that I have faced previously and if I deliberated in the prior case with good results, there is no need for me to think through the matter again.

Inconsistent with other ideals. In some situations, deliberation may reveal a detachment or lack of commitment that is inconsistent with other values or ideals a person holds. We value such things as spontaneity, love, compassion, and friendship, and these may require that we respond quite automatically to certain kinds of situations. If my wife slips on the ice, it would be inappropriate for me to stop and think about whether to help her up. Failure to extend help automatically would be harmful both to a cherished relationship and to my goal of being a certain sort of person (for example, a loving husband).[12]

There are a number of things to notice about these situations. First, in each of them, the results of the action provide the criterion for determining its rationality. Second, though people need not (indeed, ought not) deliberate in these cases in order to be rational, their nondeliberation, if it is to be rational, must be based on some awareness of the nature of their situation—for example, that it is urgent, trivial, or involves other ideals. Third, people can be mistaken about the nature of the situation in which they find themselves. Though we need not deliberate when it seems obvious that there is no reason to do so, being rational does require that we be responsive to evidence that the situation is different from what we had thought.

For this reason, it is impossible to describe a type of action and say in advance that it could never be an appropriate subject of deliberation. James used "the lighting of every cigar" as an example of such an action, but given what we now know about the harmful effects of smoking, it is clear that lighting and smoking cigars ought to be thought about. Part of being rational, then, involves being flexible and open to new information. New knowledge about one's situation may make deliberation necessary in cases where it would once have been pointless.

Rational Actions with Bad Effects

I have said that we act rationally if we act in ways that are likely to have good results. One might argue that the following case shows the inadequacy of this result-oriented criterion. Suppose a person wants to sweeten her coffee and gets the sugar bowl out of the cabinet; unbeknownst to her, someone has substituted cyanide for the sugar in order to kill her. Since she does not know that the bowl contains cyanide rather than sugar, she mixes it in her coffee, drinks it, and dies.

According to the objection, a result criterion of rationality implies that the action described was irrational because its results were bad. It seems wrong, however, to condemn the action as irrational because the agent had no idea that bad consequences might result from her action. If an action with bad results can be rational, however, then the result criterion must be wrong.

While I agree with the view that the coffee drinker's action is not irrational, there are philosophers who would disagree. They would claim that it was irrational because it was based on a false belief. Hume, for instance, wrote that an action can only "be call'd unreasonable . . . when founded on a false supposition, or when it chuses means insufficient for the design'd end."[13] Because the coffee drinker's action was based on the false belief that drinking would be harmless, Hume's criterion implies that her action was irrational.

Hume's criterion, however, is too stringent in its cognitive demands. False beliefs do not by themselves undermine the rationality of actions. Whether a person's beliefs are true or false is not relevant to whether her action is rational. What is relevant is that the belief be reasonable, that she have reason to believe that the results of the action will be good or bad. A person's action is rational if the evidence available to her indicates that her action is likely to bring about the result she seeks. In the case of the unfortunate coffee drinker, if a murderer had skillfully disguised the cyanide, leaving no indications to the victim that she ought to be cautious with the sugar, the action of stirring the cyanide into the coffee and drinking it was rational, even though its result was unfortunate. False beliefs about actual results need not discredit the rationality of a person's action. Instead, our judgments about the rationality of action need to be based on the action's *foreseeable results,* in the light of evidence *available to the agent.*

While this view of rational action is correct, I think, it raises problems of its own. For example, we can only apply it if we have some idea of what makes a belief "reasonable" and what makes evidence "available" to a person. I will not try to define these ideas here, but I believe that the criteria of rational action must not involve overly stringent criteria of knowledge or belief. Likewise, whether evidence is available depends on features of the agent. We can see this by returning to the unfortunate coffee drinker. Suppose that a chemist would have seen that the substance in the bowl was cyanide, not sugar. In one sense, then, the evidence of the cyanide was available; that is, it would have been discoverable by a chemist. If the victim lacked chemical expertise, however, then both her mistaken beliefs and her unfortunate action were rational. Even if no special expertise was required and the victim would have known it was not sugar if she had looked carefully at the bowl, her belief was still reasonable. Because getting sugar from the bowl is a routine action, it is reasonable to spoon it out automatically without examining it. Given a context in which precautions are not usually required, the fact that the victim drank the cyanide does not reflect negatively on the rationality of her act.

John Rawls makes a similar point after contrasting two senses of rationality. What he calls the "objective" sense of rationality does require full knowledge by the agent, while the "subjective" sense does not. Since we are seldom if ever in possession of full knowledge, the objective sense sets an unreasonably high standard. As Rawls notes,

> As things are, of course, our knowledge ... is usually incomplete. Often we do not know what is the [objectively] rational plan for us; the most that we can have is a reasonable belief as to where our good lies, and sometimes we can only conjecture. But if the agent does the best that a rational person can do with the information available to him, then the plan he follows is a subjectively rational plan. His choice may be an unhappy one, but if so it is because his beliefs are understandably mistaken.... In this case a person is not to be faulted for any discrepancy between his apparent and his real good.[14]

Rawls, using the notion of "subjective rationality," correctly makes provision for reasonable but false beliefs in a way that Hume did not. Actions can have unfortunate results without being irrational because we can only expect a person to act on available evidence. It is the foreseeable consequences of actions that are crucial to their rationality, not their actual consequences.[15]

We can see the same point by considering cases in which an action has good results but is nonetheless irrational. If, for example, a person tries to commit suicide simply because he has a bad headache, his action would be irrational, even if he mistakenly takes aspirin instead of poison and successfully cures his headache. The foreseeable result of his action would not have benefited this person, even though the actual result did. Hence, he was fortunate but irrational to perform that act.

My view, then, is that the rationality of actions depends on the value of the *foreseeable* results of an action for an agent, not on the *actual* results. To be rational in one's actions, one needs to satisfy criteria of *rational* belief rather than the more stringent criterion of *true* belief or knowledge.

A Final Objection

There is one further objection to a result criterion of rationality. Suppose that a person performs an action whose foreseeable results are beneficial. Nonetheless, these benefits are completely unforeseen by the agent himself. According to my criterion, his action would be rational. This seems wrong, however, since it is simply a matter of chance that his action furthers his ends because he is unaware of this. What is missing, one might argue, is explicit deliberation about the action, leading to a justified belief about its probable outcome. Without this, the agent cannot possibly be said to have acted rationally.

This objection has some force, but I do not think it requires the reintroduction of a deliberation condition. What the objection shows is that we need to draw a distinction between an *action's* being rational for a person to perform and an *agent's* being rational in performing an action.

The foreseeable result criterion is a criterion for the rationality of actions. An action is rational in this sense if, within the context of the agent's aims and the information available to him, it is the one with the best foreseeable results. The rational action is the one it *would* be rational for the agent to choose if he *were* to deliberate about probable results of acting and their value to him.

It is possible for an agent to perform the act without being aware of the facts that make the act rational, and in this case, it is fair to say that he was not rational in performing the act. Nonetheless, it is a mistake to infer that for him to be rational in performing the act, he must precede it

with explicit deliberation. All that is required is that the considerations that make the action rational should in some way be operative in the agent. That is, it need only be that a true explanation of why the agent acted as he did would include the reasons that make the act rational. That the agent did not consciously think through these reasons does not mean that he was unaware of or unaffected by them.

There are many thorny issues involved in explaining what it is for a person to act for a reason, especially when the reasons are not explicitly before the agent's mind.[16] I think, however, that my point can be made without entering into the complexities of this issue. All I want to claim is that there are cases in which (1) we give true explanations of an action; (2) the explanations have the form "He did A because . . . ," where the blank is filled in with a set of reasons; and (3) the agent did not explicitly recount the reasons to himself prior to acting.

That the reasons were operative can be shown in other ways. For example, after performing the action, the agent can cite the reasons why he did it. One might object to this by noting the difficulty of distinguishing actions in which the reasons are truly operative from those for which the agent invents a *"post facto* rationalization" (to borrow a phrase from Barth). The truth in this objection is that it is often difficult to tell whether reasons were truly operative or whether they played no role but were mistakenly or insincerely invoked by the agent. While I grant that it may be difficult to tell which situation occurred, that is no reason for concluding that there is no difference between them.

One important difference is that in situations where the reasons were operative, we suppose that had they been undermined, the agent would have acted differently. If someone does X in order to bring about Y, it follows that if he is acting rationally, then he would not have done X if he had ceased to believe it would cause Y. To call the reasons "operative" is to imply that without those reasons (or others that indicated the desirability of the same act), the agent would not have acted as he did.

This is related to my earlier point that a person's rationality is shown in part by his responsiveness to changes in reasons and evidence. Responsiveness to new evidence or reasons is central to the capacity for being rational. When a person loses the capacity to respond seriously to evidence against cherished beliefs, we may view him as rigidly dogmatic, and if his dogmatism leads to harmful actions, we think of him as a fanatic. Likewise, if someone's general ability to consider relevant facts is seriously impaired, he is judged to be insane.[17] The kind of responsive-

ness we normally expect to find in people is an indication of our belief that reasons are operative in determining behavior, and the reasons can play this role even when explicit deliberation does not occur.

My conclusion to this point, then, is that the results of actions provide the central criterion for evaluating their rationality. An action is rational if, judged within the context of the agent's aims and the evidence available to her, the foreseeable results of the action are more desirable than the foreseeable results of other options. An agent is rational in performing an action if the reasons making the act rational are operative in her. A person is rational in a more overall sense if her actions are generally related to reasons in this way. One can be a rational person in spite of occasional irrational actions. Likewise, people can be rational or irrational to different degrees. Rationality as a characteristic of persons is not an all-or-nothing thing.

Deliberation and Rational Action

The view that deliberation is required for rational action may rest on the assumption that the only way for reasons to be operative is for them to be consciously present to a person's mind prior to acting. My account assumes that this is false and thus presupposes that reasons can be operative without being explicitly called to mind. The belief that my chances of reaching the other side of the street safely are increased by looking before crossing can influence my behavior without my having to think to myself "my chances of reaching the other side safely will be increased . . ." prior to crossing the street.

Some of our reasons are the stored or preserved products of past deliberation. We may think hard about something, reach a conclusion, and then continue to act on the remembered results of that deliberation. Having settled an issue, further thought is unnecessary. In fact, it would be counterproductive to be constantly re-evaluating things that have been settled.[18] In addition, fortunately for us, deliberation need not always be a slow, "deliberate" process. We can often size up a situation and think of what to do quickly and without pondering.

I have already tried to catalog some types of situations in which deliberation is unnecessary, and I have emphasized that we need not deliberate in every case in order to be rational. But, one might wonder, when is it rational to deliberate? The answer is that deliberation—that is, careful exercises of thought about what to do—is worth doing when

it promises to help one act well. When it lacks such promise, then action without deliberation is rational and deliberation itself may even be irrational.

This answer may appear to put me in a position that is as bad as the extreme rationalist. For now, instead of requiring that we deliberate about each action we need to take, we are required to deliberate about whether deliberation regarding each action is appropriate. I seem to have multiplied rather than restricted the occasions for deliberation.[19]

This is a mistake, however, for we can take advantage of abilities we have in addition to conscious deliberation and methodical thinking. We have memory, useful habits, native and acquired skills, abilities to assess situations speedily, and the capacity to form overall plans, rules, and guidelines that can be applied to new situations without explicit thought. Just as we can talk and express our thoughts without first calling those thoughts to mind, so we can act in accord with our ideas and knowledge without consciously calling them to mind. That this process is in some ways mysterious should not blind us to the fact that it is something familiar that we do all the time.

Summing Up

Classical rationalists have been correct to emphasize that thought and deliberation can be extremely valuable. It would be foolish to deny this. Nonetheless, these processes need not be carefully carried out in all cases in order for a person's actions and beliefs to be rational. Indeed, as I have tried to show, it would be irrational to deliberate carefully about all our actions. To do so would produce results that are undesirable, and the desirability of foreseeable results is itself the central criterion of the rationality of actions. The value of deliberation is itself dependent on the value of its effects.

4
Reason, Nihilism, and Objectivity

> *The essence of what we call rational thought is leaving out things. . . . The most important thing it leaves out is the thinker—his or her unique location in the universe, with its associated urges, feelings, and motives. Rational thought pretends that it doesn't reside in a person—that it's cosmic, unemotional, and unmotivated. This delusion is its fundamental defect.*
> —Philip Slater

In discussing Socrates' arguments in chapter 1, I noted his insistence on distinguishing matters that were relevant to the truth of a view from those that were irrelevant. Other rationalists have recognized that our knowledge is often limited or obstructed by personal inclinations as well as by contingent facts about our perceptual capacities or personal history, and they have sought to overcome these limitations in order to arrive at a true picture of the nature of reality. The goal of describing reality as it would appear from an impersonal or cosmic point of view has been very influential in the development of Western scientific and philosophical thought. Such a viewpoint, which Henry Sidgwick called "the point of view of the universe" and Thomas Nagel calls "the view from nowhere," is thought to be ideal because it is the most perfect form of objectivity.[1]

The central role of objectivity in the classical rationalist tradition has been emphasized both by critics of this tradition and by its proponents. J. J. C. Smart, after defending "scientific plausibility" as a criterion for determining what things are genuinely real, writes:

> When one adopts the criterion of scientific plausibility one tends to get a certain way of looking at the universe, which is to see it *sub specie aeternitatis*. . . . To see the world *sub specie aeternitatis* . . . is to see it apart from any particular or human perspective. Theoretical language of science facilitates this vision of the world because it contains no indexical words like 'I', 'you', 'here', 'now', 'past', 'present', and 'future', and its laws can be expressed in tenseless language.[2]

As Smart's statement indicates, the truest vision of the world is taken to be the one that is free of all reference to the features of the observer.

It is easy to see that Todd Andrews' argument for nihilism in *The Floating Opera* grows out of this same tradition of metaphysical thinking. It applies to values the same impersonal criterion of reality that rationalists have applied to features of the world in general. The spirit of his reasoning is captured in the following argument:

1. The real nature of things is that which is seen from the cosmic point of view.
2. To view things rationally is to view them from the cosmic point of view.
3. When things are viewed rationally, everything is seen to lack value.
4. To attribute value to anything is, therefore, irrational.

Because nothing has objective value, nothing is worth striving for, and a purely rational being will neither strive for anything nor think that any action is better or more rational than any other action. We only think that things are good and bad, better and worse, or rational and irrational to do because we are not purely rational beings.

These implications of applying the cosmic perspective underlie both Todd's judgment that there is no reason for living and his later perception that suicide is no more rational than living. Likewise, Jacob Horner's paralysis derives from the disease "cosmopsis," for once he sees reality from the cosmic point of view, he sees that "there is no reason to do anything." Perfect objectivity produces perfect indifference and validates nihilism's claim that nothing has value.[3]

In making a connection between nihilism and the classical rationalist's ideal of perfect objectivity, I am not suggesting that classical rationalists have all been nihilists. That they have not been nihilists is shown, among other things, by the great value they place on knowledge. Indeed, it is the high value attributed to knowledge that motivates the quest for an objective standpoint. Nonetheless, though grounded in a

belief in value, this quest for knowledge plays a double role in laying the groundwork for the nihilist's view.

First, the emphasis on objectivity supports premises 1 and 2 in the argument I have just set out. Second, in the course of emphasizing the value of the quest for knowledge, many rationalists have deprecated the value of things that are unrelated to this quest. As we have seen, Socrates disparages lives that lack examination and inquiry, and Aristotle judges the contemplative life to be the very best form of life. In the *Republic*, Socrates ask a rhetorical question that is not too distant in spirit from the attitude of Barth's characters.

> Do you think that a mind habituated to thoughts of grandeur and the contemplation of all time and all existence can deem this life of man a thing of great concern?[4]

What Socrates' question suggests is that many of the things we ordinarily value, including "this life of man" are not really "of great concern." This recalls Todd Andrews's comment that all his life he had been seeing that one thing and another lacked real value, until finally he generalized his conclusion to include everything. Though they are not all nihilists, classical rationalists often move a fair distance in this direction.

The importance of the cosmic perspective is evident in many discussions of the reality of value, the validity of morality, and the meaning of life. One indication of its influence is the assumption that things can only have value if there is a God. Because many people, both theists and atheists, have equated the cosmic point of view with God's point of view, they have come to believe that things can have objective worth only if God, viewing them from the cosmic perspective, finds them valuable. They think, therefore, that to deny God's existence is to undermine all values. If there is no cosmic viewer who finds value in things, then things can have no real value.

I will later try to show that this way of thinking is mistaken, but my aim here is simply to illustrate the importance and pervasiveness of the idea of a cosmic point of view. What I would now like to describe are the connections between the attempt to view things from a cosmic perspective and the classical ideal of rationality. Later, I will argue that the cosmic perspective is not appropriate for assessing the rationality of actions and choices. This will provide a further demonstration of the unsatisfactoriness of the classical ideal.

We can best approach these issues by examining the second premise of the nihilist's argument, the belief that "to view things rationally is to view them from the cosmic point of view." Why should this appear to be true? Why should we equate the rational point of view and the cosmic point of view?

Objectivity

We can see the appeal of this idea by examining the notion of objectivity. There are many situations in which we urge a person to look at something objectively in order to make a rational judgment. When we do this, there is usually some feature of the person, some "subjective" factor that we see as an obstacle to making a sound judgment. We urge the person either to alter this subjective feature of himself (e.g., "calm down, and then think it over") or to be aware that it is affecting him so that he can try to discount its influence.

Suppose, for example, that you go to the top of a skyscraper with a friend who fears heights. He judges the observation area to be very dangerous and refuses to remain and take in the view. In such a situation, it would be natural to draw the person's attention to the fact that his acrophobia is influencing his judgment and to urge him to view the situation more dispassionately, as if he did not have this strong fear. If he can do so, he will see that there is no danger, that the barriers and thick glass are sufficient to prevent anyone from falling. In urging the person to base his beliefs on facts about the actual situation, rather than on his aversion to heights, you are urging him to be more rational and to get at the truth by taking a more objective attitude.

Fear is not the only emotion that can lead someone to make irrational judgments. The emotions in general have been a favorite example for rationalist philosophers when they have diagnosed obstacles to rationality. There are, however, many other features of ourselves and our situations that can distort our beliefs, and all of us learn to discount such features in arriving at our beliefs. At a relatively early age, for example, each of us learns that our particular spatial location is not the sole vantage point from which objects can be seen and described. We know that a large object may appear small to us because of our great distance from it. Likewise, we come to see that boredom or anxiety may make it seem that an event (a dull lecture or a dental treatment, for

example) has gone on for a long time when it actually took up a small amount of objective "clock time."

Similarly, we may learn that our value perspectives are founded on contingencies of our upbringing or position in society, and we may try to substitute broader perspectives when we make judgments of value. In the autobiographical portion of his *Discourse on Method,* Descartes stresses the value of foreign travel for overcoming this sort of subjectivity. He writes:

> [T]he greatest profit which I derived . . . [from travel] was that, in seeing many things which, although they seem to us very extravagant and ridiculous, were yet commonly received and approved by other great nations, I learned to believe nothing too certainly of which I had only been convinced by example and custom. Thus little by little I was delivered from many errors which might have rendered [me] less capable of listening to Reason.[5]

This quotation illustrates one man's famous attempt to attain the objective standpoint and also reveals that the obstacles to objectivity are social as well as personal. Custom and tradition can be obstacles to knowledge in the same way that emotions or personal contingencies may be.

In aiming for objectivity, then, we try not to be influenced in our judgments by accidents of our nature or situation. This leads to the idea that an aspect of the world is genuine only if it would be recognized as real by different observers or knowers whose natures were quite different from our own and from one another. Anyone familiar with philosophical debates about whether so-called secondary qualities (color, taste, smell, etc.) are real or illusory will recognize the influence of this criterion of reality on that dispute. The assumption is that for a quality to be real, it must not depend for its existence or nature on contingent features of those who observe it or the circumstances under which observation takes place. Qualities that do depend on these are illusory or subjective. It is because secondary qualities have been thought to depend on the nature of perceivers and perceptual conditions that metaphysicians have called them illusory, and the nihilist's argument against the reality of values parallels this exactly. Nihilists reject the reality of values because values seem to depend for their existence on contingent features of human beings.[6]

This way of thinking is not peculiar to philosophers or characters in Barth's novels. Instead, it pervades our thought and language. A

standard dictionary definition of "objective" includes words like "real," "mind-independent," "unbiased," "detached," and "impersonal." The real is that which is independent of our minds and which we can know by making ourselves unbiased, detached, and impersonal. Where our personal interests and passions intrude, our view is clouded, subjective, and unreliable. What we think we know in such a state is not "mind-independent" and thus not real.

In seeking to be objective, then, we arrive at the concept of a perspective that is purified of all contingent and subjective influences. The most familiar models for this perspective come from mathematics and scientific inquiry. The perfect scientific theory is thought to be one that could be accepted by anyone familiar with the evidence—whether that person be someone like ourselves or a very different kind of being, such as a Martian, an angel, or God. The cosmic point of view is the perspective that would be taken by a being that had only rational and cognitive powers, and it is to such a being that we address our arguments on matters of theory.

Oddly enough, the pressure toward the cosmic point of view derives as well from certain ideals of practical rationality. When we make practical evaluations and decisions, we can also be swayed by subjective factors that hinder us in making good judgments. For example, we sometimes act irrationally because we give priority to the desires we happen to be experiencing at the moment of decision. The strength of presently felt desires influences us more than the knowledge we have of other factors that are of greater importance but that are not as vividly before our minds. Cigarette smokers, for example, weigh the pleasures of present puffs more than the pains of future disease. Reason, however, requires that we not automatically give priority to present desires, that we overcome their influence by detaching ourselves from what we feel at the moment and surveying a longer stretch of our lives in order to get a better idea of the importance of our present desires.

People often suggest a similar tactic as a way of overcoming sorrow or disappointment. We are urged to take a longer view of things in order to see that, in a broader perspective, the losses we have incurred may not be so serious. The problem is that if we extend these common-sense procedures and begin to view all our needs and desires from the perspective of the long run, we may well fall victim to Jacob Horner's malady "cosmopsis." The cosmic extension of the prudential point of view may lead to nihilism by drawing our attention to the fact that no matter what choices we make, the end result in all of our lives will be the

same—death.[7] Then, one may conclude that none of our choices really matters at all, that the nihilist is correct.

Should We Adopt the Cosmic Perspective?

Now that we have seen how the ideal of objectivity—with its emphasis on impersonality and emotional detachment—generates the notion of the cosmic perspective, we can turn to the question of whether rationality requires us to take the cosmic point of view. I want to argue that even if we may sometimes gain insights by trying to achieve this perspective, the cosmic point of view is not in general identical with the perspective of rationality. Indeed, in cases of practical decision-making, it would be irrational to adopt the cosmic perspective.

Reflection on actual evaluations and choices shows that, as usually described, the cosmic perspective is simply irrelevant. Whatever its aesthetic or metaphysical charms, it leaves out the very sorts of factors that generate problems and that must be considered if one is to solve them rationally. To take a trivial case: If I am faced with a choice between chocolate and vanilla ice cream and if the cosmic point of view requires that I ignore my tastes and preferences because they are contingent, subjective features of myself, it can certainly provide me with no guidance. Indeed, adopting this point of view to guide me would be irrational because the factors it leaves out are precisely those that need to be considered. To say that one should choose between the two flavors while ignoring considerations of taste and preference is to render the choice purely arbitrary and irrational.

Even this simple example shows, I think, that the rational point of view does not coincide with the cosmic point of view. Reason requires attention to just those facts that the cosmic perspective forbids us to consider. The cosmic perspective misconstrues the role our desires, emotions, and goals play in rational decision-making. It sees them as subjective factors that are opposed to reason, when in fact they provide the material upon which reason operates.

Someone might object that my choice cannot be rational because it depends on an arbitrary fact about me—my preference for chocolate—and that this preference is itself irrational and unjustifiable. This charge is mistaken, however. While it is true that my preference is not based on reason, this does not undermine the rationality of my choice. Even a person who prefers vanilla or is indifferent to all flavors could

acknowledge the rationality of my choice since that choice is based not only on my nonrational flavor preference but also on an impersonal principle of rational choice. This principle is: Given a choice between x and y in a situation where S prefers x to y, it is rational, all things being equal, for S to choose x. The phrase "all things being equal" indicates that there are no special considerations relevant to this case. If I know that the chocolate has been poisoned or mixed with mud, things are not equal, and I have special reasons to avoid it. If such reasons do not apply, however, preference is the rational basis for this choice.

While it is true that my having this preference is a *non*rational fact about me, it is not *ir*rational. Most preferences are simply a part of our nature, and they are neither rational nor irrational.[8] Even in cases in which it would be irrational to *act* on a preference (e.g., when I choose the chocolate because I prefer chocolate, even though I know it has been poisoned), it would be inappropriate to say that the preference itself was irrational. The crucial point, however, is this: The fact that a nonrational desire is one of the bases of a choice does nothing to make that choice irrational.

There are other criteria of rational choice that are objective in the sense that they could be applied even by a person who did not share the desires or goals of the agent making the choice. One can say, for example, that a person's action is irrational if she chooses to do it, it is less likely to bring about the result she wants than some other act, and she knows that it is less likely to do so. Whether or not one shares the agent's goals or preferences makes no difference to the judgment. In this way, the principle involved in the judgment is both impersonal and objective.

If we reflect on the role that desires and goals play in judgments about rationality, we can see the mistake involved in equating rationality and objectivity with the cosmic point of view. One who adopts the cosmic perspective thinks that the appropriate test for value is expressed in the following question:

(A) Would a purely rational being, a being possessing only cognitive powers, choose x over other alternatives?

Built into this test is the idea that a purely rational being has no needs, desires, goals, or aims. It is not surprising that this test yields a nihilistic answer. No matter what x and its alternatives are, there will be no basis for choice between them. Question A, however, is the wrong question to ask. The right question is:

(B) Would a rational being possessing particular needs, desires, and goals choose x over other alternatives?

Question B allows the desires and interests of the person choosing to play their appropriate role without in any way undermining the possibility of objective and rational judgments.

Indeed, it is only by considering these factors that rational choices can be made. It is absurd to require that we ignore needs, interests, and desires because being rational generally requires us to try to realize our goals, meet our needs, and satisfy our desires. Except in special circumstances, it is irrational to act so as to thwart our goals, leave our needs unmet, or frustrate our desires. We lose sight of this when we formulate questions about values and rational choice in terms of the cosmic point of view. As a result, we are easily misled into thinking that nothing is of value and that all choices are irrational.

The Meaning of Life

The irrelevance of the cosmic point of view for value judgments can be further clarified if we turn briefly to questions about the meaning and value of life. Many people have thought that life can have no meaning if there exists no overall purpose for life, if, from the point of view of the universe as a whole, there is no guiding plan that gives significance to the lives of individuals. This idea has been lucidly discussed and criticized by Paul Edwards.[9] Edwards draws a number of distinctions that are helpful in undermining the metaphysical pessimism of the nihilist. If we distinguish between *Life* as such and individual *lives,* we can see that even if Life as such (the totality of living things and processes) lacks some overall or cosmic meaning, it does not follow that individual lives cannot retain what Edwards calls "terrestrial" meaning. What gives individual lives their meaning and value is the set of aims or purposes that individuals have and seek to realize. Individuals can have these aims whether or not Life as a whole has any purpose.

One might think that if we accept the idea that Life can have a "terrestrial" meaning that does not rest on a cosmic base, then we are somehow accepting a second-best alternative and resigning ourselves to an inferior form of value. This is a misconception. The notion of "terrestrial" meaning or value is the basic and primary standard of value. We can see this by noting that there could exist cosmic purposes that would undermine rather than enhance the value of our individual lives.

If the overall purpose of Life (as a whole), for example, were to provide entertainment for a powerful, sadistic spirit, this would certainly not contribute to making individual lives meaningful, even though it would confer a purpose on Life as a whole. Edwards is certainly correct when he writes,

> If a superhuman being has a plan in which I am included, this fact will make (or help to make) my life meaningful in the terrestrial sense only if I know the plan and approve of it and of my place in it, so that working toward the realization of the plan gives direction to my actions.[10]

The same insight is captured in John Rawls's formal definition of what it is for something to be good. He writes,

> A is a good X for K (where K is some person) if and only if A has properties which it is rational for K to want in an X, given K's circumstances, abilities, and plan of life (his system of aims), and therefore in view of what he intends to do with an X.[11]

"Good," according to Rawls, is always an abbreviated form of "good for," and the person for whom something is good is always a specific individual or some group of individuals who share a set of needs, interests, or desires. It is only from the perspective of such persons that value judgments can be made.

In other words, the basic perspective from which we make rational evaluations is the perspective of individual agents and their own specific goals and purposes. The cosmic perspective is not the basic point of view from which such judgments are made. It is either not relevant at all or plays a subsidiary role to that of the perspective of the individual agent. It is not, therefore, the point of view a rational person would take in making decisions or judgments of value.

The Passion for Objectivity

There is a paradox involved in injunctions that we ought to strive for the greatest possible objectivity, when that is understood to mean that we ought to shed, among other things, our emotions, feelings, and desires. The paradox arises because achieving such objectivity is extremely difficult and requires great effort. As rationalists always insist, our emotions are powerful, and the effort required to overcome them is very substantial. In order to make this effort and to strive to live up to the objectivist ideal, we must have some powerful motivation to do so, and

this suggests that we must summon powerful emotions and feelings in order to achieve this.

If this is necessary, then we have a very odd situation, one that is aptly described by Max Deutscher, who writes:

> We would be completely committed to neutrality, utterly partial to impartiality, strictly positioned on having no position, and very hot about being cool.[12]

The "heat" required for being "cool" is necessary to motivate us. The striving for a better view or the truth about something requires interest and involvement, not detachment or lack of concern. Anyone who has ever tried to think hard about a problem will see the truth in Deutscher's remark that

> To lose one's passions is to lose one's capacity for that close and continued involvement with things and people without which one cannot bear with the difficulties, pains, and shocks of discovery and continual acquaintance.[13]

Deutscher's conclusion is that the requirements of total objectivity and detachment are absurd. Rather than leading to a perception of the real nature of things, they would do nothing but produce boredom and indifference.

Certainly, if one thinks of Socrates as the paradigm of the examined life, one sees immediately the passion and dedication that motivated his quest. While there is a certain distant calm that he conveys in some parts of the *Phaedo* (when he is about to die), the Socrates of the *Apology* and the early dialogues is full of energy and totally involved with his quest for wisdom. His pursuit of the rational life is certainly no passionless affair.

In general, then, the assumption that rationality requires objectivity and that objectivity requires unemotional detachment seems to rest on a number of errors. The ideal of perfect detachment is not worth striving for.[14]

Is the Objective View a View at all?

Many people think that there is an objective view of things, namely the view contained in scientific theories. At the beginning of this chapter, I quoted J. J. C. Smart, who equates the scientific perspective with the view *sub specie aeternitatis,* the point of view of eternity. To see the world

in this way, for Smart, is to see it with perfect objectivity. It "is to see it apart from any particular or human perspective."[15] It is not clear, however, that this ideal of perfect objectivity makes any sense at all. Does it makes sense to talk, as Smart does, of seeing things "apart from any particular perspective"?

The assumption of those who champion total objectivity is that if we achieved total objectivity, we would be in a position to see the world as it is. Our view of the facts would not be skewed by a partial or limited set of interests. We would just see things as they are. We would be in touch with reality and know the truth about it. Does this vision make any sense?

Consider the following mini-fiction, entitled "Of Exactitude in Science," by the Argentine writer, Jorge Luis Borges. Borges describes an empire in which the cartographers aspired for perfection. They wanted maps that would leave nothing out. After constructing larger and larger maps that were more and more complete, they finally constructed "a Map of the Empire that was of the same Scale as the Empire and that coincided with it point for point." What was the reaction to this great achievement? Later generations, Borges tells us, found the map "cumbersome" and "abandoned it to the Rigors of sun and Rain." At present, nothing remains of the map, except for tattered fragments that are occasionally found in the desert, "Sheltering an occasional Beast or beggar. . . ."[16]

Borges's parable is an effective parody of the ideal of perfect objectivity. It reduces to absurdity the idea that a perfect theory would tell the whole truth from a purely objective perspective. What Borges shows is that if this perspective could be attained, it would be useless because the view of reality it provides would be so complete that it would not help us to improve our understanding. Maps are only useful if they are selective, and being selective requires leaving things out. What gets left out depends on one's needs, purposes, and interests. A street map, for example, leaves out things that a topographical map does not. If you insist on producing a purely objective description that is not at all determined by any particular perspective, then you end up with a map of the same scale as the reality it portrays. Far from being a great advance in knowledge, such a map merely duplicates one's original position, being faced with a complex reality and needing some help to find one's way around it.

What is true of Borges's map is true of our theories, beliefs, and perspectives. They must simplify if they are to be of any use to us, and if they fail to simplify, they will simply overwhelm us. If they are to be of

any use, they must be governed by some needs or interests that derive *from us* and not from the reality we want to understand. Pure objectivity demands that we ignore ourselves and so does not permit us to lay down principles for selection. Pure objectivity, then, contrary to the dream of its advocates, would not advance our knowledge. Rather, it would make knowledge and understanding impossible. Every view, including those that derive from the sciences, is a partial view, and this kind of partiality is a necessary condition of a belief or theory contributing to our understanding. Hence, the quest for pure objectivity is totally misguided because a "view from nowhere," that is, from no perspective at all, is no view.[17]

Is objectivity useless then? Is there never a reason to transcend our subjective views and strive to be objective?

If by "objectivity" we mean the total objectivity of Borges's map makers or of Smart's vision of the view from eternity, then it is both useless and unattainable. Nonetheless, calling on people to be more objective in some contexts is worthwhile. In such cases, what one is doing is urging that a particular feature that one believes is getting in the way of genuine understanding should be ignored. In such cases, one is not urging total detachment; instead, one is recommending detachment from some quite specific obstacle to knowledge or rational thought. Where rationalists have gone wrong is in generalizing from the truth that emotions and other features of ourselves sometimes get in the way of rational thought to the false conclusion that we would be more rational if we were totally without emotions or totally detached from all concerns. It is this overgeneralization that is the source of their error.

Claims that one ought to be more objective are themselves only justified when one has definite reasons to believe that a particular feature of a person (prejudice, fear, wishful thinking) is an obstacle to understanding or rational action. Our passions and other "subjective" features of ourselves are what motivate our thinking and our interest in knowing the truth. They also provide the criteria of selection that make certain kinds of facts relevant or irrelevant. To rid ourselves of them would simply disable us, rather than make us more rational.

Summing Up

The plausibility of nihilism derives from the classical rationalist idea that values can be real only if they would be recognized by beings adopting a purely objective perspective. The nihilist's case can be undermined by

our recognition that the cosmic perspective is not the appropriate point of view from which to make judgments of value. Once we see the inappropriateness of the extreme version of objectivity that comes out of the rationalist tradition, we can see why nihilism is mistaken.

The pursuit of pure or total objectivity is a misguided ideal for several reasons. If objectivity means detachment, then pure detachment would undermine our motivation to seek truth, understanding, and rational action. Likewise, a totally objective view would be useless to us because our understanding can only be improved when we have a specific interest that allows us to select from the infinite array of facts. To be purely objective would undermine our ability to simplify and hence to understand. We ought not to aspire to a purely objective point of view because it would be of no use to us. It would neither increase our understanding nor improve our ability to live good lives.

5
Reason, Knowledge, and Truth

> *Life is like a festival; just as some come to the festival to compete, some to ply their trade, but the best people come as spectators, so in life the slavish men go hunting for fame or gain, the philosophers for the truth.*
> —Pythagoras of Samos

For classical rationalists, the possession of knowledge is an intrinsic good. Indeed, it is the supreme good, and the activity of pursuing knowledge and discovering the truth is the most valuable activity in which a person can engage. It was Socrates' dedication to this goal that cost him his life, as he made it clear to the Athenian jury that if he were offered a choice between a life in which philosophical inquiry was prohibited and death by hemlock, he would choose death by hemlock.

One may wonder about the rationalist's quest: is it two separate quests, one for knowledge and one for truth? Or are these two names for the same goal? In one sense, there is but a single goal here. To say that someone knows something implies that she has a true belief about it. For this reason, it is no more possible to have false knowledge than it is to sculpt a round square. Whoever seeks knowledge necessarily seeks truth.

In spite of this, it is important to see that two distinct values are intertwined in the rationalist's quest for knowledge. Not every true belief is knowledge because someone can hold a true belief for bad reasons. In the *Theaetetus* (201c), Plato gives the example of a jury that rightly convicts a person of a crime but does so on the basis of insufficient evidence. Though the jurors have a true belief about the guilt of the accused, they do not have knowledge. Given their lack of adequate evidence, we might say that *for all they knew*, he was really innocent. Even if the jury is correct in its judgment, it lacks sufficient evidence to justify it, just as Euthyphro lacked justification for his conclusions about the piety of prosecuting his father. Building on this idea, Plato suggests

that knowledge is "true belief with the addition of an account" (201d), where "account" means a sufficient accumulation of evidence to justify belief.

The need for a justification, then, is a second necessary component of knowledge, and the importance of believing for the right reasons is an important rationalist goal. It is this aspect of classical rationalism that is captured in W. K. Clifford's formulation of an "ethics of belief." Clifford minced no words in condemning belief in the absence of justifying evidence. "It is wrong," he wrote, "always, everywhere, and for everyone, to believe anything upon insufficient evidence."[1] Rationalists are committed to seeking knowledge, and when they cannot meet high standards of evidence, they value suspending belief rather than accepting ill-founded beliefs.

The Value of Knowledge

We may grant the value of knowledge and yet be troubled by the extent to which it seems to crowd out other things of value for the rationalist. Because the mind (or soul) is thought to be the part of us that best apprehends truth, the features of human nature that are not involved with mental activity tend to be deprecated, and rationalism becomes entangled with an extreme form of asceticism. This comes out very strongly in Plato's *Phaedo,* where Socrates makes the following remarks:

> So long as we keep to the body and our soul is contaminated with this imperfection, there is no chance of our ever attaining satisfactorily to our object, which we assert to be truth. In the first place, the body provides us with innumerable distractions in the pursuit of our necessary sustenance, and any diseases which attack us hinder our quest for reality. Besides, the body fills us with loves and desires and fears and all sorts of fancies and a great deal of nonsense, with the result that we literally never get an opportunity to think at all about anything. . . . [I]f we are ever to have pure knowledge of anything, we must get rid of the body and contemplate things by themselves with the soul itself.[2]

What Socrates appears to be doing here is evaluating everything in terms of its relationship to the quest for truth. Though he focuses on the extent to which the body is a hindrance to the pursuit of knowledge and evaluates our relation to our bodies for this reason, his point is readily extendible to such other things as concern for nature, art, the well-being of other people, and indeed all of our social and personal relations.[3]

The conclusion that none of these things is to be valued, except insofar as they contribute toward the acquisition of knowledge, is a stark and unattractive view. For Socrates, the basic conditions of human life are essentially evil because they are distractions from our true goal. "It seems," he says,

> to judge from the argument, that the wisdom which we desire and upon which we profess to have set our hearts will be attainable only when we are dead, and not in our lifetime.[4]

Believing that his soul will depart from his body at death, Socrates looks forward to death as the state in which pure knowledge is possible. Death, he says, will be welcomed by those who are dedicated to the pursuit of wisdom.

> Those who really apply themselves in the right way to philosophy are directly and of their own accord preparing themselves for dying and death. If this is true, and they have actually been *looking forward to death* all their lives, it would of course be absurd to be troubled when the thing comes for which they have so long been preparing and looking forward.[5]

It is easy, I think, to miss the full import of what Socrates is saying as one reads the *Phaedo*. We miss it because we admire Socrates' equanimity and dignity in the face of his impending death and because we associate wisdom with the capacity to meet death and other disasters with dignity. Since this is a valuable goal, we may concur with Socrates without fully appreciating the extremity of his negative judgment on the conditions of ordinary human life. In effect, his view is that human life possesses no real value apart from what it might contribute to knowledge, and in this respect, its value is probably negative, since it tends to distract people from the pursuit of knowledge.[6]

In some ways, it is surprising to find Socrates saying these things, for he himself appears in the dialogues as a person with passionate loyalties to his friends and his country and with a strong zest for life. Nonetheless, the statements are clear and unequivocal, and what Socrates says in the *Phaedo* exhibits the implications of attaching a supreme and exclusive value to knowledge. If one holds that knowledge is the only thing of intrinsic value, one is committed to evaluating all other things solely by reference to their possible "educational" value, and one would be in no position to support any moral or other constraints on the pursuit of knowledge.

Yet, it is clear that there are such constraints. There are times, for

example, when curiosity must be frustrated because indulging it would simply be rude or insensitive. We may seek to know what is none of our business, and our inquiries may violate another person's rights of privacy. Likewise, if we have gained some knowledge of a person's private life, communicating this to others may be quite undesirable, even though it would increase the amount of knowledge in the world.[7] Cases such as these show either that knowledge does not always have positive value or that even if it is always valuable, other values can still take priority over it. In either case, a limit is placed on the permissibility and desirability of both acquiring and sharing knowledge.[8]

We need not resort to fictional or hypothetical cases to make the point that the value of acquiring knowledge is not sufficient to justify inflicting great suffering. There are historical instances of peoples being abused and tortured, allegedly for the purpose of acquiring medical and biological knowledge. Recent debates about the possible dangers of genetic experimentation and research raise the same question. Though much of the argument centers on how real the possible dangers are, I presume that all parties to the debate would agree that if the dangers were substantial enough, the research ought not to be carried out.

My criticism of this feature of rationalism, then, is that by placing an exclusive value on the acquisition of knowledge, it implies that other valuable aspects of human life are of little or no importance. If we hold things other than knowledge to be valuable, this feature of the classical rationalist ideal will be unacceptable. An ideal that forces us to relinquish so many valuable features of human life is an ideal that ought to be forsaken.

A Pragmatic Defense of the Quest for Knowledge

Classical rationalists have believed that we should adhere to high standards of evidence and pursue knowledge because knowledge and its pursuit are both intrinsically and supremely valuable. This view, I have argued, tends to devalue other important aspects of human life. It is possible, however, to construct a different kind of argument for valuing knowledge highly. The alternative strategy, which is consistent with the spirit of my criticisms of classical rationalism, is a "pragmatic" one. This pragmatic view admits that there are things other than knowledge that possess value and forsakes the goal of maximizing knowledge where this

conflicts with other important goals. Nonetheless, according to the pragmatic defense of rigorous inquiry, the vigorous pursuit of knowledge provides the best way for attaining whatever other goals we have. It stresses the general usefulness of knowledge, rather than its intrinsic value, and tries to show the great practical value of upholding high standards of evidence.

John Kekes makes use of this pragmatic strategy in his book *A Justification of Rationality*.[9] Kekes is concerned to defend rationality against the challenge of the anti-rationalist skeptic. He wants to prove that adhering to rational criteria of evaluating beliefs is superior to relying on faith, taste, mystical insights, or other nonrational sources of belief. For Kekes,

> The justification of rationality is the justification of the employment of a method. The method is a device for problem-solving and it should be employed because everybody has problems, because it is in everybody's interest to solve his problems, and because rationality is the most promising way of doing so. (168)

Kekes's strategy, then, is to show that rational methods are desirable because they are useful to anyone. This is an attractive strategy because it does not rest on claims about the intrinsic or supreme value of knowledge and intellectual pursuits. Rather, it assumes that people have different needs and interests and attempts to show that rational methods are best no matter what one's other interests are.

Kekes draws a distinction between two sets of criteria of rationality. What he calls "internal" criteria of rationality provide standards for the evaluation of theories. They provide standards of evidential rationality, criteria that tell us when it is rational to believe a theory. According to Kekes, a theory is rationally acceptable if it is logically consistent, conceptually coherent, has greater explanatory power than competing theories, and is capable of being tested and criticized. These are the internal criteria of rationality.

In his view, then, theories qualify as *rational* if they meet a variety of criteria relevant to determining their truth. (By "theories," Kekes simply means sets of beliefs, whether they be technical scientific beliefs, moral or religious beliefs, or everyday beliefs about the weather or the likely winner of a baseball game.) Consistent, conceptually coherent theories are good because inconsistent, incoherent ones must be false. Theories with greater explanatory power are good because they provide a fuller understanding of the world. Finally, theories that are criticizable are

good because they provide opportunities for determining whether available evidence and potential evidence tend to support rather than refute them.

In addition to these "internal" standards, the application of which constitutes the *method* of rational inquiry, there is also an "external" standard of rationality: problem-solving success. According to Kekes, solving problems is the goal of rationality. Actions and beliefs are rational by virtue of their contribution to solving problems.

Kekes's theory contains both a *result* criterion of rationality and a *method* criterion. Of the two, the result criterion, success in solving problems, is more basic because it is so clearly irrational not to try to solve one's problems. Kekes defends the method of using evidential criteria of rationality by claiming that adhering to them is the most effective problem-solving technique available to us. To skeptics about rational methods of inquiry, Kekes claims that these rational methods are the best way to achieve goals that the skeptics themselves want to achieve. His theory, then, contains both a result criterion and a method criterion of rationality, but it gives priority to the result criterion. Problem-solving success is the ultimate criterion of rationality.

What sorts of problems is rationality supposed to solve for us? According to Kekes, there are two sorts of problems. The first are "problems of life." These are unavoidable features of human life such as protecting oneself from the environment, resolving conflicts between one's desires and the constraints of society, and finding ways to achieve happiness (125). These problems require us to act and to form policies about how to act.

In addition, there are "problems of reflection." These arise in trying to determine which theory about the world is likely to help us in solving problems of life. Problems of reflection do not directly involve action. In fact, they are often a substitute for action, since in thinking about them, we try to anticipate what would be the effects of possible actions. If we can foresee that the effects of an action would be harmful, we can avoid it and thus lessen the risk of doing things that harm us.

Problems of life and problems of reflection are connected because the theories we test in reflection are instruments whose purpose is to help us solve problems of life. They do this by providing an accurate description of that part of the world that is related to our life problems. The reason we hold a theory, Kekes says, is "because it is expected to provide solutions to problems of life" (126).

The basic thrust of Kekes's argument, then, is that we ought to judge

theories by rigorous rational standards because having true theories puts us in the best position to solve our problems of life. Because rational standards of theory evaluation are the most effective means of solving problems and because every human being has problems, every reasonable person should use rational methods to evaluate beliefs about the world.

Kekes's argument is attractive because he retains the high intellectual standards of classical rationalism while showing that they subserve our practical interests. Moreover, since practical problems do seem to be unavoidable, the antirationalist cannot escape the force of an argument based on them. It does seem to be necessary to accept rational standards as Kekes portrays them. As he says,

> Conformity to standards of rationality is not a matter of choice, for provided that one acts in his own interest, he has to act rationally. . . . If he does not mean to act in his interest, then rationality indeed has nothing to offer him. But given that human beings are what they are, such a policy cannot be pursued for long. It leads either to death or inconsistency. (169)

Even antirationalists have goals, and in striving to attain them, they will proceed effectively only if they conform to criteria of rationality. Kekes gives an example:

> To take an extreme case, one may imagine a mystic who aims at total desirelessness, at the repudiation of goals and purposes, but then one imagines a person whose problem is to negate his humanity. And that problem also requires a solution, which mystical tracts and manuals are only too eager to provide. Being human dooms one to having problems, and theories are the most useful devices for solving them. (166–67)

Kekes's central arguments are similar to ideas in the pragmatic tradition that derives from C. S. Peirce, William James, and John Dewey, all of whom emphasized the fact that inquiry is primarily a means of solving human problems and is not ordinarily carried out for its own sake. Kekes develops this idea forcefully in constructing his answer to skeptics who doubt the value of rational methods.

Truth Versus Usefulness

There is a notorious problem that pragmatic theories encounter, however, and that is the problem of truth. If, as Kekes and other

pragmatic thinkers claim, the primary criterion of rationality is problem-solving or usefulness, it seems to follow that we ought to adopt whatever beliefs are most useful. If the most useful beliefs happen to be those that are true (or best supported by evidence), there is no difficulty. If, however, there are instances in which false beliefs prove more useful than true ones, then a pragmatic criterion of rationality will sometimes approve of accepting false beliefs.

Kekes is aware of this problem, and he attempts to solve it by distinguishing his theory from other forms of pragmatism that give rise to it. According to him, the weakness of a purely pragmatic theory is that it identifies rationality exclusively with problem-solving and thus

> severs the connection between rationality and truth. What makes a theory rational is that it gives a possible account of how things are. . . . [Success] may be due to luck or to inability to see the dire long-range consequences of short-term problem-solving. One wants theories to succeed, but only for a special reason: for having provided an accurate picture of the world. . . . The internal [i.e., evidential] standards of rationality will help to distinguish between fortuitous success and success due to verisimilitude. (132)

Unfortunately, in trying to avoid the pragmatic tendency to devalue truth, Kekes backs away from his earlier insistence on the centrality of the external, problem-solving criterion of rationality.

In the passage just quoted, Kekes invokes a "special" reason for wanting theories to succeed—a desire for truth—and he appeals to this "special" truth-loving reason to provide support for the evidence-oriented criteria of rationality. Earlier, however, Kekes defended the evidential criteria of rationality by claiming that "conformity to them leads to successful problem-solving" (133). Here he acknowledges that false theories may also help us solve problems, and this forces him to invent a new, nonpragmatic reason for wanting our theories to be true. Here, truth is presented as an intrinsic value, while his original view was that the value of truth and high evidential standards can only be instrumental. His original view provides no basis for thinking that rational people must care about truth for its own sake. Yet, in shunning the implications of his pragmatism, he appeals to a value that is foreign to his own theory. One cannot claim both that problem-solving success is the basic criterion of rationality and that reason requires a special concern for truth or "rational" methods of inquiry.

This problem is fatal to Kekes's attempt to synthesize classical and

pragmatic conceptions of rationality. His dilemma shows the tensions between evidential rationality and practical utility. Kekes's attempt to reconcile these two different standards is a project one wants to succeed, given both the attractiveness of each contending value (truth and usefulness) and the difficulty of choosing between them. His view is the one that we should explore prior to admitting that we must choose between truth and usefulness. Nonetheless, we cannot have it both ways. We need to choose between classical rationalism and pragmatism.

Given the difficulty of such a choice, it is not surprising that Kekes himself wavers. While the passage quoted above expresses Kekes's desire to maintain a classical, truth-oriented version of rationalism, there are other passages where he gives priority to usefulness. This emerges most clearly in his discussion of whether logical consistency is an absolute requirement of rationality. Can it ever be rational to adopt a theory that is logically inconsistent? Evidential rationality rules this out because a logically inconsistent theory must be false. Nonetheless, Kekes claims that there are "rational theories that violate fundamental rules of logic and are thus illogical, but are not thereby irrational" (137).

In arguing for this rather shocking conclusion, Kekes cites evidence concerning the Nuer, an African tribe whose beliefs and practices were described by the anthropologist E. E. Evans-Pritchard.[10] While there are controversies about how best to interpret the Nuer's beliefs, what is important here is Kekes's claim that the Nuer accept illogical theories and that their acceptance of these theories is rational.[11] Not surprisingly, he defends their acceptance as rational by appealing to the problem-solving success of their theories.

> The rationality of the illogical theology to which Nuer are committed derives from the successful way in which this theology enables Nuer to live relatively happily in a world which they see as fraught with terror. (142–43)

Kekes tries to minimize the force of this concession to extreme pragmatism by arguing that the logical consistency criterion can be waived only in "problem-situations where there is an urgent problem and only one solution" (149). He stresses that the Nuer have no alternative theories from which to choose and that they lack the critical, intellectual tradition that can generate new beliefs effectively. If they were to give up their traditional beliefs, they would have nothing.

Even if Kekes is correct that the situation of the Nuer is very rare, this does not lessen the importance of his concession to pragmatism in this

passage. What is crucial is that Kekes is willing to grant that the problem-solving criterion is dominant over the evidential criterion. Given this, his theory must allow that it is possible for a set of beliefs to fail to meet *all* the criteria of evidential rationality and still be rational to accept because it (best) solves (perhaps urgent) problems of life. If there were people whose problems could best be solved by taking refuge in inconsistent, incoherent, uncriticizable theories with weak explanatory power, this move would be rational, according to this part of Kekes's position.

To have a consistent view, Kekes must either revise his assessment of the Nuer's acceptance of inconsistent theories or give up his adherence to special "truth-loving" reasons for belief. He cannot have it both ways. Nor can the rest of us.

The Awful Truth About Truth

Opponents of pragmatism are correct, then, in arguing that pragmatism cannot accord to truth and evidential standards the high value classical rationalists have given them. For the pragmatist, truth and adherence to high standards of evidence are valuable and rational *only insofar as they are useful* for producing practical benefits. Beyond that, reason does not require that one be concerned about truth and evidence. While concern for truth as such may be allowed by reason, pragmatic arguments cannot show that it is irrational to care about truth and evidential standards only insofar as they are practically useful.

One could argue that the diminished status that pragmatic accounts of rationality give to truth and evidential standards shows that pragmatism is mistaken. My reflections, however, have not led me to this conclusion. Rather, I have come to believe that pragmatists are correct in their belief that the basic criteria of rationality are practical rather than theoretical. Once this is accepted, it inevitably follows that the value of truth and high evidential standards are contingent on their usefulness.

I realize that this is a distasteful conclusion, since it involves the rejection of a very attractive component of the classical ideal of rationality. Nonetheless, my conclusion is not unprecedented, for it is just the view defended by William James in his often criticized essay "The Will to Believe." Since there is likely to be strong resistance to my conclusion and since the force of James's essay has not, in my opinion, been fully appreciated, I would like to consider his discussion of these

issues. In this way, I hope both to support my own criticisms of the classical ideal and to increase the appreciation of James's powerful arguments.

Summing Up

Classical rationalists have placed so high a value on knowledge and its acquisition that they have disparaged other valuable parts of life. Knowledge, however, is neither the sole nor the supreme good, and its acquisition is not always desirable.

Rationalists may accept this conclusion and try to reinstate their support of knowledge and high evidential standards by arguing that these are extremely valuable in the pursuit of our practical goals. This is the strategy outlined by Kekes. If my criticisms of his view are correct, however, such a pragmatic argument must lead to a diminished status for truth and evidential standards.

For rationalists, the "ethics of belief" expresses some of the most central components of their ideal, making the proposal to depart from high evidential standards of belief a very distasteful one. If I am correct, the awful truth is that such departures can be quite rational.

6
The Ethics of Belief: A Jamesian View

> *I am so far from feeling bound to believe for purposes of practice what I see no ground for holding as a speculative truth, that I cannot even conceive the state of mind which these words seem to describe, except a momentary half-wilful irrationality, committed in a violent access of philosophic despair.*
> —Henry Sidgwick

William James's essay "The Will to Believe" was a response to those nineteenth century thinkers who advocated the use of rigorous standards of evidence not only in philosophy and science but in all areas of life.[1] In the last chapter, I quoted W. K. Clifford's emphatic denunciation of accepting belief without sufficient evidence. Clifford not only asserted that it was always wrong to believe without sufficient evidence. He went further and claimed that there was a "universal duty of questioning all that we believe."[2] For him, it appears, Cartesian doubts were to be cultivated as a way of life. In a similar spirit, T. H. Huxley labeled the adoption of beliefs for personal advantage as "the lowest depth of immorality."[3]

In opposition to these thinkers, James rejected the view that beliefs had to satisfy strict evidential standards to be legitimate. He argued that beliefs could be rationally justified by nonevidential considerations, that preferences, desires, and interests could provide legitimate grounds for belief. Where classical rationalists emphasized the need for impersonal, unemotional judgment, James contended that our "passional nature" could be as relevant to adopting beliefs as the assessment of evidence.

Readers of James's essay may be surprised by my claim that James defends the rationality of believing without adequate evidence, for

James often sounds like an antirationalist. While I think it a mistake to interpret him as an opponent of reason, I will begin by discussing a part of his essay that lends support to this view.

James identifies his primary thesis as the view that

> our passional nature not only lawfully may, but must, decide an option between propositions, whenever it is a genuine option that cannot by its nature be decided on intellectual grounds. (11)

In defending this thesis, James seems to argue that our passions do in fact determine our beliefs, that beliefs are seldom, if ever, really based on compelling evidence. He notes, for example, that we automatically reject many views simply because they are not backed by the *"prestige* of opinions." For the most part, we simply absorb beliefs from people around us; our believing is a function not of rational assessment but of fads and fashions. "Our faith," he says, "is faith in someone else's faith" (9).

James goes on to claim that even our belief that there is such a thing as truth and that we are capable of knowing it is "a passionate affirmation of desire." If challenged by a skeptic, we can find no satisfactory reply. It is a matter of "one volition against another," an instance of one person being willing to make an assumption another "does not care to make" (10).

At times, James suggests that the ethics-of-belief controversy itself is an instance of passional conflict. There are two propositions—"We must know the truth" and "We must avoid error." Each is put forward as the "first and great commandments for would-be knowers" (17). But, James says, which rule one gives priority to is a matter of personal temperament. Clifford's commitment to his own version of the ethics of belief is itself a function of Clifford's passional nature, as any such choice must inevitably be. As James writes:

> We must remember that these feelings of our duty about either truth or error are in any case only expressions of our passional life. . . . He who says 'Better go without truth forever than believe a lie,' merely shows his own preponderant horror of becoming a dupe. He may be critical of many of his desires and fears, but this fear he slavishly obeys. (18)

James concludes that he himself is more fearful of losing truth than of succumbing to error. He prefers the path of risk rather than the path of caution.

In these passages, James seems to be saying that both particular

beliefs and general standards of belief adoption appeal to people because of their emotional temperament rather than their reason. Ultimately, all our decisions are nonrational—even the decision to be rational. If this is true, then, someone who opts for believing without good evidence is no more vulnerable to criticism than one who accepts only those beliefs that are supported by rigorous examination. Even if reason rules, James seems to say, it is only at the behest of passion.

If this were James's view, he would not be claiming that he is correct and Clifford incorrect in their stances regarding the ethics of belief. He would simply be expressing a personal preference, since a rational evaluation of risky versus cautious methodologies would be out of the question. If James did hold this view, then he would be an irrationalist. What I want to argue, however, is that James was a pragmatic rationalist. He believed that reason itself requires us to reject Clifford's ethics-of-belief position.

James's Rationalism

My interpretation is supported by the fact that James does not simply express his preference and stop there. Instead, he frequently asserts that his methodological choice is superior to Clifford's. He writes:

> Clifford's exhortation has to my ears a thoroughly fantastic sound. . . . In a world where we are so certain to incur [errors,] . . . a certain lightness of heart seems healthier than this excessive nervousness on their behalf. . . . (19)
> [W]here faith in a fact can help create the fact, that would be an insane logic which should say that faith running ahead of scientific evidence is the "lowest kind of immorality" into which a thinking being can fall. . . . (25)
> [A] rule of thinking which would absolutely prevent me from acknowledging certain kinds of truth if those kinds of truth were really there, would be an irrational rule. (28)

James indicates in these passages that he considers Clifford's rationalism to be "unhealthy," "insane," "irrational." By implication, his own view is healthy, sane, and rational. It is better and more rational, he believed, to allow some violations of the usual rules that tie belief to evidence than it is to forbid them in all cases.

But how can this be? How can James possibly be correct? In answering these questions, we must recall that James sanctions the role

of the passions in belief choice only when someone is considering "a genuine option that cannot by its nature be decided on intellectual grounds" (11). (There is one passage where James withdraws this qualification; I will consider it later in this chapter.) While his opponents urged a uniform, constant use of the methods and standards of scientific inquiry, James was quite sensitive to the variety of circumstances in which we think and act. High standards of evidence are, he thought, appropriate to scientific or other intellectual matters that are purely theoretical and do not directly affect practice. In theoretical contexts, he granted that objectivity and caution are appropriate. As he said,

> Let us agree . . . that wherever there is no forced option, the dispassionately judicial intellect with no pet hypothesis, saving us, as it does, from dupery at any rate, ought to be our ideal. (21–22)

In matters of theory, when we are under no pressure to accept or reject a hypothesis, we can allow ourselves a certain leisure while further inquiries are pursued.

In our practical activities, however, we are most concerned with acting in ways that further our interests and goals, and in these contexts, it may make no sense to employ scientific methods and standards. In chapter 3, I quoted James on the misery of the person who engaged in careful deliberation about trivial matters of everyday life. Though James is concerned in "The Will to Believe" with important (rather than trivial) matters, his point is the same. We need to evaluate the consequences of employing particular methods or standards in a given context. If applying "rational" methods of assessing evidence yields undesirable results, then it is irrational to apply those methods.

Nonevidential Reasons for Belief

To bring out this point, James develops the notion of a "genuine option." A genuine option is a choice between two or more *live* hypotheses when that choice is both *momentous* and *forced*. To be live, a hypothesis must be attractive to the person considering it. For the choice to be momentous, it must be one that will profoundly affect someone for good or ill, and for it to be forced, it must be an unavoidable choice, a situation in which failure to decide would have the same effect as

committing someone to one of the options. Finally, James adds the proviso that the truth and falsity of the hypotheses are intellectually undecidable.

James is asking his reader whether it would make sense to follow Clifford's maxim in the following kind of situation. A person, S, is confronted with a choice between two hypotheses, p and q, each of which has just as much evidential support as the other. All the available evidence has been surveyed, and there are no opportunities for gathering further evidence. If S believes and acts on p and if p is true, then S will enjoy immeasurably great happiness. If S believes and acts on q and if q is true, then S's life will be unaffected. If S suspends judgment and makes no choice between p and q, S's life will be affected just as it would be by the rejection of p and the acceptance of q. What should S do?

Two things are clear. First, S would obviously prefer that p be true because its truth and the adoption of relevant practices based upon it would bring great happiness. Second, it would be irrational for S to believe q, since it is recommended neither by the evidence nor by any possible benefits.

Clifford's maxim would, of course, lead S to suspend judgment, but given the possible benefits of belief, would suspension of judgment be rational? Would it be irrational to accept p, which is unsupported by the evidence but which would be advantageous to the believer?

James's answer is that adoption of the belief would be rational and that adherence to Clifford's maxim would be an overly restrictive and counterproductive form of "rule worship."[4] Whether reason *requires* one to believe p in such a case may not be obvious, but it seems clear enough that reason would at least *allow* belief, that it would not be *irrational* to accept p. Belief in this case is simply the relevant means to a worthwhile goal. If we grant the desirability of the end, the effectiveness of the means, and the general principle that an act is rational if it is an effective means to a desirable end, then belief in this instance is rational. Similarly, if we believe it is rational to advance one's own interest or to act so as to produce the most happiness or pleasure, then we must concede that it can be rational to accept a belief when doing so will advance one's interests or produce the greatest happiness.

If one is inclined to think the choice irrational, this reflects a tension within the concept of rationality itself. The rationality of *belief* adoption is usually assessed by examining the relation of the belief to evidence for its truth. The rationality of *actions* is usually assessed by reference to

expectable results—the extent to which particular actions achieve a person's goals better than others. Because James's pragmatic outlook led him to see belief choices as actions, he held that the criteria of rationality that apply to actions (expectable results) apply to beliefs as well. Unlike Clifford, who saw *evidence* for truth as the only reason for belief, James allows the good *results* of beliefs to count as reasons for adopting them as well. A person adopting a belief in the circumstances James describes could certainly give reasons for his belief, though they would not be the kinds of reasons that count as evidence.

I conclude, then, that in describing cases of genuine options that are intellectually undecidable (i.e., not resolvable by evidential considerations), James effectively shows that our passional nature (our preferences, desires, and interests) can play a legitimate role in determining belief choice. Viewed from the perspective of means/end rationality or utilitarian thinking, this influence of our passional nature can be described as rational.

Some Objections Answered

I will soon try to show that James's reasoning supports an even more radical conclusion, but before doing so, I would like to clarify his position and reply to a few objections.

First, it is important to see that James's position is completely general and has no special connection with questions about religious belief. Although James was concerned with religious beliefs in "The Will to Believe," that was merely one application of a general principle that he held.

Second, one might think that the force of James's argument depends on Clifford's position being an extreme and simplistic version of the ethics of belief. One might suppose that a more sophisticated version of the ethics of belief would not be open to James's attack. Brand Blanshard, for example, summarizes the ethics of belief in the rule "Equate your assent to the evidence."[5] This maxim emphasizes that belief is not an all-or-nothing thing, that we can recognize varying degrees of strength in evidence and feel varying degrees of confidence in the truth of beliefs. It urges us to adapt our degree of confidence in a belief to the strength of the evidence for it. While this may be a worthwhile modification of Clifford's view, it does not change anything.

As Blanshard recognizes, James's main point is that "evidence is not the only thing that justifies belief."[6] This key point must be denied by even the most sophisticated advocates of the ethics of belief.

Third, it has often been claimed that James incorrectly assumes that believing is an action and that we have a degree of control over what we believe, which we do not in fact possess. Since we cannot adopt or reject beliefs at will in the way that we can switch a light on and off or raise and lower our arms, all the talk of options, choices, and decisions is misleading. We simply do not have it in our power to do what James recommends.

While this objection raises a number of significant issues about belief, it seems to leave James's position untouched. First, James himself recognizes that there are usually severe limits to our control over what we believe. This is precisely what he emphasizes in his contrast between live and dead hypotheses, for dead hypotheses are those which a person cannot even seriously entertain, let alone adopt.

Second, neither Clifford nor any one else who is a rationalist can consistently deny that we have some degree of control over our beliefs. Rational ideals make sense only on the assumption that we can deliberate about what to believe. Recall that Clifford holds that we are able not only to believe or disbelieve but also to suspend belief, that is, to keep ourselves from reaching any conclusion when the evidence does not warrant one. The ideals implicit in his ethic of belief presuppose that we can at least exercise indirect control over our beliefs by such acts as focusing our minds on relevant evidence, considering the force of arguments, and excluding the influence of irrelevant factors. If this objection were correct, it would undermine not only James's position but that of Clifford and classical rationalism as well.

Finally, while we may not be able to switch beliefs on and off, we can take steps that are likely to affect what we believe.[7] Even if we could not, however, the issue does not really turn on questions about our actual belief-controlling abilities. We need only to be able to imagine such an ability to make James's point because the basic issue is a matter of principle. We have two sets of rational criteria, one evidential and one practical, and we want to know which criteria are dominant. We try to decide by raising the following question: To whatever extent we can exercise control over beliefs, would it ever be rational to adopt a belief on pragmatic grounds? This question can be raised and debated without assuming total belief control, just as we can debate whether it would be

more valuable to write a great symphony or to cure a dread disease without assuming that we actually possess the power to do either.

A More Shocking Conclusion

None of these objections, then, undermines James's position, and I agree with James when he remarks toward the end of his essay: "I do not see how this logic can be escaped" (29). If the argument to this point is correct, however, an even more shocking conclusion follows from it. Though I have so far defended belief on nonevidential grounds only in situations involving genuine options that are intellectually undecidable, James's arguments provide a basis for deleting this restriction and accepting the view that it is rational to accept any belief that promises significant benefits to the believer. James himself took this further step, affirming that "we have the right to believe at our own risk any hypothesis that is live enough to tempt our will" (29). In this form, James's account would even support the adoption of beliefs on passional grounds that are, on evidential grounds, known to be *false*. All that is required for justification is a significant enough advantage.

Consider the following rather bizarre case, which is suggested by James's reference to situations in which "faith in a fact can help create a fact." Imagine a person who is not a millionaire being offered a million dollars if he can succeed in making himself believe that he is a millionaire. This would literally be a case in which believing something would make it true. As it stands, however, it is false, and the person has conclusive evidence that it is false. It is not a case where the intellect is powerless to resolve the matter. Nonetheless, James's argument shows that it would be rational to accept the belief, for this would bring about both the truth of the belief and an extremely beneficial change in the financial status of the person to whom the offer is made.

If this offer were made to Clifford, Huxley, Blanshard, or other proponents of the ethics of belief, their personal commitment to ideals of evidential rationality might be so strong that they would turn it down. We might even admire them for the rejection, viewing it as an act of epistemic heroism. Nonetheless, if the offer were accepted, we could not reasonably criticize its acceptance as irrational. Assuming the desirability of the wealth offered, the effort required to accept the false belief would be rational, even if it required a visit to a hypnotist or some other master of mental modifications.

I grant that there is something very unattractive about this case and that it is distasteful to think about trading off ideals of truth and evidence for sums of money or other personal advantages. One tempting assessment is that while it could be rational to do this, it would still be a kind of moral failure. Even this is not obvious, however. Suppose that the offer were accepted by Clifford and that he used the money to better the living conditions of English factory workers or provide educational opportunities for children who would otherwise become laborers at a very early age. There are numerous acts of benevolence that might be made possible by getting the needle on the lie detector to point to "believes" when asked if he were a millionaire. The acceptance of this offer, then, could be both rational and moral.

This case is admittedly outlandish, but it does show that the results of beliefs are capable of being reasons for believing. Moreover, it shows this in a way that makes strikingly clear the gap between practical rationality and truth-oriented evidential rationality. One could object that it is only in fanciful examples that things work out this way and that in fact no good ever comes of false or unjustified beliefs. But surely, there is no way to know *a priori* that truth is always beneficial.

James also discusses cases involving personal relations. If I assume that you like me and act in a friendly manner, you are more likely to become my friend. If I wait for clear evidence of your liking me, my epistemic caution may express itself as a suspiciousness which will drive you away. Similarly, if you are my friend and you assure me that you did (or did not do) some particular act, when the evidence points in the other direction, my friendship may require that I take your word. Although there are limits of credibility in such cases, the existence of a personal relationship requires that a strong "benefit of the doubt" be given to one's friend, that one not simply believe the word of a friend in proportion to the extent to which his claims are corroborated by other evidence.[8]

We can imagine, then, cases in which one is better off not adhering to a rigorous Cliffordian ethic of belief. Moreover, there may be instances where a person is rational to avoid evidence that tends to refute his belief. It may be, for example, that physicians have greater healing powers when patients believe them to be more knowledgeable and more powerful than they are, that trust generates its own placebo effect.[9] If this is true, then a too confident view of the powers of one's physician may be quite beneficial. Of course, in some cases, such belief can be detrimental. My point, however, is not to justify a particular evidentially

unwarranted belief but to argue that the effects of belief are relevant. These cases support that view.

Self-Deception and Irrationalism

This brings me to the final criticism of James that I will consider. I can well imagine that one might want to charge both James and me with doing nothing less than issuing an open invitation to massive self-deception and total irrationalism.

As for the charge of sanctioning self-deception, there is some justice in the objection, for if what I have argued is correct, self-deception may sometimes be rational. Even if one would not want to encourage its widespread use, there seems no denying that it can be beneficial in some cases, and where this is so, my argument does justify it.[10]

To believe that self-deception can be rationally justified, however, is not to sanction irrationalism. Indeed, the strength of James's position is that he sees that rationality is a broader notion than his opponents allow, for it includes practical criteria of evaluation as well as evidential criteria. Someone who acts on James's view satisfies the criteria of practical rationality by adopting effective means toward the realization of a desirable end. She must also be rational in another way, however, for in order for her passion-based belief to be rational, she must have strong evidence that adopting the belief in question will have the desired beneficial effect and will not lead to ill effects that outweigh the belief's advantages. With respect to predicting the actual effects of her belief choice, the Jamesian rationalist will have to be as attentive to evidence as the most rigorous follower of Clifford's principles. In no sense, then, does James's view sanction irrationalism or wishful thinking.[11]

This point provides a reply to the objection that one who follows James's principle will inevitably be forced to more drastic distortions of reality. This objection is based on the idea that someone who adopts a belief unsupported by evidence (and who intends to maintain that belief) will have to deceive himself about many facts bearing on the matter in question and hence will be forced to hold more and more false beliefs. In addition, he will acquire more false beliefs because the willfully adopted belief will function as evidence in assessing new questions, thus generating a snowball effect in the amount of falsity entering his system of beliefs. In either case, the result must eventually be harmful.[12]

Certainly, a rational Jamesian will have to consider these possibilities, but they would only rule out willful belief adoption if a belief inevitably generated greater and greater distortions. In any case, the position I have defended is compatible with the proposition that in practice the opportunities for rationally adopting beliefs that are unsupported by evidence are very limited. James himself saw this quite clearly. Although he argued that *"in abstracto,"* one could believe anything at one's own risk, he went on to say that *"In concreto,* the freedom to believe can only cover living options which the intellect of the individual cannot by itself resolve" (29). In theory, the very radical principle "It is rational to believe whatever is useful" is true, but in practice this usually reduces to the restricted thesis containing the requirement that the belief must be a genuine option whose truth is intellectually undecidable.

In closing this discussion of James, I would like to make two remarks about James's philosophical reputation. First, in his writings after "The Will to Believe," James went on to equate truth and utility, thus giving birth to the pragmatic theory of truth. This was a terrible blunder on his part, and numerous critics have taken this part of his theory as the focus of their comments and successfully attacked it.[13] The unfortunate result of this has been to distract readers from James's pragmatic theory of rationality and justification, which is a powerful, not easily refutable theory. Second, James is often treated as a tender-hearted and muddle-headed sentimentalist whose works derive from religious sympathies. Yet, the same result-oriented conception of rationality he developed is espoused by many allegedly tough-minded thinkers who take seriously such theories as rational egoism, utilitarianism, hedonism, and a means/end conception of rationality. Indeed, James's view would seem, in fact, to be a logical consequence of any of these theories. If it is rational to act so as to maximize beneficial consequences, advance our own good, produce pleasure, or achieve our goals effectively, and if beliefs are actions, then reason allows us to consider the consequences or the beliefs we adopt. Like it or not, this is a view the tough-minded must take seriously.

Summing Up

In this and the previous chapter, I have discussed the place of knowledge and evidential standards in the classical ideal of rationality. I have argued that pragmatists are correct in emphasizing the centrality of practical

rationality and that efforts to use pragmatic arguments to shore up classical ideals of knowledge and belief must fail. Concern for truth and evidence are often useful, and to that extent, practical rationality requires that one be concerned with truth and evidence. However, it only requires such concern to the extent that truth and evidence further our interests. Thus, the pragmatic theory allows departures from standards of truth and evidential rationality that would be forbidden even by classical rational ideals. While practical reason may not require that we adopt the "superpragmatism" of Barth's Doctor and view everything as "therapeutic, antitherapeutic or irrelevant," there is nothing irrational about such a view.

Conclusions

> *"Where does our investigation get its importance from, since it seems only to destroy everything interesting, that is, all that is great and important?"*
> —Ludwig Wittgenstein

The last four chapters have dealt primarily with defects of the classical ideal of rationality. Building on ideas suggested by Barth's novels and elaborating more fully the components of the classical ideal, I have tried to show that it is not something to which we should aspire. In spite of the greatness and importance of the tradition from which the classical ideal emerges, it is not itself a worthy ideal.

It is not worthy because (1) it exaggerates the importance of deliberation about action, while ignoring the results of actions as a test of rationality; (2) it mistakenly suggests that a cosmic point of view is appropriate for value judgments, while neglecting the standpoint of individual persons as a framework for evaluation; and (3) it tends to place an absolute value on truth, knowledge, and high standards of evidence, while denigrating the importance of other aspects of human life.

Though I have attacked the classical ideal, my arguments are not against rationality itself. Indeed, I have made the point that it would be irrational to live according to the classical ideal. I have, therefore, appealed to, not rejected, reason. Even if my discussion were to stop here, the result would not be entirely negative, since my arguments show that rationalists need not be saddled with the extreme ideal that is the legacy of the classical tradition.

There is a more important reason why the results of the last chapters are not entirely negative. They suggest the direction in which we must move in order to arrive at a reasonable conception of rationality that makes clear why rationality is valuable. We know that a reasonable ideal of rationality will have to attend to the *results* of actions, that it will have

to take seriously the *agent's* perspective in assessing actions and beliefs, and that it will have to acknowledge the *plurality* of interests, values, and ideals that are important to human life rather than limiting itself to cognitive ideals.

This richer, more sensible view of rationality, which places reason in the context of human activities, has already made an appearance in my discussions of pragmatism. In the next chapters, I want to explore a generalized pragmatic conception of rationality, sometimes called the "means/end" conception of rationality. This conception appears both to illuminate many aspects of rational action and to provide a powerful answer to critics of rationality.

PART III

MEANS/END RATIONALITY

Introduction

Hume's famous pronouncement that reason both is and ought to be the slave of the passions is, on its surface, an iconoclastic debunking of the value of rationality. Oddly enough, however, it suggests a conception of rationality that is quite powerful and attractive. According to this view, reason does not set our ends or goals. These derive from our passions, that is, from the desires and aversions we happen to have. The job of reason is to discover things that please us and the means for acting so as to acquire them.

A number of ideas that emerge from my criticisms of the classical ideal of rationality suggest that such a "means/end" conception of rationality may provide an apt description of the proper function of reason in human life. Indeed, the means/end conception is probably the most widely held view of rationality among philosophers and social scientists.

In the next chapter, I will describe this conception and indicate what makes it so attractive. In chapters 8, 9, and 10, I will consider difficulties for the means/end theory.

7
The Means/End Conception of Rationality

> *Since reason consists of just adaptation of means to ends, it can only be opposed by those who think it a good thing that people should choose means which do not realize their professed ends.*
> —Bertrand Russell

In the remark quoted above, Bertrand Russell captures the gist of the Humean conception of rationality by identifying reason with the "just adaptation of means to ends." He also makes clear why it is hard to be against reason in this sense.[1]

My discussions of deliberation and objectivity lend further support to the means/end conception of rationality. In attacking the classical view that good deliberations make an action rational, I argued that the rationality of an action consists of its having foreseeable results that are desirable. In discussing objectivity, I argued that it is the agent's perspective, the framework of a person's aims and desires, rather than a rarefied cosmic point of view, that provides the proper perspective for evaluating actions. Putting these ideas together yields the conclusion that an action is rational if, on the basis of the information available to the agent, it is the act most likely to produce consequences she desires. This conclusion also fits well with my criticisms of the classical ideal of rationality, since they are based in large part on the idea that trying to adhere to the classical ideal would produce results that most of us do not desire.

In the means/end conception, then, the results of the previous chapters converge with both pragmatic and Humean conceptions of rationality. For Hume, reason is the slave of the passions in the sense that its function is to make sure that a person's desires are satisfied. Moreover, the pragmatic concept of usefulness is the idea that the

rationality of actions is determined by the likelihood of their producing results that are desirable to the agent. Rationality in action, on this view, consists of nothing more (nor less) than practicality and efficiency. The rational act is, in the language of high school yearbooks, the act most likely to succeed.

Answering the Antirationalist Challenge

This conception of rationality is so straightforward and so close to commonsense ways of thinking and acting that one may hesitate to call it an ideal at all. Nonetheless, the commonsense quality of the means/end conception is a source of its power, since it is hard to see how anyone could reject the desirability of acting according to this criterion. To do so would deny the desirability of achieving one's own goals, and the mere having of goals seems to require that we favor their achievement. While it makes sense to reject the classical conception of rationality, it is hard to see how anyone could sensibly reject means/end rationality.

Defenders of rationality have two tasks: to describe the nature of rationality and to show that rationality is something of value. The simple but powerful notion of means/end rationality appears to complete both tasks with incredible directness. It tells us that to act rationally is to act so as to achieve our aims, and it follows that if we want to achieve our aims, we will thereby want to be rational.

With the means/end conception in mind, we can appreciate the force of some antirationalist criticisms while seeing why they are misguided. Those who oppose objectivity, analytic thinking, detachment, science, technology, and other allegedly rational ways of thinking and acting because they are harmful, those who see "rationality" as a threat to human good are invoking rationality rather than rejecting it. They are saying that these methods and attitudes have bad effects. It is implicit in their argument that we will achieve our human goals better if we do not rely on these methods. They are not arguing that we should forsake the attempt to achieve our goals. If they were, there would surely be less interest in the antirationalist point of view.

When issues concerning the value of particular ways of thinking or approaching problems are raised, reason is inevitably invoked. To show that we should cease to think scientifically, objectively, or analytically, one would have to show that the foreseeable consequences of doing so would be better for us than the foreseeable consequences of maintaining

a commitment to these methods. Thus, means/end criteria of rationality must operate here. Moreover, since it is an empirical question whether we would improve our situation or worsen it by forsaking the methods of rigorous inquiry, antirationalists must provide evidence to support their prediction that we would be better off without using these methods. Accordingly, they must invoke not only the basic practical criterion of means/end rationality but also the standard criteria of evidential rationality.

While my arguments against the classical ideal are based on the idea that we will achieve bad results by giving absolute preeminence to cognitive activities and standards, I am not claiming that deliberation, objectivity, knowledge, and truth are always or usually harmful or that they are generally impediments to attaining our ends. That might be true in some possible world, but ordinary experience and history show that it is not true in ours.

In discussing the views of Kekes and James, I stressed that pragmatism does not give truth and evidential rationality as high a value as they are given by classical rationalists. The positive side of this point, however, is that pragmatism shows that no one can ignore truth and evidence entirely. As Kekes shows, the most rabid anti-intellectual, simply by virtue of his physical needs, must have an interest in knowing a vast range of truths about his environment. Without these, he cannot effectively further his own ends. While the pragmatic view that intellectual standards and goals are justified by their usefulness does make them subservient to other human interests, it also gives them a crucial role in human life. Given that the world we live in both lacks guarantees of satisfaction and contains threats to our welfare, we must value the cognitive processes that help us to protect, sustain, and enhance our lives.

What if someone simply denies any interest in using effective means to achieve her goals? How could we reply to such a complete antirationalist? In a sense, there is no possible reply to such a person. We might well doubt her sincerity, however, and observation of her behavior might show that she in fact prefers actions that advance her interests. In such a case, we would be justified in dismissing her antirationalism as merely verbal. Genuinely doubting the value of rationality requires more than simply mouthing the words "I doubt the value of rationality."

If the antirationalist skeptic actually avoids actions that further her ends, we would be likely to think of her as highly irrational or even

insane. No one could persist in such behavior and survive for long (unless others intervened on her behalf). Kekes was correct to assert that a complete rejection of practical rationality would lead either to inconsistency (acting according to principles one denies) or death (not acting purposefully at all and suffering the consequences).

Ideals and Nonpractical Ends

To emphasize practical rationality may suggest that it is irrational to care about goals that are not immediately related to our physical well-being. Pragmatism, in particular, has been portrayed as anti-intellectual by many critics. Can proponents of means/end rationality leave room for the pursuit of truth, for artistic creativity, morality, and other ideals? Can they allow what seems to be true, namely that someone can be willing to discover the truth, even when this means forsaking the bliss of ignorance? Need such a decision imply irrationality or fanaticism?

These questions and the qualms they express about means/end rationality arise from construing means/end rationality too narrowly. To see why this is so, we need to consider the distinction between "rational" and "irrational." One might think that this distinction is like that between "true" and "false" or "valid" and "invalid." In these latter cases, the categories they mark are usually thought to be exhaustive. Any argument that is not valid is invalid. Any proposition that is not true is false. But the rational/irrational distinction is not like this.

If we interpret "rational" to mean *required* by reason and "irrational" to mean *forbidden* by reason, then these terms do not exhaust all the possibilities. There are many actions that reason neither requires nor forbids. For example, if I am choosing between two similar pairs of socks, reason neither requires that I pick one particular pair nor forbids me to do so. Either choice is *allowed* by reason. Because reason can allow a choice that it does not require, the fact that a particular choice is not rationally obligatory does not imply that it is irrational.[2]

With these distinctions in hand, we can return to our earlier questions about intellectual values and other nonpractical goals and ideals. Reason, according to the means/end theory, does not require us to adopt these goals, but neither does it forbid us from doing so. If some people have a special interest in knowing the truth—apart from other benefits it might bring, then one of their goals is knowing the truth.

Consequently, when they determine the rationality of particular actions, they will give weight to whether or not these actions promote this goal.

Recall that Kekes, in trying to synthesize classical and pragmatic conceptions of rationality, invoked a "special reason" for upholding high evidential standards, the desire to have an accurate description of the world. I criticized him for appealing to such a reason, and argued that reason (in the sense of means/end rationality) did not require that one have such a goal. Nonetheless, it is undeniable that some people have this goal, and for them, there would be special reason to prefer true and well-founded beliefs. While means/end rationality does not require us to have intellectual goals, neither does it forbid them. Therefore, it is wrong to charge means/end rationalists with a failure to allow that maintaining high evidential standards or seeking truth can be valuable in themselves.

This point about intellectual goals can be generalized, for the means/end conception of rationality allows the adoption of any goals whatsoever. It is entirely agnostic about ends. In Bertrand Russell's words,

> 'Reason' . . . signifies the choice of the right means to an end that you wish to achieve. It has nothing whatever to do with the choice of ends.[3]

What determines the choice of ends are the "passions," the particular desires or aversions one happens to have. In view of the ends one happens to find appealing or unappealing, certain actions become rational, but the ends themselves are neither rational nor irrational.

This feature of the means/end conception has been attractive to many recent thinkers because it allows them to make judgments about rationality without committing themselves to value judgments that are controversial or not susceptible to empirical verification. According to the means/end view, the rationality of actions can be empirically determined. If we know what someone desires and what actions she can perform, the rational action is, roughly, the one with the highest probability of bringing about the desired end. To know which action is rational does not, on this view, require that one judge whether the agent's aims are themselves valuable.

Another Look at Nihilism

The means/end conception provides us with two strategies for answering the nihilist, the person who denies that anything is valuable at all.

The nihilist's position gets its sting because the absence of objective values is thought to imply that no actions are rational, that all actions are equally worthy or unworthy of performance. (Of course, if nihilism is true, this hardly matters.)

The first strategy for replying to nihilism follows from the value agnosticism of the means/end theory. Means/end theorists can admit that nothing is objectively valuable while denying that this fact does anything to undermine the rationality of actions. Since the rationality of actions is determined by their efficacy in bringing about ends that people desire, then if an action has the best chance of attaining someone's ends, it follows that it is rational. Rationality, according to this strategy, is simply independent of objective values.

A second anti-nihilist strategy is to argue that it is a mistake to ground the rationality of actions in "objective" values because the real value of anything depends on whether it is rational to choose. To know what is valuable, we must know whether it is rational to choose, and, as we have seen, what is rational to choose depends on a person's desires rather than some totally "objective," impersonal facts. In other words, the value of anything derives from its being rational for specific agents to choose. As John Rawls writes:

> The basic value judgments are those made from the standpoint of persons, given their interests, abilities and circumstances.[4]

A particular thing is good for some person if it has properties that it is rational for that person to want, in view of "his circumstances, abilities, and plan of life (his system of aims)" (399). To the extent that human beings differ, what is good for them differs as well. To the extent that people are alike in their needs, abilities, or aims, there will be things that are good for virtually everyone. Rawls calls these "primary goods" because they are required for carrying out almost any sort of life plan. They include such things as health, vigor, intelligence, wealth, rights, and opportunities (62). The most important good, Rawls thinks, is self-respect, since it is necessary for a person to feel that her plan of life is worth pursuing.

Rawls's definition of "good" in terms of "rational to choose" stands the classical theory on its head. According to the classical view, the mind surveys reality and discovers what is valuable. The perception of value then triggers desires, which motivate actions in pursuit of what is valuable. For Rawls and other Humeans, desires and aims come first,

and things are valuable by virtue of their connection with what people actually want.

This type of value theory is both objectivist and relativist. It is a relativist view because the value of something depends on the "circumstances, abilities and plan of life" of particular persons, and these vary from person to person. This kind of relativism in no way undermines objectivity, however, for it is an objective matter whether or not a particular thing is conducive to the achievement of a person's aims. If we think of an objectivist theory of value as one that gives sense to the idea of mistaken judgments of value, then Rawls's theory is objectivist.

Relativism is often associated with skepticism about values, and it is likely that relativism and subjectivism are often blended together in people's views about value. Part of the appeal of relativism, however, must be due to its correct emphasis on the idea that values are contextual. What is good medicine for me might well be your poison. The objective value of the medicine differs for each of us, in that it would be rational for me to choose it (given my needs) and for you to refuse it (given yours).

Whether we adopt the strategy of defining rationality in terms of efficiency (leaving out values entirely) or the strategy of defining value in terms of rational choice, the means/end theory provides a plausible response to nihilism. Value judgments can either be dispensed with or interpreted in a way that makes them verifiable and unmysterious. Nihilism is either refuted or shown to be a purely metaphysical doctrine with no implications about the rationality of our actions.

Evaluating Actions

What I have said so far should show that the means/end theory is both plausible and attractive. We need, however, to look more closely at its account of what makes an action rational, since there appear to be cases in which an action can succeed in realizing an agent's goals and still be irrational.

Suppose, for example, that I am driving in bad weather with my family in the car and that I have a desire to see if my car can travel at one hundred miles per hour. Although pushing the accelerator to the floor is an effective means of making the car reach that speed, most of us would

think that the action is irrational. To make the point especially clear, imagine that the highway is crowded, that visibility is poor, and that the chances of an accident occurring are substantial.

If we simply equate a rational action with one that achieves its end, my pressing the accelerator would be rational, since it will bring about an end I desire. Since there is nothing intrinsically irrational about wanting to drive a car at one hundred miles per hour, a means/end theorist would explain the irrationality of my action by showing that it is inconsistent with other aims and desires that I have. For example, if I act on my desire to speed down the highway, this will jeopardize my chances of realizing other desires, including my desire to arrive home safely, to protect my family, to avoid killing or injuring others on the road, and to finish writing this book.

Rawls emphasizes the idea that specific aims and desires must be evaluated in relation to other aims with his notion of a "life plan." (See 407ff.) While the expression "life plan" may suggest a rigid, overintellectualized conception of rational living, this interpretation is not warranted. What Rawls means by a life plan is a system of aims, and the term reminds us that we have many aims that relate to each other in diverse ways. Some are concerned with the immediate future and others with the long term. Some are passing, and others are relatively stable. Some are central to our lives, and others are peripheral, even trivial. In evaluating possible actions, we need to consider how attempts to realize some ends will affect others. A rational person will give greater weight to desires that cohere with and enhance the prospects of satisfying our central goals rather than interfering with them. One wants to achieve as many of one's important goals as possible.

Any sensible means/end theory of rationality is bound to become more complex as it attempts to specify how conflicting aims ought to be treated. Things would be simpler if all of our aims were entirely independent. In that case, a rational life would consist of a series of successive actions, each one aimed at satisfying one or another of our aims. This is impossible, however, because acting to fulfill some aims makes it difficult or impossible to achieve others. My short-term, peripheral desire to see the speedometer hit one hundred ought not to be satisfied because it jeopardizes other aims that are more central to my life plan. Our general system of aims provides the framework both for evaluating particular desires, goals, and actions as rational or irrational and for evaluating particular objects or states of affairs as good or bad.

The Powers of Reason

Even if one holds that our aims are rooted in nonrational desires and other features of our nature that are not chosen, the role of reason on this account is substantial. Comparing reason to an executive officer seems more appropriate than comparing it to a slave. On this account, rationality enters into a person's awareness of the various goals that might be affected by particular actions and plays a role in discovering which goals are of greatest importance. Even if we imagine this task to consist of no more than measuring the intensity of particular desires, it will often call for a high degree of self-awareness and substantial knowledge about particular aims. Rationality will also involve judgments of probability, since the likelihood of success or failure in achieving goals is a crucial determinant of the worth of particular actions. In addition, by arranging our actions in an order, reason can help us maximize the number of aims we achieve. I may want X now, but realizing that if I get it, I must sacrifice Y, I can decide to achieve Y first and then move on to X.[5] These are some of the many roles that reason can play, even if it does not determine our ultimate aims.

Finally, reason can both kindle and dampen our desires. Knowing that if I strive for X, I must sacrifice numerous other goals, my desire for X may simply dwindle. Or I may find myself actively desiring something because it is a necessary means toward realizing a goal of mine. Even Hume acknowledged this role of reason, noting that

> The moment we perceive the falsehood of any supposition, or the insufficiency of any means our passions yield to our reason without any opposition. I may desire any fruit as of an excellent relish; but whenever you convince me of my mistake, my longing ceases.[6]

This acknowledgment of the power of reason over passion makes Hume's slave metaphor look even less appropriate.

Reason and the Emotions

It is worth saying a few words about reason and the emotions at this point. Nothing in the above account implies that a rational person will be unemotional or that rationality requires the shedding of one's

emotional nature. It is true that people sometimes fail to respond to evidence or give insufficient weight to important reasons because they are under the influence of some powerful emotion. That, however, is simply one factor that sometimes explains irrational behavior. It is not grounds for condemning the emotions generally.

One might wonder whether it is rational to have emotions. That is an odd question, but it is worth considering. First, it is only an odd question when posed generally. There is nothing peculiar about asking whether it is rational to have particular emotional responses to situations or facts.[7] I can wonder whether a particular fear or hatred is rational, and if I decide negatively, I might take steps to rid myself of that feeling. Asking whether it is rational to have emotions at all is odd partly because we lack the power to rid ourselves of all emotions. Putting that aside, however, we can see that the question raised is whether it would be preferable (in terms of our aims, etc.) not to have emotions. For most of us, the answer is clearly negative, for our lives are greatly enriched by our emotional responses to the world. Indeed, it is not clear what would even be meant by a "rich" life that was devoid of emotions. The only kind of person for whom getting rid of the emotions would be worthwhile would be someone for whom indifference to everything would be an improvement in his life situation. If all emotions are painful, apathy might well be a worthwhile goal. Apart from this kind of case, rationality implies nothing negative about the emotions. There is nothing intrinsic either to rationality or the emotions that forces us to choose between them.

In fact, from a means/end perspective, there can be no rationality without emotions because our passions play such a central role in determining our aims. Without desires, no ends would appeal to us, and there would be no standard of effectiveness by which to evaluate actions as rational or irrational. In an important sense, then, the means/end account makes rationality dependent on our having emotions.

Summing Up

The means/end conception of rationality has several important virtues. It seems to remedy several defects of the classical ideal, provides plausible answers to nihilists and skeptics about rationality, and shows why deliberation, knowledge, and objectivity are usually (but not always) valuable.

According to the theory, the essence of rationality is effectiveness—the performance of actions that are most likely to satisfy our desires. Our aims and desires can be of any sort. They need not be selfish, for example, since there is nothing to exclude the desire to make other people happy from someone's life plan. The rational person need not be an egoist.

Finally, nothing in the means/end account requires that there is always a single act that is the very best act for the agent to perform. When there is more than one rationally permissible action, reason allows us to do any of them. There is no reason for a rational person to suffer Jacob Horner's problem of being paralyzed by a plethora of equally good options. If it is rational to do *either* A or B, it is rational to *do* either one and irrational to do *neither,* especially in cases where inaction causes harm or a loss of desirable results.

8
Reasons, Motives, and Morality

> *If a Martian who does not care about human life decides to live in our midst but does not see any reason to accept our conventions, we cannot say correctly that the Martian is morally obligated not to harm us.*
> —Gilbert Harman

As we have seen, the means/end theory has many attractive features. It provides a clear conception of rationality that enables us to work through a variety of difficult issues. In spite of these virtues, however, the theory is not without its problems. In this chapter, I want to consider some difficulties that arise because means/end theories link reasons so closely to a person's desires and motivations.

Reasons as Motivators

The means/end theory implies a very close relationship between there being a reason for someone to do a certain act and that person being motivated to do it. For means/end theorists, the rationality of actions depends on the likelihood of their satisfying a person's desires. We only have reason to act in ways that will satisfy some desire of ours. It follows that if an action will produce a result that a person does not desire, there is no reason for that person to perform the act.

For means/end theorists, then, there is no reason for people to act on behalf of ends they do not desire. Since desiring some end necessarily involves some motivation to achieve it, we can express this view by saying that something can be a reason for a person's acting only if a person is motivated to act in accord with it. There is no such thing as a nonmotivating reason.

Mean/ends theorists do not claim that desires always lead to action.

They can fail to do so, for example, when someone has conflicting motivations. My desire for coffee ice cream, for example, may not actually lead me to buy some because I may have a stronger desire for chocolate. If I had no desire at all for coffee ice cream, however, I would have no reason at all to purchase it. As things stand, I have some reason to buy coffee, even though I don't actually do so. What is crucial to the idea of reasons as motivators, however, is that reasons must always possess some motivational force in order to be reasons at all. They must always be linked to what a person wants. Thus, when we determine what it is rational for a person to do, we must base our assessment on information about what that person is motivated to do.

The same view can be extended to cover evaluations. If someone thinks that something is good or that some act ought to be done, it follows that she must want that thing or want that act to be done. She may be motivated to act out of self-interest, out of concern for another person, or because the action conforms to a principle she holds. The motivations can be quite diverse, but there must always be some form of motivation underlying a person's reasons and evaluations.

This view is often called "internalism" because it links reasons to motivations that already exist in what Bernard Williams calls a person's "motivational set."[1] By contrast, "externalism" is the view that there can be reasons for a person to act that are not linked to a person's actual motivations. According to externalists, there may be reasons why a person should perform an action even though she has no desire to act that way and no desire for the results that the action will produce.

This point, however, is precisely what internalists reject. Williams, after analyzing both internal and external reasons, concludes that

> it is very plausible to suppose that all external reasons are false . . . [T]he only real claims about reasons for actions will be internal claims. . . .[2]

Later, he suggests that statements asserting the existence of external reasons for action are "false, incoherent, or really something else misleadingly expressed."[3]

I grant Williams's claim that internalism is plausible and that it may appear strange that things a person does not care about could provide reasons for that person. Nonetheless, I want to argue that external reasons are not as odd as he suggests. Indeed, in evaluating both people's actions and their beliefs, we frequently invoke reasons in spite of the fact that we know they will not influence the person whose actions or beliefs we are considering.

The Limits of Internalist Morality

Doubts arise about internalism when we think through the implications of the reasons-as-motivators view for our conception of moral reasons. Internalism appears to imply an extreme version of ethical relativism that undermines our ability to criticize actions that are blatantly immoral. While I will not try to show that all forms of ethical relativism are false, I will try to make clear how much of our ordinary beliefs we have to reject if we accept the internalist view and its extreme relativistic implications. At the same time, I will try to make clear that external reasons (i.e., reasons not tied to a person's actual motivations) play a familiar and important role in our ordinary ways of thinking about morality.

One may wonder about the legitimacy of appealing to moral beliefs to criticize a conception of rationality. My general reply to this concern is that all beliefs are testable in part by seeing if they are consistent or inconsistent with other beliefs that we take to be true or well-founded. There is no reason to disqualify our moral beliefs from playing such a role.

Indeed, this is not a novel kind of criticism at all. In chapter 1, I described how Plato tried to defend his rational ideal against the objection that it implies a commitment to the totally egoistic, immoral way of life exemplified in the story of Gyges. Likewise, I argued, Barth's novel, *The Floating Opera,* raises doubts about the value of reason and objectivity by suggesting that they lead to nihilism and moral indifference. If reason leads Todd Andrews to try to blow up a boat with hundreds of passengers, then reason may not be such a good thing.

The appeal, then, to the moral consequences of a theory of rationality is neither novel nor strange. It is simply one way to test the acceptability of one belief or theory by seeing how it coheres with other beliefs or theories that we hold.[4]

Harman's Relativism

The implications of internalism for morality are most clearly brought out by Gilbert Harman, who both defends the internalist view and makes explicit its striking implications about the status of moral principles. Applying the internalist view of reasons to morality, Harman

writes, "To think that you ought to do something is to be motivated to do it."[5] Moreover, he says, if someone else asserts that you ought to do something and that you therefore have a reason to do it, their judgment presupposes that you have some motivation to do it. If the act they claim you ought to do is not connected to anything you care about, then, Harman says, you have no reason to do it.

This point applies to all reasons for action, including moral reasons. Harman illustrates it by considering the case of a vegetarian who claims that his carnivorous friends ought not to eat steak. This claim, Harman says, makes no sense. If you are a vegetarian and you want to say of P, a nonvegetarian,

> that P ought not to eat steak you imply that P has a reason to accept your principle. . . . But if P does not have any reasons to accept that principle, as is quite probable, . . . it cannot be said that P ought to accept that principle. For it would be inconsistent to say that P ought to accept the principle when he has no reasons to accept it. But then it cannot be said that P ought not to eat steak, if his principles give him no reason not to eat steak, and he has no reasons to accept any principles that differ from those he now accepts. (89)

The vegetarian, of course, might think that there are good "external" reasons for P to accept some new principles. Like Williams, however, Harman believes that there are no external reasons. Whether there is any reason for P to alter his eating habits does not depend on "external" facts about P's actions or their consequences. Rather, it depends entirely on "internal" facts about whether any of P's current motivations would lead him to adopt vegetarian views. As Harman writes,

> [F]or someone to have (good) reasons to do something is for there to be (good) reasoning 'available' to him that *would lead him* to decide to do that thing. (125, my italics)

If the principles cited by the vegetarian are external and thus do not motivate P, his carnivorous friend, to refrain from eating meat, then they do not count as reasons for P.

Of course, if P has some motivation not to harm animals but has a stronger motivation to continue eating meat, then he will have some reason to heed his vegetarian friend. His behavior will not alter, however, because he has a stronger reason for continuing his carnivorous practices. What is crucial, however, is that if he has no concern for animals and thus no desire to avoid harming them, then he has no reason

at all to stop eating meat. He only has reason to do what he has at least some desire to do.

According to Harman, then, we can only say of people that they ought to obey a moral principle if they themselves hold the principle, if they can further their own ends by complying with it, or if they are otherwise motivated to act in accord with it. If these conditions are not met, they have no reason to comply with it. In fact, for Harman, in such a case, it makes no sense to tell someone that he ought to adhere to a particular moral principle. As he says,

> [I]t would be a misuse of language to say of hardened professional criminals that it is morally wrong of them to steal from others or that they ought morally not to kill people. Since they do not share our conventions, they have no moral reasons to refrain from stealing from us or killing us. (112)

Moreover, Harman says, although we are inclined to say that "it was wrong of Hitler to have ordered the extermination of the Jews," this implies

> that Hitler had a reason . . . not to do what he did. But . . . he could not have had such a reason. If he was willing to exterminate a whole people, there was no reason for him not to do so. (109)

Harman adds the comment, "That is just what is so terrible about him." While this comment suggests that Hitler *ought* to have subscribed to principles forbidding genocide, Harman's view forbids him to say this. Since Hitler apparently had no aversion to genocide and adhered to no principles forbidding it, he had no reason not to engage in it. Genuine reasons must be internal, but for Hitler the prohibition of genocide was an external reason and thus not a genuine reason at all.

What Harman's discussion makes clear is that if we conjoin internalism with the fact that different people accept different moral principles, it follows that the same moral principles do not apply to everyone. Which morality, if any, applies to a person is relative to the kinds of reasons or principles that motivate that person.

Many people find ethical relativism to be a plausible and attractive view. Generally, however, they do not fully realize the implications of such a theory. What distinguishes Harman's statement of the theory is both his derivation of relativism directly from a means/end theory of rationality and his almost unflinching acceptance of the most extreme

and most troubling implications of ethical relativism. I presume that the conclusions he draws about the hardened criminal and about Hitler are distasteful to any person with moral concerns and that Harman would not affirm them unless they appeared to follow inexorably from a theory he thinks must be true. That he does affirm these conclusions about morality is testimony to the power of the means/end theory and the internalist view that all reasons must motivate.

Are There Nonmotivating Reasons?

What Harman's argument makes clear is that internalism is inconsistent with a view of moral reasons that we ordinarily take for granted. If we are convinced of the truth of internalism, then, like Harman, we will be led to the view that moral reasons do not apply to people who are indifferent to them. On the other hand, if we confidently believe that moral principles can apply to persons who reject them (such as Nazis and hardened criminals) and if acceptance of the means/end theory and internalism is inconsistent with this belief, then this inconsistency by itself provides at least some reason to suspect that internalism and the means/end theory are false.

In addition, if we believe that we understand what it means to say of someone who rejects a moral principle that there are reasons why he should comply with it, then we understand what an "external reason" is. Since Williams suggests that external reasons are either false or incoherent and since Harman claims that they involve a misuse of language, then the fact that we often appeal to and seem to understand such reasons in the context of moral discussions suggests that these internalist criticisms of external reasons are mistaken.

So, rather than agreeing with Harman that the plausibility of internalism provides a compelling argument for ethical relativism, one might equally conclude that the implausibility of extreme relativism provides a reason to reject the internalist conception of reasons as motivators.

While I believe that these considerations provide substantial grounds for rejecting internalism, there are two reasons why it would be unwise for me to rely solely on them as the basis for an anti-internalist view. First, both internalism and the means/end theory are themselves widely held views that possess a good deal of initial plausibility. Second, many people, including those who take moral demands quite seriously, appear

to lack confidence in the ultimate validity of the moral beliefs they accept and are thus uncomfortable using moral beliefs in arguments against other kinds of theories. For these reasons, it is important to look for other ways to argue against internalism. Can the case against internalism be made in areas that don't involve contested claims about moral objectivity?

In later chapters, I will try to show that the means/end theory fails as an account of practical rationality even when we leave moral concerns aside. Here I want to cast doubt on the means/end theory by considering the way in which we think about how evidence provides reasons for factual beliefs. This will help to make plausible the idea that reasons need not motivate in order to be genuine reasons. If genuine reasons for belief can fail to motivate, then the general internalist requirement that moral reasons must motivate to be genuine will be undermined.

In order to see how there can be reasons that are genuine and yet that fail to motivate, it is important to distinguish between two different ways in which we talk about reasons. The first way is explanatory. If we want to explain actions that people have already performed by reference to their reasons for acting, it is obvious that the only reasons that can be explained are those that in fact motivated the person's behavior. Reasons that don't motivate an action cannot be used to explain it.

We cite reasons, however, not only to *explain* behavior but also to *evaluate* it. While it makes no sense in explanatory contexts to cite reasons a person did not have, in evaluative contexts it makes perfect sense to talk of reasons that do not motivate. To say that a person has a reason to act in a certain way is to make a normative claim about what *ought* to influence that person. Such claims make sense, even if the reasons cited fail to have influence. When we criticize someone for failing to respond to a reason that we believe ought to be taken seriously, we are using "reason" in a normative, evaluative sense and not in a neutral, explanatory sense.[6]

Reasons and Evidence

While the evaluative sense of "reason" is prominent and familiar in moral contexts, it is not limited to morality. A similar normative conception of reason is common in our thinking about purely cognitive matters. When we consider a person's beliefs, we do not ordinarily think

that logic and factual evidence cease to be reasons for belief solely because that person fails to take them seriously. Suppose that a bigoted person insists both that all members of a particular ethnic group are dishonest, acknowledges that the members of this group that he knows well are not dishonest, and yet continues to assert that all members of this group are dishonest. When we point out that his beliefs are inconsistent, he is not swayed and continues to assert his prejudiced view that all members of this group are dishonest. If we hold the internalist view that evidence must motivate belief in order to count as a reason, we could not say that this person's prejudicial generalization is irrational. We would be committed to the view that reasons are defined by their efficacy and that arguments that fail to convince provide no reason for their conclusion, even if they are logically sound.

One might think that we are more comfortable with the idea of external reasons about belief (than we are about external reasons for action) on the grounds that internalism makes no sense in the cognitive realm. This is a mistake, however. We can easily extend the doctrine that reasons must motivate to matters of factual belief. One could imagine, for example, a theory of rational belief based on the phenomenon of cognitive dissonance, the feeling of discomfort people usually have when they see that their beliefs are mutually inconsistent. According to such a theory, a person would have a reason for rejecting a belief only if the discomfort of cognitive dissonance causes a desire to reject it. Conversely, a person who is quite comfortable with her beliefs and experiences no such dissonance would have no reason to change beliefs. According to such a theory, the function of argument would be to change someone's mind by instilling or appealing to feelings of cognitive discomfort.

William James suggests a related view in his essay "The Sentiment of Rationality." After asking what are the "marks" of a rational view or theory, he answers:

> A strong feeling of ease, peace, rest, is one of them. The transition from a state of puzzle and perplexity to rational compression is full of lively relief and pleasure.[7]

While I have just spoken of cognitive dissonance as a cause for rejecting beliefs, James emphasizes a feeling of cognitive harmony as a reason for accepting beliefs.

The flaw in any such view, however, is evident. If someone has blatantly contradictory beliefs, is aware that the beliefs are contradictory, and yet experiences "ease, peace, [and] rest" rather than cognitive

dissonance, the reasons-as-motivators theory would imply that there is no reason for him to alter his beliefs. Why is there no reason? Because the person does not experience cognitive dissonance and has no motivation to change his beliefs. Where such motivation is lacking, reasons have no foothold.

To take a more extreme case, imagine a kind of cognitive eccentric, someone who experiences cognitive dissonance but has no desire to relieve himself of it. He might even enjoy dissonance among his beliefs, just as some people enjoy dissonance in music. This attitude is suggested by some lines from Walt Whitman. To the question "Do I contradict myself?," Whitman replies: "Very well then I contradict myself," adding proudly, "I am large, I contain multitudes."[8] If Whitman's description of himself is accurate, then the view that cognitive reasons must motivate would imply that he had no reasons to render his conflicting beliefs consistent.

If a person is not motivated by logical considerations, we must either say that he is irrational (because he is not motivated by logical principles) or that logical principles do not apply to him (because he is not motivated by them). I think it is clear that the person described is irrational and that his irrationality consists precisely in his failure to be motivated in his beliefs by logical principles.

In saying this, I do not mean to retract my earlier "Jamesian" conclusion that the evidential irrationality of a belief might be over-ridden by its practical benefits. If embracing contradictions truly enhances the life of a Whitmanian romantic, then this might well provide an over-riding reason for holding inconsistent beliefs. Nonetheless, logical and evidential standards still apply in these cases. If there is evidence against a cherished belief, it provides reasons against that belief, even if it may be rational to reject the evidence in order to gain specific benefits. Note, too, that in such cases, it is the expected benefits that justify holding an (evidentially) unsupported belief and not simply the person's feeling motivated to accept or reject a belief.

My point in sketching these cases is both to show that the internalist view can be extended to logical and evidential reasons and to make clear how different this conception is from our ordinary ideas, which definitely commit us to the existence of external reasons. We believe that there are logical and evidential standards that apply to people whether or not they accept them or are inclined to adhere to them. When people ignore reasons that they ought to take seriously, they are being irrational.

To talk of reasons in evaluative (as opposed to explanatory) contexts is to talk about how people *ought* to reason or act, not how they actually

do. If this is true for evidential reasons, it may also be true for moral reasons as well. Just as a person who fails to operate according to logical principles is illogical, so a person who fails to act according to moral principles is immoral. While reasons can and do motivate, they do not cease to be reasons simply because they fail to do so.[9]

Capacities and the Availability of Reasons

One might think that there is an important connection between reasons and motivations, even if it is not as close as internalists claim. One might think that reasons need not always motivate and still believe something can be a reason for a person only if she has the *capacity* to be motivated by it.[10]

This view is attractive for several reasons. It does seem to be true that something cannot be a reason for me to accept a belief if I am incapable of understanding it. Einstein's proofs of the theory of relativity, for example, cannot be reasons for me to accept the theory because I cannot understand them. If I can understand a relevant argument but ignore it, then I am proceeding irrationally; but if it is beyond my comprehension, then my failure to be influenced need not reflect negatively on my degree of rationality. This is related to my earlier point that a person can only be responsible for considering evidence that is available to her. Evidence that one cannot understand, even if one is confronted by it, is not available in the required sense.

Similarly, in the moral case, if Hitler lacked either the power to understand the constraints of morality or the ability to refrain from the acts it prohibits, then one might think that moral principles would not provide reasons for him to act. Lacking the capacity to have his actions motivated by moral reasons, he would not satisfy the conditions for being a moral agent and would not be responsible for his acts. He would be in a category like that of nonhuman animals or the criminally insane.[11]

To say this is to recognize that moral reasons can be inapplicable to a person who cannot recognize them. This is still quite different from Harman's view. Harman says that moral principles are inapplicable simply because a person does not acknowledge their validity or share the principles that they draw on. By contrast, according to the "capacity" view, moral principles are inapplicable to people only if they cannot be understood or obeyed by them.

What is attractive about this view is that it combines the externalist's assertion of the independent validity of reasons with the internalist's insistence that there must be some connection between what is a reason for a person and facts about that person's motivational state.

In fact, however, this view concedes too much to the internalists. In judging what reasons *ought* to motivate a person to believe or act, we use as our criterion some notion of what a normal person would be moved by, not what a specific individual might be moved by. An available reason is one that I could be expected to appreciate. If I lack the capacity to be influenced by a certain kind of reason, that may do nothing to show that the reason lacks genuine force or weight. Rather, at least in some cases, what it reveals is a defect in me. A person, for example, who is never influenced by the exposure of contradictions in his beliefs would be a person who has a severe cognitive defect, an inability to respond to a reason that normal people can respond to. Similarly, the hardened criminal that Harman describes or someone like Hitler might actually lack the ability to respond to moral reasons. Since normal people can understand and respond to such reasons, the existence of people who cannot does not show that the reasons in question are defective or lacking in genuine force. Rather, it is the person who cannot respond to them who is revealed to be defective. So, even the lack of a capacity to respond to a reason would not show that the reason is inapplicable to a person.

In the case of a defective person, it might be odd to say that the person *has* a reason to act morally or reason logically. Nonetheless, it would remain true that there *is* a reason why he should do so, and that is the key point that is required for externalism to be true. What is central is that actually motivating people is not required for a reason to be genuine. Because this is possible, internalism, the view that reasons must motivate in order to be reasons, is false. Likewise, the means/end theory is refuted because it requires that all reasons relate to the achievement of ends that a person already has. As plausible as that view is, the existence of external reasons shows it to be mistaken.

Summing Up

In this chapter I have tried to show that if we equate rational action with actions that satisfy an agent's desires, we will be forced to say that moral reasons apply only to people who desire to act morally. This, along with

the internalist doctrine that reasons must motivate in order to be reasons, leads to an extreme version of ethical relativism.

While I have not tried to prove that ethical relativism is false, I have tried to make clear just how radical a departure from ordinary moral beliefs is required if one embraces the extreme type of ethical relativism that Harman develops.[12] Moreover, I have argued that we can make good sense of the idea of something's being a genuine reason without having motivating force by thinking about logical and evidential reasons. We often believe that these sorts of reasons apply to people who are not swayed by them and that their status as reasons is not undermined by their failure to affect a person's beliefs. If this is so, then some reasons are external rather than internal, and the doctrine of internalism is false.

A means/end theorist may reply that we should not assume that reason applies to actions and desires in the same way that it applies to beliefs. Therefore, in order to show that there can be non-motivating reasons, we must return to the sphere of action and explore more thoroughly the relations between reasons and desires. If I am correct, we will discover even deeper flaws in the means/end account. Not only is it true that reasons need not motivate in order to be genuine, it is also true that some desires provide no reason to act and that their mere presence is an indication of irrationality.

9
Irrational Desires

> *The only possible reason there can be why any phenomenon ought to exist is that such a phenomenon actually is desired. Any desire is imperative to the extent of its amount; it makes itself valid by the fact that it exists at all.*
> —William James

For means/end theorists, the basis of value is found in desire. The only reason for acting is to satisfy one's desires. Moreover, there is no limit to what a person might desire and, therefore, no limit on what it might be rational for a person to seek. While we do sometimes speak of desires as irrational, means/end theorists claim that this can only mean that the desire in question is incompatible with other, more important desires, and a desire is more important if it is more strongly felt. A person's own desires provide the only criterion for judging which desires are most important and thus which desires it is rational for a person to satisfy.

The point that no desire is in itself irrational, that reason does not rule out any object of desire was driven home by Hume. In this well-known passage, he wrote:

> 'Tis not contrary to reason to prefer the destruction of the whole world to the scratching of my finger. 'Tis not contrary to reason for me to chuse my total ruin to prevent the least uneasiness of an Indian or person wholly unknown to me. 'Tis as little contrary to reason to prefer even my own acknowledg'd lesser good to my greater, and have a more ardent affection for the former than the latter.[1]

While Hume was willing to accept these extreme implications of his theory, contemporary means/end theorists do not generally stress such strange ideas when explaining that their view simply accepts the desires of the agent, whatever they happen to be. In deciding whether the theory is acceptable, however, it is clearly relevant to reflect on such cases as these.

Kurt Baier claims that Hume's examples show the means/end theory to be untenable. The actions Hume describes reduce the theory to absurdity because they are paradigm cases of "what is meant by 'contrary to reason.'" Baier then adds his own example, pointing out that

> on Hume's view we would have to say, of a man who poured petrol over his hand and lit it with a match, that he acted in accordance with reason because he chose the appropriate means to his end, to burn his hand. But, clearly, aiming at that (for no reason whatever) is not in accordance with reason—it is mad.[2]

What shall we make of this? Baier seems to demand that there be some justifying reason for wanting to burn one's own hand, for example, that it is necessary for medical reasons or to win a large bet. By contrast, means/end theorists require no justifying reason for this desire because they believe that desires need no justification, that desires themselves provide reasons for action. But might there be desires so bizarre or extreme that acting simply to satisfy them would be irrational? Baier's example suggests that there are. One may, however, be puzzled about the criteria by which irrational desires are to be identified. We do not want a theory that allows us to condemn desires as irrational simply because we do not share them or because they are unusual.

In an attempt to provide a nonarbitrary way to evaluate desires, Bernard Gert argues that there is a limited set of desires that are intrinsically irrational. According to Gert, it is irrational for people to desire any of the following things for themselves: death, disablement, pain, deprivation of freedom or opportunity, and deprivation of pleasure.[3] Because it is irrational to desire these things, an action that is effective in causing them will not qualify as rational.

Gert does not deny that there are some circumstances in which it is rational to prefer one of these evils to some alternative. He insists, however, that it is irrational to want them for themselves. As he notes, we would all distinguish between a terminally ill person who prefers death to pointless suffering and someone who for no reason wants to die. Likewise, we distinguish between someone who prefers to have a gangrenous leg amputated rather than die and someone who simply wants to have a leg removed. If the choice of an evil is to be rational, it must be a means to avoid some greater evil or to bring about some good.

Gert's list of evils gains further support if we consider the conditions

that are thought to be symptomatic of insanity. We do question the sanity of a person who goes out of his way to harm himself or forgoes things he knows would be satisfying. Investigation may show that he has beliefs about the effects of these actions that put them in a different light. The asceticism that Socrates advocates in the *Phaedo,* for example, is tied to his belief in an afterlife and his view that his long-run interests are best served by avoiding bodily pleasures. In the light of his views about how best to attain greater goods after death, we may judge his actions to be rational. However, if he lacked these special reasons for self-denial, we would think of him as irrational.

Gert's account appears to reveal a crucial gap in the means/end theory, an inability to explain what is involved in judgments about sanity and insanity. The means/end theory can account for certain forms of insanity, as when someone consistently acts contrary to his own most important desires. However, it cannot account for cases in which a person's insanity manifests itself in the desires he has and the ends he seeks. Ordinarily, we do think it irrational to aim at the things Gert calls evils, and finding that a person desires those ends increases rather than decreases our concern about his overall mental condition. It is plausible to claim, then, that rationality does rule out certain ends. If this is true, the means/end theory must be false, since it allows *any* end to be chosen and requires only that effective means be used for attaining whatever one desires.

Faced with these examples of apparently irrational desires, there are three responses available to means/end theorists. First, like Hume, they can maintain the theory and assert that if it implies that desires for death, pain, disablement, etc. are rational, then they are. Second, like Gert and Baier, they can reject the means/end theory, conceding that these examples reduce the theory to absurdity. Third, they can try to develop a more sophisticated version of the means/end theory in order to show that the theory need not have these implications. This would involve showing that although it may appear that any means/end theory must grant the rationality of burning one's arm if one feels like it, this is not true.

In the rest of this chapter, I want to consider this third response. I will do this by examining two sophisticated versions of the means/end theory, both of which appear to enable us to classify certain desires as irrational. If they can do this, it will show that the means/end theory need not be undermined by arguments like those of Baier and Gert. The

views I will consider are those of John Rawls and Richard Brandt, since their discussions of rationality are among the most thorough treatments of these issues.

Rawls on Primary Goods

In chapter 7, I noted John Rawls's view that things have value in relation to the life plans of individuals. Since Rawls also refers to a life plan as a "system of aims," this suggests that a person's good is defined by the things she actually seeks or desires. I also noted that Rawls describes a number of things as "primary goods," saying of them that they are "things which it is supposed a rational man wants whatever else he wants" and that all rational persons will prefer "more rather than less primary goods."[4] That there are these pervasive, primary goods results from the fact that while human beings differ in many of their desires, they also have important features in common.

What are the primary goods? First, there are those which society distributes: rights, liberties, powers, opportunities, income, and wealth. Second, there are those which are natural: health, vigor, intelligence, and imagination (62). Viewing this list, it is immediately clear that there are significant overlaps between Rawls's list of goods and Gert's list of evils. Rawls, for example, identifies powers, opportunities, and health as primary goods, while Gert identifies the loss of abilities, freedoms, and opportunities as evils. There is a fair measure of agreement between them about the things that have central value for human beings.

This agreement suggests that Rawls has accounted for the kinds of goods and evils that critics of means/end theories have stressed. The difference between them, one might think, is that while Gert simply asserts that some things are evils, Rawls provides a theoretical account to show why this is so. Value, according to Rawls, is always relative to what people would choose, given their plan of life. Some things, however, are valuable to everyone because of the central role they play in any plan of life. In Rawls's words, "A rational plan must . . . allow for the primary goods, since otherwise no plan can succeed" (410). Because the primary goods are necessary for achieving any ends whatsoever, they will always be valued. No rational person will deprive herself of these goods because doing so would diminish her ability to achieve her aims. To desire the loss of primary goods is to desire that one be less effective in satisfying

her desires. This is exactly the kind of action the means/end theory regards as irrational.

There is a problem with this argument, in spite of its plausibility. The problem is that not every life plan requires the primary goods in order to be successful. Imagine, for example, a person who desires to be a slave or an invalid. In such a case, the primary goods of liberty, powers, health, and opportunity would not be desired. Indeed, they would be impediments to fulfilling the plan, and thus, according to the means/end theory, it would be rational to avoid them.

If reason requires simply that desires be consistent with life plans and if certain life plans do not require the primary goods, then the primary goods will not be insured a privileged status. If one wants to guarantee them a special status, one will have to put limits on what can count as a rational life plan. Since Rawls in fact does this, we must turn to his criteria for a rational life plan to see if they rule out the kinds of irrational desires we are concerned with.

The Rationality of Plans of Life

Rawls offers a rather complex definition of a "rational life plan." According to him, a life plan is rational if it is "consistent with the principles of rational choice" and "would be chosen" by someone operating with "full deliberative rationality." The key concepts here are *principles of rational choice* and *full deliberative rationality*. What does Rawls mean by these?

By the "principles of rational choice," Rawls means a variety of principles that are meant to insure the efficient attainment of the key elements in a life plan. According to these principles, one aim may be preferable to another if it can be satisfied with less cost or if it is more likely to be realized. Likewise, some aims are superior to others because they are more "inclusive"; they do not interfere with and may advance the realization of a person's other aims (412–13).

The notion of inclusiveness is especially important in assessing particular desires. A rational plan, Rawls tells us, will "mirror a hierarchy of desires" by encouraging "the fulfillment of [a person's] more permanent and general aims." In addition, it will allot the

> basic resources of time and energy . . . to activities in accordance with the intensity of the wants that they answer to and the contribution that they are likely to make to the fulfillment of other ends. (410)

The net effect of applying the principles of rational choice is to weed out desires that tend to interfere with the success of the general life plan, while giving greater weight to those that support other components of the plan.

The second condition that a life plan must meet in order to be rational is that it be chosen under conditions of "deliberative rationality." This criterion requires that the plan be judged in the light of informed consideration. It is basically an informational requirement that Rawls borrows from Sidgwick, who defined what is "good on the whole" for a person as that which

> he would now desire and seek . . . if all the consequences of all the different lines of conduct open to him were accurately foreseen and adequately realized in imagination. . . .[5]

By meeting this requirement, we would filter out desires to act that are based on a failure to use information about the results of action or to imagine the consequences vividly. Rawls supports Sidgwick's test, and claims that in the condition of full deliberative rationality, we would come to see just what our most fundamental desires are.

If Rawls (or any other means/end theorist) wants to claim that these criteria guarantee a privileged place for the primary goods in any life plan, then he must argue that no life plan could satisfy the principles of rational choice and the criterion of deliberative rationality unless it included a desire for the primary goods. This is necessary if he wants to show that no rational person would aim to deprive herself of health, liberty, ability, or other primary goods.

Unfortunately, these additional conditions fail to insure that rational people will always opt for the primary goods. Nor do these conditions provide an adequate criterion for judging which plans of life are rational to adopt. The key problem is this: Rawls's theory stresses the importance of a person's satisfying her most central and fundamental desires, but which desires are fundamental is a matter of subjective preference. If a person, aware of all the facts, settles on an irrational aim as her fundamental aim, the principles of rational choice will do nothing to rule it out. Likewise, if someone settles on this aim under conditions of full deliberative rationality, aware of all the consequences of her choice, this aim cannot be ruled irrational.

Someone who decides that her fundamental aim in life is to be a slave will not require the primary goods of liberty and opportunity. She may

realize that there are some things she will not like about slavery, but if she regards them as peripheral, her central desire to be a slave will take precedence. Since we can make the same argument about any of the other natural and social primary goods, this shows that Rawls's theory does not escape the original Gert-Baier objection to means/end theories.

"Cool Moment" Theories

This objection to Rawls's view draws on an argument that Gert puts forward to support his theory of irrational desires. Gert calls the main competitors to his own view "cool moment" theories. According to such theories, he says, a desire is irrational

> if and only if one knows (or should know) that acting on that desire will result in one's failing to satisfy some desire or set of desires which in a cool moment one has decided is significantly more important. (27)

The concept of deliberative rationality used by Sidgwick and Rawls is one version of what Gert means by a "cool moment" criterion of rationality. It guarantees that someone is not acting in haste or under the sway of powerful emotions that render thought impossible or without regard to facts that are both available and relevant.

Gert argues that no such theory can successfully rule out irrational actions. In support of his view, Gert describes the case of a person who desires to kill himself in the most painful manner possible. Though he has other desires, including a weak desire to see a psychiatrist, the person's desire for a painful death predominates over all others, even when they are considered in a cool moment (27–28). According to the means/end theory, even a sophisticated one like that of Rawls, acting on this desire is rational. Moreover, such theories must say that it would be irrational for the person to seek psychiatric assistance because a cure would thwart what is now his most important desire.

I believe that Gert is correct about "cool moment" theories and that his argument exposes the failure of Rawls's theory to solve the problem of irrational desires. While Rawls asserts that the primary goods would be desired by all rational people, his discussion fails to show any necessary connection between the primary goods and the criteria of rational action contained in his theory.[6]

Brandt on Rational Action

Richard Brandt develops and defends a version of the means/end theory which explicitly attempts to show what makes certain desires irrational.[7] Brandt's theory is grounded in a psychological theory of motivation. Hoping to avoid basing his theory on controversial value judgments, Brandt wants to derive what is rational for a person to do from what she actually does or would do under certain ideal circumstances. To say that someone acts irrationally is to say that if she had subjected her own action to certain standards, she herself would have acted differently. According to Brandt, this judgment can be made without applying to the agent any value principles that she herself would reject.

Brandt's criterion of rationality has two parts. The first part takes a person's aims and desires as given and judges an action by determining whether the person has made the best use of available information in deciding what action will satisfy his desires. It is a test of the rationality of actions as means to desired ends. The second part addresses the rationality of ends. It focuses directly on the problem of irrational desires, for Brandt realizes that a person may act irrationally because his desires themselves are irrational. Brandt claims that a desire is irrational if it would cease to be felt after a person has undergone "cognitive psychotherapy." This is a process in which desires are confronted with repeated, vivid presentation of facts about the origins and nature of the desire itself. A desire is rational, Brandt says, if it would survive this process and irrational if would be extinguished by it.

Brandt's full criterion for a rational action, then, is that an action is fully rational if the desires from which it issues would survive "cognitive psychotherapy" and if the agent has used full information in choosing the means to satisfy his desires.

I am going to limit my discussion to the second part of Brandt's criterion, since my aim is to see whether means/end theorists can handle the problem of irrational desires. There is a symmetry, however, between the two parts of Brandt's criterion, for in each case, something (an action or a desire) is rational if it is maximally influenced by information. In discussing how one may subject desires to criticism and evaluation, Brandt states his main thesis:

> I shall call a person's desire, aversion, or pleasure 'rational' if it would survive or be produced by careful 'cognitive psychotherapy' for that person. I shall call a desire 'irrational' if it cannot survive compatibly with clear and repeated judgments about established facts. (113)

Recall that even Hume acknowledged that our desires could be aroused and dampened by what we believe. Brandt exploits this same point, arguing that many desires would be "extinguished" if the person who experienced them repeatedly drew his own attention to certain facts about those desires.

Brandt describes a number of types of "mistaken" desires to illustrate his theory. Some irrational desires rest on false beliefs and diminish or disappear when the beliefs are corrected. Brandt gives as examples the person who has an aversion to a food because she thinks it will make her ill and someone who pursues a particular career because he thinks that his parents will be disappointed if he does not. If these desires and aversions are deep, it may take counter-conditioning efforts to extinguish them, but these efforts can be effective. Nonetheless, just as Pavlov's dogs eventually stopped salivating at the sound of a buzzer when the buzzer no longer preceded food, so, according to Brandt, if a person constantly reminds himself that choosing a particular career will not please his parents, he will cease to desire it. The desire for the career will not extinguish, of course, if the person also enjoys the kind of work involved or finds it challenging. In that case, the desire would survive the process and thus qualify as rational (115–16).

A second type of mistaken desire is one that is unduly influenced by the attitudes of other people. For example, someone may have an aversion to an occupation because it is not prestigious, even though he enjoys the work and is well suited to it. Brandt calls this aversion "artificial" and claims that attention to his own needs, interests, and desires, along with reminders that the attitudes of others are less important than one's own, will help to extinguish the aversion and allow this person to follow his own "natural" desires (116–20).

A third type of mistaken desire or aversion develops from generalizing an atypical experience. Someone who was once badly frightened by a dog may have an aversion to all dogs. If she reminds herself of the low probability of being hurt by any specific dog and recognizes that her own experience was atypical, this will tend (with effort) to diminish the aversion (120–22).

Finally, Brandt notes cases where desires are exaggerated by early experiences of deprivation. People who grow up without the affection of parents or friends may have extreme desires to win approval and affection from other people. Or, people who grow up in poverty may be unable to spend money easily, even when they have more than enough. This is rather like the mistaken generalization cases, and people can gain control over excessive desires and aversions by seeing that their present tendencies result from situations that no longer hold and by reminding themselves of the facts of their present situation. This process may take time, Brandt says, but "vivid repeated representation of knowable facts should bring about a reduction in intensity" of these excessively strong desires and aversions (122–26).

While this sketch of Brandt's views may make him appear unduly optimistic, this impression is not correct. First, Brandt is surely right in thinking that our beliefs can and do influence our desires. Focusing on relevant facts often does have the kind of effect he describes. Second, he does not deny that much time and energy may be required to extinguish some desires and aversions. Finally, he does not claim that all "mistaken" desires and aversions will extinguish as a result of cognitive psychotherapy.

The fact that "mistaken" desires do not extinguish raises both a practical and a theoretical question. The practical question is "what should a person do about mistaken desires that do not extinguish?" The theoretical question is "should we classify a mistaken desire that does not extinguish as rational or irrational?"

Brandt answers the practical question by noting that it does not always make sense for a person to get rid of irrational desires. If the cost in time, energy, and money (for therapeutic assistance) is very high, it may be rational to live with one's irrational desires and aversions. This will depend, presumably, on how high these costs are and how much these desires interfere with one's other aims and desires.

Brandt answers the theoretical question by concluding that a desire that cannot be extinguished by cognitive psychotherapy qualifies as rational. He writes:

> If a desire will not extinguish, then it is not irrational. This result is consistent with the general view that a desire (etc.) is rational if it has been influenced by facts and logic as much as possible. Unextinguishable desires meet this condition. (113)

According to Brandt, then, unextinguishable desires are rational, no matter what they are desires for.

An important implication of this conclusion is that Brandt's catalog of "mistaken" desires is simply a list of illustrations. There is nothing necessarily irrational about any of them. If desires that rest on false beliefs, false generalizations, early deprivations, or undue influence of others cannot be extinguished by cognitive psychotherapy, then they are not irrational. For Brandt, there are no inherently irrational desires.

The Extinguishability Criterion

The key to Brandt's account is the "extinguishability criterion." Desires and aversions that would extinguish under cognitive psychotherapy are irrational, and those that would not are rational. While desires of the sort he catalogs as "mistakes" may usually extinguish under cognitive psychotherapy, they remain rational *for particular agents* if cognitive psychotherapy *would not* extinguish them.

The extinguishability criterion is a formal criterion of rationality, in the sense that it leaves it entirely open what things will be rational to desire. In this respect, it is like Rawls's criterion of full deliberative rationality, and Brandt's theory seems to suffer from a split similar to that found in Rawls. While Rawls offers a formal criterion of choice and value, he also describes a set of primary goods, specific things that any rational person is supposed to want. As we saw, however, the formal criterion of value does not require that one choose the primary goods. Similarly, Brandt gives both a formal criterion for the rationality of desires and a list of types of irrational desires. The criterion and the list are distinct, however, and the judgment that mistaken desires are irrational is independent of the criterion and may actually conflict with it.

Consider Brandt's case of the person who wants an academic career because his parents are academics and he thinks they want him to follow in their footsteps. Suppose that he is unsuited to academic life, that he does not enjoy the work, that his prospects are not very good. Finally, suppose that he learns that his parents do not want him to duplicate their career choice. In spite of this and after repeated efforts at cognitive psychotherapy, he continues to desire an academic career. The desire does not extinguish.

According to Brandt's formal criterion, we have to call his desire for an academic career rational, in spite of its unsuitability and the false basis on which the desire is founded. Yet, Brandt's account of how desires can be irrational because they are founded on false beliefs seems to provide strong grounds for judging this desire to be irrational.

We can imagine similar conflicts between the extinguishability criterion and the other examples in Brandt's account. In all such conflicts, it would not be absurd to conclude that the extinguishability criterion is less fundamental than the criteria suggested in the catalog of mistaken desires. That catalog, I believe, tells us more about irrational desires than the extinguishability criterion, but Brandt is committed to the centrality of the criterion within his theory.

Even though Brandt's extinguishability criterion is flawed, he is nonetheless correct that whether a desire will extinguish is an important fact about how a person should react to it. Suppose that a person has an irrational desire to smoke cigarettes, that she understands the health hazards involved in smoking, and that she even has a psychological understanding of why she has this desire. Suppose further that attempts to extinguish the desire fail and that whenever she stops smoking entirely, she feels utterly miserable. In such a case, it might make sense for the person to recognize that she simply cannot rid herself of this desire and to accept it as part of herself. While she might take steps to smoke less or to minimize the health hazards by using special filters or low-tar tobacco, giving up smoking might cease to be a rational option for her.

In this case, unextinguishability is important to determining how best to act. Yet, even here, we need not consider the desire to be rational. The fact that the person cannot get rid of the desire to smoke does not suffice to make it rational, even though it may make it rational to act on it. What this case shows is that there are situations in which it is rational to satisfy an irrational desire. It does not show that the irrational desire is rational. Even this case does not support Brandt's criterion.

Brandt's theory is one version of what Gert called "cool moment" theories, and for this reason, it is vulnerable to Gert's objection to such views. If someone develops a desire to kill himself in the most painful manner possible and if this desire cannot be extinguished, Brandt's view requires us to say that it is a rational desire, even though we might hold in general that suicide is only rational as a means toward avoiding a great amount of suffering or some other significant evil.

Is Benevolence Rational?

In addition to misclassifying certain irrational desires as rational, Brandt's criterion is open to the charge that it mistakenly classifies certain rational desires as irrational. It does this in cases where the desire in question proves to be extinguishable. Brandt discusses one such case which seems to cause him some discomfort. This is the case of benevolence, the desire to bring about happiness or well-being in others.

One of Brandt's points about benevolence is that a rational person need not be benevolent. While some might object to this claim, I will not. In any case, it should come as no surprise that Brandt denies that benevolence is required by reason, since his basic view is that no desires are intrinsically rational or irrational. My objection to Brandt is that we can imagine cognitive psychotherapy leading to the extinction of benevolence in someone, and in such a case, his view forces us to say that the person's previous benevolent desires had been irrational.

How might cognitive psychotherapy extinguish benevolence? Brandt considers the sympathy that we normally feel in seeing another person bleeding from injury and wonders whether

> repeated self-stimulation to the effect that another's blood is not connected with one's own pain would lead to at least partial extinction of sympathetic response. (144)

Brandt seems to doubt that such efforts would diminish benevolent desires in most people. Putting this empirical doubt aside, he addresses the central question: would benevolence be irrational if it were to extinguish? He answers that a

> person's benevolent responses . . . are irrational only if he *can* (causally) get rid of them by saying to himself things like 'His suffering does not hurt me.' Otherwise, they are rational. (145)

This reply reveals one of the errors in Brandt's account, the mistaken implication that when benevolence is extinguished in this way, the person involved becomes more rational. There is no reason to accept this conclusion.

Even if a desire turns out to be extinguishable, we may deny that it was irrational because the desire and the attempt to fulfill it played a positive role in a person's life. What Brandt's account overlooks is that we usually classify desires as irrational only when they are impediments

to a person's living well and engaging in worthwhile activities. If a normally benevolent person participates in an experiment to see if his benevolent desires are extinguishable and if the experiment succeeds, it is odd to think of this as a gain in rationality. Likewise, if a person is able to rid himself of his love of music, knowledge, or friends by repeating facts about the transience of human life, we would regard the waning of these desires as symptoms of decline. Yet, on Brandt's view, this process would indicate that these desires had been irrational all along, even though they had made a positive contribution to that person's life.

Finally, Brandt's criterion mistakenly implies that we are ordinarily ignorant about which of our desires are rational or irrational. Is my desire to see the Grand Canyon rational or irrational? Is my desire that my children live happily rational or irrational? These questions seem to have obvious affirmative answers, but they would not be obvious if Brandt's view were adopted because I do not know whether these desires would survive or extinguish in cognitive psychotherapy.

In fact, of course, our knowledge of whether desires or aversions are rational does not depend on judgments about extinguishability. This is especially clear in the case of the extreme aversions we call phobias. We know that excessive fears of heights, insects, open spaces, thunder, and many other things are irrational because we know that the object of the fear does not genuinely threaten the person's well-being and that the person with the phobia is capable of knowing that he is not genuinely threatened. Moreover, we know that the phobia itself contributes to distress and unhappiness for the person who suffers from it. All of these judgments are entirely independent of any knowledge of whether the phobia is extinguishable. People seek help for these aversions because they know that they are irrational, and they can know that they are irrational even if they doubt that the therapy will succeed in extinguishing their fear.[8]

Brandt's problem with irrational desires and aversions that do not extinguish is one form of the traditional problem of weakness of the will. People often fail to act in ways they know to be best for them. Yet, for means/end theorists like Brandt, it is impossible to suppose that a person could fail to want what is good, since the good is simply that which the person wants or would want when fully informed. The plausibility of this view (and the related reasons-as-motivators doctrine) is severely weakened by the fact that people often fail to do what is best, not because we do not know what is best but because we are lazy, tired, or depressed. That the best of reasons may fail to motivate, even under

ideal conditions of full knowledge, is a fact that no theory of rationality should overlook or deny.[9]

Summing Up

In this chapter, I have tried to show that means/end theories cannot adequately account for irrational desires. There do seem to be ends that no rational person would seek, as Baier and Gert argue.[10] Attempts by insightful thinkers like Rawls and Brandt to develop versions of the means/end theory that can distinguish rational from irrational desires have not succeeded.

One can, of course, continue to hold the means/end theory if one is willing to call killing oneself, burning one's arm, or signing away one's liberty for no reason rational acts. A theory of rationality ought not to yield such rulings, however, and it ought to be able to explain why such acts are irrational, even when people genuinely desire those ends.

10
Rational and Irrational Ends

> *It is therefore of the last importance, in the conduct of life, to have just opinions with respect to good and evil; and surely it is the province of reason to correct wrong opinions, and to lead us into those that are just and true.*
> —Thomas Reid

In criticizing the classical ideal of rationality, I argued that when we evaluate actions, we must look at their foreseeable results and not just the deliberative process that precedes action. Means/end theories seem to do this, but by accepting any result that is desired (or would be desired under ideal conditions), means/end theories ignore the substantive value of the results of actions. They focus on whether the results of actions are desired and not on whether they are worth pursuing. The failure of means/end theories shows, I think, that theories of rational action must focus on the value of the ends people seek.

This suggests that in order to know what is rational to do, we must know what is positively valuable. We must follow in the footsteps of Plato and Aristotle and seek to discover the nature of the good. According to Bernard Gert, this is a mistake. In Gert's view, reason allows the pursuit of many goals. Indeed, it allows us to do many things simply because we desire to. Where Gert parts company with means/end theorists is in putting some limits on the range of things we may rationally pursue. Some goals are necessarily defective. If we avoid these defective goals, however, then reason permits us to do what we like. For Gert, the ideal of rationality is essentially negative: the only thing reason requires is that we avoid acting on desires that are inherently irrational.

The Avoidance of Harm to Oneself

According to Gert, some things are intrinsically undesirable, and because of this, some desires are inherently irrational. Unlike other

philosophers, he does not try to provide an abstract criterion for identifying irrational desires. Instead, he simply lists the desires that are irrational. They are the desire for one's own death, disablement, pain, or deprivation of freedom or pleasure. Anyone who for no reason simply wants to die, be disabled, suffer pain, or be deprived of freedom or pleasure has an irrational desire. Each of these states is described by Gert as an evil, and the desire to suffer any of these evils is irrational.

As I noted earlier, Gert does not deny that in special circumstances, it can be rational to seek one's own death, disablement, suffering, and so forth. But one always needs a reason to justify doing so, and the only thing that counts as a reason is that by seeking one of these evils, one avoids a worse evil. So, for example, it is rational for me to undergo a painful medical procedure if this is the only way to avoid even greater suffering, disablement, or death. Even bringing about my own death could be rational if the alternative is "a fate worse than death" for myself or someone I care about.

Having listed the basic evils, Gert claims that the only desire that reason actually requires is the desire to avoid these evils. In his words,

> [T]he only things that we know are desired by all rational persons is to avoid the evils. Rational persons not only cannot desire evil, they must also desire to avoid it. They cannot be indifferent to whether or not they suffer evil.[1]

Avoiding evils for oneself is the basic and the only end that reason requires of everyone. Indeed, according to Gert, a person need not even strive for what is good in order to be rational. While reason does require that no one avoid what is good, it does not require efforts to achieve what is good. As he says,

> If one is not suffering, it is not irrational not to make an effort to gain a significant amount of additional ability, freedom, and pleasure. (50)

The avoidance of evil, not the pursuit of good, is the fundamental rational goal.

In making this point, Gert is making a value judgment but not a moral judgment. He is talking about what we might call prudential evil—harm to one's own well-being. Like Brandt, he denies that reason requires a concern for other people. Rational people may be benevolent, but they may also be indifferent to others or even malevolent, desiring

that others suffer evil. For Gert, while the desire to harm oneself is inherently irrational, the desire to harm others is not. Reason does not forbid acting on such a desire unless one sees that doing so will cause harm to oneself. People who harm others for no reason can justly be called cruel, callous, insensitive, and immoral, but they need not be irrational.

While we sometimes describe people who are totally lacking in concern for others and desire to harm others as sick, crazy, insane, psychopathic, or irrational, Gert rejects this judgment, arguing that concern for self is central to rational behavior in a way that concern for others is not. His point receives some confirmation from Herbert Fingarette's study of the concept of criminal insanity. Discussing whether a sane person must recognize the moral norms of society, Fingarette writes,

> I have been concerned primarily with the person's awareness of moral attitudes in society, not the question whether the person himself shares these attitudes or acts in conformity with them. For he may be aware of them but uncommitted to them; and he may take them into account, but only in order better to plan how to violate the communal morality without being detected or punished. Nevertheless, the awareness of those moral attitudes and laws, the ability to discriminate among them *in order to conduct a minimally prudent daily life*, is a prime psychiatric criterion of contact with reality and of an intact ego.[2]

What is basic to rationality in this view is the desire to protect oneself and the ability to assimilate information that is required for protecting oneself. A rational person need not be directly concerned with the welfare of others.

Having noted this, it is important to add that Gert regards benevolent desires as perfectly rational, in the sense that they are allowed by reason. There is nothing irrational about desiring another's well-being or acting to enhance it. Indeed, one type of reason that justifies allowing oneself to suffer some evil is that doing so will prevent evil to other people or produce some significant good for them. Gert does not deny that social and personal concerns can play a central role in the lives of rational persons.[3]

In addition, unlike Harman and other internalists, Gert does not require that reasons motivate people in order to be reasons. In particular, moral reasons can provide "external" reasons for actions, grounds that require actions a person has no desire to do or that forbid actions

that a person wants to engage in. Moral reasons can apply to people who do not apply them to themselves.

Overall, then, Gert's view contains three key components: a list of irrational desires, an emphasis on avoiding evil (as opposed to seeking good), and an emphasis on concern for self (as opposed to others). The power of Gert's view comes from the skill with which he focuses on what are widely regarded as basic evils. It is hard to deny that it is irrational for anyone to want to suffer death, pain, disablement, deprivation of freedom, or deprivation of pleasure.

The Status of Gert's Theory

While Gert makes many plausible and insightful points, he avoids offering a general theory in which to place these points or an overall justification for his views. Indeed, he seems to think that neither of these is possible, that once he has listed the basic evils and the corresponding irrational desires, nothing more can be done because nothing is more basic than they are.[4]

Gert does note the relationship between his list of irrational desires and the notion of self-interest, but he does not think this link provides any additional support for his list. He writes,

> The concept of self-interest, if it is not intolerably vague, must be explained by referring to what I have called irrational desires and reasons. (39)

While Gert would not reject an equation of his list with the fundamental ways in which a person's interests may be harmed, he thinks his list is basic and cannot be justified or explicated by reference to self-interest.

I think that the concept of *interest* is useful here. It helps in both bringing out the plausibility of Gert's view and in making clear how his view differs from means/end theories. For means/end theorists like Harman, Rawls, and Brandt, it is our desires, goals, and aims that provide the basis for judgments concerning values and rational choice. It is the fact that a person wants something and includes it among the aims in his life plan that confers value on that thing. Like other Humeans, they advance a "desire-based" theory of reason and value.

Gert rejects desire-based theories because he believes that some desires are intrinsically irrational. His central insight is that it can be contrary to people's interests to have their most important desires

satisfied. It is our interests rather than our desires that provide the basic criteria by which to assess the rationality of actions. If someone knows that an action is contrary to her interests, then—barring special justification for performing it—it is irrational for her to perform that action. Moreover, simply wanting to perform the action does not provide the kind of special justification that might render the action rational.

The crucial fact about interests is that they are objective in ways that desires are not. While desires are an aspect of one's psychological state, interests are not entirely dependent on psychological facts. I can even have interests of which I am totally unaware and that I have no motivation to promote. Desires, on the other hand, are typically (though not invariably) things of which we are aware and are inherently motivational. While I may have no desire to consult a doctor, it may nonetheless be in my interest to do so. If I have no symptoms and am ignorant of a developing threat to my health, I may have no reason to believe that I ought to see the doctor, and yet it could be in my interest to do so. While means/end theorists would define interests in terms of desire, these examples show this to be a mistake. Interests, then, possess a degree of objectivity that desires lack and provide a more proper basis for assessing the value of particular actions to a person. If I know that an action is in my best interest, then it is rational for me to do it, even if I have no desire to.

I believe, then, that talk of interests may be illuminating in a way that Gert does not acknowledge. Nonetheless, this difference is not substantive, for we both agree on the independence of interest from desire.[5]

There are other, more serious problems with Gert's view, however. In order to expose them, I want to discuss three choices involving masochism, suicide, and a rather odd life-or-death situation. By considering these cases, we can both uncover some defects in Gert's view and come to a better understanding of what makes irrational desires irrational. As we will see, rationality requires more than the mere avoidance of evil. It requires acting to produce results that have positive value.

Masochism and Suicide

Gert classifies the desire for pain as an irrational desire, but he thinks it can be rational for a masochist to act on such a desire if he enjoys having

pain inflicted on himself (31). This is not a foolish position to hold. If we imagine a person who finds the experience of pain gratifying, it might be rational for that person to undergo painful experiences. Yet, this particular liking is not merely odd. It seems different from, say, a taste for odd combinations of food. More important, however, Gert's allowing the rationality of seeking pain for the pleasure it produces suggests that he would have to make the same concession for all of the other evils, excepting death. A person might enjoy being disabled, enslaved, or deprived of opportunities and pleasures. Yet, surely, there is something about such desires that is as pathological as the desire of the person who wants to die painfully. Once Gert allows for the rationality of masochistic desires, it is not clear that he can preserve his general view of irrational desires and evils.

If it seems psychologically impossible that a person might enjoy these various deprivations, it might help to imagine such a case in more detail. Imagine a person who is filled with guilt and self-hatred and whose only satisfaction comes from being treated in contemptuous and abusive ways. Thinking himself worthy of abuse, he enjoys being maltreated. The maltreatment he seeks might take the form of beatings and physical pain, but he might desire to be deprived of liberties, powers, and opportunities.

The sharp demarcations proposed by Gert appear to dissolve when we imagine such cases more fully. Consider a person M who comes to have a desire for pain. He realizes that such a desire is irrational and initially does not act on it. However, the desire becomes both stronger and more persistent, and eventually the tension generated by this unsatisfied desire makes it impossible for M to engage in other activities. Finally, he arranges to be beaten in a painful but noninjurious manner. He suffers through the process, but emerges feeling quite relieved, free of tension, and able to live normally. After a time, however, the desire to suffer arises again and becomes increasingly strong. M again decides that he can only tolerate his existence if he is beaten. He arranges another beating, emerges relieved once more, and is able to resume his normal life.

When M once again begins to feel his masochistic desire, he reasons that unless he acts on it, he will only endure a great deal of tension and will finally have to succumb to the desire. He decides both to arrange to be beaten and to make this a regular part of his life. Given his situation, this decision seems quite rational. Gert, I expect, would claim that his

view can handle this case, that M has a good reason for undergoing the beatings. It is as rational for M to undergo periodic beatings as it is for most of us to visit the dentist. Why? Because reason allows one to endure pain in order to avoid greater pain.[6]

The problem for Gert is that the mere persistence of a desire should not by itself change its status from a desire that it is irrational to satisfy to one that is rational to satisfy. According to his view, nothing about the strength, persistence, or intensity of desire can make it rational to act on, but this appears to be false.

Gert's original counter-example to the cool moment theory involved a man whose most important desire was the desire to die. Would we not have to agree that suicide could be rational for him? If this were his most important desire, might not his continual frustration be so severe that it would be impossible for him to live well? Would it not be rational for him to take his own life? Common sense, I think, would allow this. The difficulty for Gert is that mere persistence and intensity change the status of the person's desire in a way that should not be allowed by his theory.

I think that the key to understanding the situation of both the masochist and the suicidal person is the recognition that both would be better off without those desires, that having these desires is against their interests. If either M, the masochist, or S, the would-be suicide, has a choice between satisfying his desire (through beatings or death) or ridding himself of the desire (through some sort of treatment), the choice of the treatment would clearly be the better and more rational one, the one most in his interest. Nonetheless, a person in such a state might be so caught up in his desires that he would refuse treatment. This choice would be irrational.

Gert's original example of the person who wants to die for no reason oversimplifies the issues in two ways. First, it does not tell us anything about the effect of having this desire on the person's life. If it is indeed a strong desire, then normal life is going to be difficult. Second, Gert's description does not refer to the other options available to S. In his second example, that of the person who wants to die in the most painful manner, Gert mentions that he also has a weak desire to see a psychiatrist. This fact makes the example much more powerful. It is not an incidental detail, for it implies that there are alternatives available and that S may be able to free himself of the desire without satisfying it.

The rational choice is the one with the best foreseeable consequences. If S can be expected to know that a treatment is possible, reason requires

that he prefer the treatment. If treatments exist, but he has no way of knowing about them, he may be rational to choose death as the best solution to his problems. What is rational to do and what is in S's interest are functions not simply of his desires but of his general interests and the range of options available to him. Gert correctly emphasizes the independence of S's interests from his desires, but he does not stress that what is rational for a person to do always depends on what other options the person has.

What makes suicidal and masochistic desires special is that anyone would normally be better off without them. Given a choice between satisfying these desires and getting rid of them, one would always be better off getting rid of them. Irrational desires are desires whose satisfaction is obviously detrimental to the agent.

With this in mind, we can better understand the importance of Brandt's notion of extinguishability. Irrational desires are those that a rational person would prefer to extinguish rather than to satisfy. If they turn out not to be extinguishable, however, it may be in a person's best interests to act on them. The harm done by acting on the desire may be less than the suffering that results from struggling against it. Consequently, whether a desire is extinguishable is an important fact in determining how it is rational to act. Contrary to Brandt, however, extinguishability is not the criterion of irrationality. The criterion is whether extinction is preferable to satisfaction.

What makes a desire irrational is that its satisfaction is generally harmful to a person's overall interests. All of the types of irrational desires described in Brandt's catalog of mistaken desires and aversions can be accounted for by this view. Desires that result from false beliefs, mistaken generalizations, and undue influence of other people, as well as those that are excessive because of early deprivation are usually irrational because seeking their satisfaction is likely to diminish the well-being of the agent.

Consider Brandt's example of a person whose irrational fear of dogs is based on an early frightening experience. This strong aversion to dogs is a matter of concern because it may deprive him of pleasures, forcing him to avoid activities he would enjoy (taking walks, bicycling) and causing him needless stress and suffering. Likewise, the undue influence of parental attitudes toward particular careers is irrational because it may make a person choose a career that will be less satisfying to him than some other. These and the other cases Brandt discusses are all instances

of desires that interfere with the agent's pursuit of his own well-being. It is not simply their causal history or their extinguishability that makes them irrational. It is the fact that the agent knows that what he desires will not promote his interests.

Rawls's account of primary goods can also be accommodated by this view. Given the general facts of human nature, the primary goods almost always enhance a person's life. Depriving oneself of them is irrational not simply because it interferes with one's life plan but because it diminishes one's well-being. A life plan that requires giving up the primary goods is almost always one whose successful outcome would itself be harmful.

The cases of masochistic and suicidal desires help us to see several key points. First, Gert is correct to argue against the view that what is rational to do is entirely a function of what one desires. Second, he is incorrect in overlooking the fact that the persistence and intensity of desires are relevant to whether an act is rational. They are relevant because of their effects on a person's overall well-being. Acting on what he calls irrational desires can be rational even in cases where he suggests it would not be. Finally, once we understand that irrational desires are desires for what is contrary to a person's interests, we can see what is plausible in both Brandt's and Rawls's theories. We can also see the source of their failings: They do not allow for discrepancies between what people desire (or would desire under optimal circumstances) and what is genuinely in their interest.

The Anhedonic Man

There is another defect in Gert's account that can be approached by considering a rather extreme situation. Imagine a person A, who is suffering from the disease "anhedonia," the inability to derive pleasure or satisfaction from anything. William James quotes the following description of an anhedonic man from a work by the French psychologist Ribot:

> Every emotion appeared dead within him. He manifested neither perversion nor violence, but complete absence of emotional reaction. If he went to the theatre, which he did out of habit, he could find no pleasure there. The thought of his house, of his home, of his wife, and of his absent children moved him as little, he said, as a theorem of Euclid.[7]

We can imagine A sinking slowly into this state and being distressed by it at first, as he realizes that things that had been important to him have ceased to matter. Finally, however, he becomes indifferent to his indifference and does not even suffer from boredom.

Would it be rational for such a person to kill himself? If he is not suffering, Gert must say that suicide would be irrational, for on his view, choosing to die can only be justified as a way of avoiding some evil or bringing about some good. Yet, it is hard to see why a life of total indifference would be preferable to death. If total indifference is no better than death, then there appears to be no basis for condemning this choice as irrational.

The judgment that suicide would be rational for this person depends on a crucial assumption, however. There must be reason for A to believe that his anhedonic state is permanent. If he knows that his condition can be altered, it would not be rational to kill himself, for doing so would deprive him of the satisfactions of normal life.

Let us suppose A to be in the following situation. After a time, he develops a desire to kill himself, and this is the strongest desire he has. He learns, however, that his condition can be altered through some form of drug therapy. The options he has before him are these:

(1) he can kill himself;

(2) he can take a pill that will relieve him of his suicidal desire and return him to a permanent anhedonic state (i.e., it will destroy both his suicidal desire and his capacities for satisfaction);

(3) he can take a pill that will both destroy his suicidal desire and restore his capacities for deriving satisfaction from life.

Which is the rational choice for A?

I think that option 3 is clearly in A's best interest and that it is, therefore, the rational thing for him to do. Because of his anhedonic condition, however, A himself will have no desire to choose option 3, even though he is aware that it will restore his capacity to lead a normal, satisfying life.

The choice A would make is option 1, since his only desire is for death. This choice, however, is not in his best interest and is irrational. Since A's only desire is for death, a means/end theorist will have to agree that option 1, suicide, is the rational choice for him. This seems to me to be clearly mistaken.

Gert's view commits him to saying that it would be equally rational for A to choose either option 2 or option 3. Why is this? Because Gert claims that reason does not require one to act for the good. Reason only

requires that one act to prevent evil. It seems obvious, however, that if A chooses to continue living, he is much better off taking the pill that restores his capacities for satisfaction rather than the one that leaves him in an anhedonic state. Gert's view, however, does not require that A make this choice.

Gert might reply that by refusing to take option 3, the anhedonic person is depriving himself of pleasure and thus is acting irrationally. I do not think this reply is available to Gert, however, since he wants to hold in general that reason does not require the pursuit of what is good. Yet, if a failure to do what is good always counts as a case of depriving oneself of that good, then Gert's emphasis on the importance of avoiding evil simply collapses into the view that we should pursue what is good. While I believe this to be the proper conclusion, for Gert to acknowledge it would deprive his theory of one of its central distinguishing features, the assertion that rationality is essentially connected with avoiding evil rather than with seeking good.

The central lessons that I draw from this case are as follows: Reason does not simply require that we act in accord with the negative goal of avoiding evil. Neither does reason simply require that we act in accord with our desires. Rather, reason requires that we choose the act with the best foreseeable consequences. Acting for the best is the goal that reason requires.

Summing Up

In this chapter, I have tried both to explain the nature of irrational desires and to clarify the goal that reason sets before us. Irrational desires, I have argued, are desires for things that are harmful to the agent. For this reason, people would be better off getting rid of their irrational desires rather than satisfying them. Second, the goal reason sets before us is that we act for the best, that we perform the act with the best foreseeable consequences.

To say that reason requires acting for the best is likely to inspire one of two conflicting reactions. Some may find this view to be entirely trivial and uncontroversial. Yet, as we have seen, means/end theorists deny this, as does Gert, who claims that reason only requires avoiding evil. On the other hand, some may find this view totally problematic. What, after all, is the best? What things are of value? And whose best

must be pursued? That of the person acting? That of some specific groups? All human beings? All sentient beings?

Obviously, these questions need to be addressed. The difficulty of these questions is one of the chief attractions of the means/end theory, since it determines what is best by looking to what people actually desire. This, however, we have seen to be unsatisfactory.

PART IV

ACTING FOR THE BEST

Introduction

> *Granted, then, that "What shall I do?" is a request for a value judgment, namely, "What is the best thing to do?" we have to ask ourselves by what criteria we are supposed to judge which of the courses open to the agent is best.*
>
> —Kurt Baier

I have argued that it is irrational to act in ways that one knows will have less good results than other possible actions. A person who knowingly fails to act for the best, then, is acting irrationally.

But what is "the best"? It is plausible to think that what is best for people is determined by what they desire, but we have seen that this answer is unsatisfactory. Another perennially attractive answer is given by hedonists, who claim that pleasure is the good no rational person would fail to seek. According to this view, to act for the best is to act in the way that is most likely to produce the most pleasure.

Opponents of hedonism claim that it is a defective theory, arguing that it cannot account for human ideals and for the value of virtuous traits of character. According to them, what is best for human beings does not consist simply of pleasurable experiences, and therefore, a rational person would not simply choose a life of pleasure.

It is to these issues that the next chapters will move, since it appears that a theory of rationality cannot avoid the question of what things are worth pursuing.

11
Pleasures and Values

> *We can only justify to ourselves the importance that we attach to any of these objects by considering its conduciveness, in one way or another, to the happiness of sentient beings.*
> —Henry Sidgwick

If acting rationally is acting for the best, then in order to act rationally, we must know what makes the results of actions valuable. According to hedonism, while many things are valuable, only one thing is valuable for its own sake—pleasure. Other things are valuable only insofar as they produce the experience we call pleasure, satisfaction, or happiness.

Hedonism is a theory of value rather than a theory about rationality, but it has direct implications for our understanding of rationality. In telling us that pleasure alone is valuable, it tells us that rational people will pursue pleasure. That is the goal that reason requires. To act for the best is to act so as to maximize the pleasure experienced either by oneself or by others.

The fact that this inquiry has led to a consideration of hedonism is cause for both satisfaction and distress. It is a cause for satisfaction because hedonism is a perennially attractive theory that goes back to the Greeks and that has been defended by such important thinkers as Jeremy Bentham, John Stuart Mill, Henry Sidgwick, and C. I. Lewis.[1] Because of this, it is likely to contain significant insights. Nonetheless, our arriving at hedonism is cause for distress because the theory has been subjected to criticism since ancient times and is widely regarded as a defective view. In this chapter, I will try to make clear both why hedonism is attractive and what its limitations are.

Hedonism says that the creation of pleasurable states of mind is the aim that rational persons will pursue. Moreover, it tells us that reason requires that we always choose more rather than less pleasure. To choose the lesser of two pleasures in any instance is to fail to act for the best. In

addition, pain, unhappiness, and dissatisfaction have negative value and are always to be avoided because they detract from a person's well-being.

This view is, in effect, a utilitarian theory of rational action. Utilitarians have stressed the maximization of good consequences as the goal of morality and have assumed that in cases of nonmoral choice the same criterion would show which actions are rational to perform. While hedonistic utilitarians hold that pleasure is the only intrinsically good consequence of action, ideal or pluralistic utilitarians hold that things other than pleasure—such as knowledge, truth, virtuous character traits, or beauty—are intrinsically valuable. The theory I am considering is a hedonistic utilitarian theory of rational action.

In drawing a contrast between hedonistic and ideal utilitarians, I do not mean to suggest that hedonists deny the value of knowledge, virtue, love, beauty, or other recognized goods. They insist, however, that the value of all these things is derivative, that they owe whatever value they possess to their tendency to produce pleasure. While hedonists have been accused of holding a philosophy fit for pigs, they can in fact grant the value of the noblest goals and ideals, since the latter are capable of producing satisfaction in the minds of people.

The Lure of Hedonism

Hedonism is attractive for a number of reasons. First, although it says that there is one single thing which all people should pursue, it is capable of recognizing the great plurality of things that are good for human beings. Anything capable of producing pleasure, satisfaction, or happiness is good, and, as we know, many things yield these benefits. Likewise, because different things produce pleasure for different people, hedonists can acknowledge the variations in value that things have for different people while at the same time insisting on the underlying unity of all goods.

In addition, if all things possess their value in relation to the pleasure they produce, we can use a single criterion to judge the most diverse sorts of goods and to evaluate actions. How can things as different as milkshakes and Beethoven symphonies be compared? Simply by considering how much pleasure they produce. That which produces more pleasure is more valuable. If the amounts of pleasure produced varies in different people, milkshakes may be more valuable for some people and Beethoven symphonies more valuable for others. If one action is likely to

produce more pleasure than another, the more pleasure-productive action is the more rational one to perform. If this judgment seems to be that of a cultural philistine, consider whether it would be better to provide a six-year-old child with a milkshake or a recording of a Beethoven symphony. As we saw earlier, when considering whether something is good, we have to consider who it is good for. Some things can be very valuable without being good for all people.

By reducing all evaluations to a common scale, hedonism promises the possibility of an objective decision-making procedure. Once we agree on the goal of maximizing pleasure, we can make decisions by considering the amount of pleasure any given action is likely to produce, the probability of its successfully producing that pleasure, and the "costs" (in time, effort, money) in producing it. We then compare the "expected utility" of the action with the expected utility of other possible actions. The action with the highest expected utility is the rational action to perform. The most famous of utilitarian decision-making theories is Jeremy Bentham's "hedonic calculus," but there are contemporary thinkers who continue the attempt to quantify these judgments in order to make them precise and scientific.[2] Even if such calculations can only be carried out in rough fashion, Bentham's project continues to appeal both to practical people in search of authoritative ways to make decisions and to philosophers enamored of the prospect of demonstrating truths about values.

Desires and Satisfactions

Classical hedonism is not a desire-based theory. The hedonist's test of value is not whether someone desires something but whether it produces pleasure. Desires may provide the motivation to act, but they do not by themselves confer value on their objects. This is clear from the fact that we can get what we desire and still feel disappointed and unfulfilled. An object of desire may fail to produce the good we had sought from it.

Some contemporary utilitarians claim that what we want to maximize is the satisfaction of our preferences and desires. They think this frees them from problems with classical hedonism, but such preference theories are simply versions of the desire-based, means/end theories of rationality that I have criticized.[3]

These desire-based theories of value may derive some of their plausibility from the ambiguity of the word "satisfaction," which can

mean either the (mere) attainment of what one had wanted or a positive experience of fulfillment or pleasure. Once we see that a person can satisfy a desire and yet not feel satisfied, it becomes clear that what we really value for itself is satisfaction in the sense of pleasure or fulfillment. We value the (mere) satisfaction of desire because we believe it will produce a positive experience of satisfaction in us.

The fact that desire and value are only contingently related can be seen in two ways. First, there is no contradiction in imagining a person who experiences deep dissatisfaction, even though all of her desires are satisfied. Second, we can experience satisfaction or pleasure from things that we never wanted or tried to produce. One need not desire to see a sunset in order to enjoy its beauty.[4] So "preference utilitarians" are wrong to identify what is good with the (mere) satisfaction of desire.

In practice, of course, people's desires are often based on past experiences that reveal what is satisfying for them. Moreover, as Rawls points out, there is a satisfaction that often results from the successful carrying out of one's plans, since this can enhance a person's confidence in her abilities and produce increased self-respect. Nonetheless, the connection between what we desire and what is truly satisfying is contingent. Talking about the satisfaction of desire makes desires look more central to the theory of value than they are. Once we see through the ambiguities, it becomes clear that experiential satisfaction stressed by traditional hedonism is more central than the satisfaction stressed by desire-based theories. It is the psychological capacities for experiencing positive satisfaction on which human values rest.[5]

Objections to Hedonism

As we have already seen, the fact that a theory successfully solves a number of problems need not rule out its possessing other features that make it unacceptable. For this reason, it is important to look at some of the common objections to hedonistic theories of value.[6]

It is frequently objected that not all pleasures or satisfactions are valuable. A common example of a pleasure that lacks value is the enjoyment of other people's suffering. If the enjoyment of suffering is not good, then it is incorrect to equate value with pleasure.

This objection seems to miss the mark. While we might condemn sadistic pleasures from a moral point of view, the question here is whether satisfying experiences are of value to the person experiencing

them. If a person takes pleasure in others' suffering, the experience would be valuable to him, and he would be rational to choose it over other less satisfying experiences. It may not be morally good, but it can still be good for that person. This is no different from the fact that a thief may be better off after his crime, even though he has improved his situation by immoral means. If sadism, callousness, or righteous indignation cause someone to take pleasure in the suffering of others, that pleasure enhances the person's well-being and may be rational to seek.

A second common objection to hedonism is that satisfactions are not really measurable, and thus that any form of quantitative hedonism requires impossible judgments and comparisons. While I agree that measurements of satisfaction and dissatisfaction may be extremely crude, they are not impossible. People choose chocolate over vanilla, Bach over Jerry Lee Lewis, and dental work with novocaine rather than without on the basis of judgments about amounts of pleasure and pain. Similar judgments are made in more complex cases like the choice of a profession or a place to live. Admittedly, these calculations are crude. We cannot tell in advance just how much satisfaction one kind of situation will bring. Nor can we know just how probable it is that a particular option will succeed. We are often reduced to hunches and feelings as bases of choice, but even these are far from blind leaps. The role played by estimates of satisfaction may be clearer when we look at the options we easily rule out rather than looking at choices between front-runners. I may not know whether I will be happier as a philosopher or a historian, but I have good reason to believe that either would make me happier than being a coal miner, a migrant laborer, or a trapeze artist.

Estimating satisfactions is a useful activity that we frequently engage in. Even if an exact calculus of pleasures is impossible, this no more discredits our usual utility estimates than the impossibility of faster-than-light airplanes discredits all airplanes.

Given the difficulty of making careful utility calculations, a rational person may content herself with results that are satisfactory without worrying about whether they are the very best possible results. If she knows that A is better than B, reason requires trying for A. But if she knows that B is quite good and is not aware of other options, it may be rational to let matters rest and not seek to discover still better results. People can act for the best without engaging in vigorous investigations to discover the very best options.

A third objection to hedonism is that the notion of satisfaction is so

vague that any theory that defines rational self-interest in terms of satisfaction is vacuous. To say that reason requires the pursuit of satisfaction tells us nothing because it does not tell us which things are satisfying.

I agree with the letter but not the spirit of this objection. It is a virtue of hedonism that it accounts for the plurality of things worth pursuing. Since people differ in their capacities for satisfaction, there are many different things that different people will be satisfied by and that they ought to pursue. One who can take pleasure in the beauty of an argument or the quest for truth would be foolish to limit herself to the pleasures that nonhuman animals are capable of. The multiplicity of possible sources of human satisfaction means that the hedonist's principle cannot *by itself* tell us what to do. Coupled with a knowledge of both our particular capacities for satisfaction and the various activities and objects we might pursue, however, it can direct us toward a rational pursuit of a good life.

Does Hedonism Rest on a Bad Pun?

The objection I have just considered can be pursued further, for one may feel that the hedonist's ability to recognize so many sorts of values casts a suspicion on whether the doctrine has any meaning at all. Hedonists always begin by saying that pleasure is the only good and pain the only evil, and we seem to understand them because we think of pleasure and pain as definite sorts of sensations. In trying to show, however, that hedonism does not limit what is valuable to physical pleasures, hedonists expand the doctrine to include anything from which people derive satisfaction or happiness. This sounds quite fine until one begins to wonder whether there is any single experience that occurs whenever a person is happy about something or takes satisfaction from it. Is there one good that we experience as a result of doing a job well, eating a favorite food, helping a friend, or having high self-esteem? Is there one sort of experience that occurs whenever we take satisfaction from diverse events and states? If so, the hedonist should describe it to us. If not, it may be a sham to suggest that the theory locates all value in one sort of thing.[7]

This objection raises genuine and difficult problems for hedonism, although I am not sure that it undermines the theory. Because the issues

involved here are quite large, I shall only indicate a direction of thinking that the hedonist could use in reply.

First, I think it can be conceded that hedonists have been too casual in their use of terms. "Pleasure" and "happiness" are certainly not synonymous. In particular, it is important that happiness is not essentially a feeling that comes and goes. When we say of someone that she is happy or has a happy life, we are not simply attributing a sensation to her. On this point, the critics are correct. Nonetheless, we do talk of "feeling happy," and this is a state of mind one can experience.

Of course, feeling happy and being happy are not the same. Real happiness must meet the requirement of duration. A person would not *be* happy if her moods switched daily from extreme elation to extreme depression. Nonetheless, there are important connections between being happy and feeling happy. We would not describe someone as a happy person or say she had a happy life if she never *felt* happy. Moreover, if someone felt happy most of the time, it is not clear that it would make sense to say that she was not really happy after all.[8]

For these reasons, it is plausible to think that there is an experiential component to being happy that does make happiness a close relative of pleasure and satisfaction. Sidgwick used the general phrase "Desirable Consciousness" to cover the various sorts of positive experiences that possess intrinsic value, and he had enough confidence in introspection to think it obvious that such states could be picked out by intelligent persons. Hastings Rashdall, who was himself a critic of hedonism, agreed with Sidgwick on this point. His introspective efforts convinced him that

> When we compare the glow of satisfaction which *sometimes* attends a conquest over temptation, we feel at once that the resulting feeling has something in common with the state of mind into which we are put on other occasions by a cup of tea.[9]

This kind of judgment will strike many people as quaint and foolish. Introspection, long taken to be the clearest instance of a mental power, has been attacked by the major movements in twentieth-century philosophy and psychology. So, it is hard to appeal to introspection to confirm the truth of hedonism.

Nonetheless, I do not think that the hedonist's point can be decisively refuted. First, while some people argue that there is no one common element present in all satisfying experiences, this judgment

itself depends on introspection as much as the judgment that there is a common element. Second, even if various kinds of pleasure differ significantly, that need not show that it is wrong to call them all pleasures. Certainly pains differ significantly in what they feel like, and yet, there seems to be no reason not to classify them together under a single concept. The same may be true of pleasure.

William Alston has suggested that it is misguided to look for some single, conscious quality that distinguishes pleasure from other experiences. He has urged a motivational theory of pleasure according to which pleasures are simply those experiences one *prefers* and thus would be motivated to experience.[10]

The trouble with this suggestion is that it appears to lead us back to desire-based theories of value. A motivational theory of pleasure does not take irrational motivations into account and thus overlooks the possibility that someone might be motivated to produce or continue a painful state. What traditional hedonists want to say is that it is the goodness of the experience that leads people who are rational to seek its continuation. The motivation to seek continuation is a result of the pleasantness of the experience, not what is meant by calling it pleasant.

Does Value Reside in the Mind?

In a probing discussion of the nature of value, David Wiggins tries to refute all theories of value that "locate all ultimate or intrinsic value in human appetitive states" such as desires and experiences. For Wiggins, objects in the world are equal partners in the "conceptual structure of value," and our ability to benefit from them depends on our thinking of them as having a value that is independent of their relation to us.[11] He illustrates his point by discussing the experience of a man who unexpectedly comes upon a breathtaking view of a mountain range.

> The sight of them . . . entrances him. In marvelling at the valley and mountains he thinks only how overwhelmingly beautiful they are. The value of the state [i.e., his own psychological state] depends on the value attributed to the object. But the theory which I oppose says all non-instrumental value resides in the man's own state, and in the like states of others who are actually so affected by the mountains. (105, n. 19)

In rejecting theories that make value depend on our experience, Wiggins concludes that

> No appetitive or aesthetic or contemplative state can see its own object as having a value which is derivative in the way which is required by the thesis that all non-instrumental value resides in human states of satisfaction. (105)

As we have seen, hedonism (as well as desire-based theories) makes value dependent on human mental states. If Wiggins is correct, the theory is fundamentally flawed.

Wiggins's objection combines two separate points. First, he thinks that hedonism denigrates the value of objects in the world by reducing it to a feature of ourselves. This, he thinks, conflicts with our ordinary belief that the majesty of mountains, for example, is independent of us, that we do not make the mountains majestic through our response to them. Second, he claims, our ability to take satisfaction from the world presupposes that we view it as objectively valuable, apart from our own experiences. If we felt that we bestowed the quality of majesty on the mountains, they would cease to be majestic for us. This second argument is a version of what Sidgwick called the paradox of hedonism.[12] Sidgwick thought that if people pursue pleasure alone and view everything else as mere instruments for attaining pleasure, they will actually decrease their chances of getting pleasure from things. For Wiggins, then, hedonism and other psychological theories of value are both inconsistent with our ordinary experience of value and self-defeating.

I believe that hedonists can rebut both these charges. Hedonists do not deny that the qualities that make objects valuable are to some degree independent of us. The qualities that produce satisfaction, pleasure, or aesthetic delight in us exist independently of our minds. Such features as the size, shape, and color of the mountains, the features that account for their grandeur, would belong to them whether or not any humans perceived them. Moreover, though hedonists stress the capacity of humans to derive satisfaction from things as the basis of value, it is equally necessary that objects have the capacities to produce these states in us.

Value is objective in the sense that objects would possess these qualities even if people lost their capacity to respond with satisfaction. If I am tone-deaf or insensitive to natural beauty, I might well regard this as a defect in me and lament the impoverishment of my life. Given that we know that certain things can enhance human life, we can think of their value as external to us because we can imagine that people might fail to derive satisfaction from them, and in such cases, we would regard

the people as less well off, rather than regarding the objects as devoid of value.

What about Wiggins's charge that hedonism and other psychological theories of value are self-defeating? Wiggins claims that we can only derive satisfaction from things if we "attribute" value to them. But surely this is false. The person who is enchanted by the beauty of the mountains may simply respond to it without having previously believed that natural beauty had any special value. According to C. I. Lewis, we learn what is valuable by noting what objects cause valuable experiences in us and then seeing that the object is a reliable source of such experiences. We begin with an immediate liking and only later "attribute" value.[13]

It may be that there are cases where the process is reversed and satisfaction follows a judgment of value, as when people cultivate a taste for something. Even here, however, the belief that something is valuable is not what brings about the capacity to take satisfaction from it. One does not come to enjoy the works of Picasso or Magritte simply by strengthening one's belief in the greatness of their art. Believing that something is valuable is not sufficient for experiencing its value.

Instrumental Value

Wiggins's third objection is that it is presumptuous for human beings to think of states of ourselves as the only inherently valuable things and to regard all else as merely instrumentally valuable. This point, which has recently been stressed by environmentalists, strikes a sympathetic chord in many.

In responding to it, it is important to see that the phrase "instrumental value" is a technical term whose connotations may be somewhat misleading. While the class of things to which hedonists attribute instrumental value is very broad and diverse, the words "instrumental value" call to mind tools and utensils, especially ones that we do not care for deeply. Such things as thumbtacks, typewriter ribbons, hammers, and subway tokens are objects that we use but have no personal attachment to. We would just as soon do without them if they were unnecessary, and we do not care about individual instances of these objects. Any subway token or thumbtack will do.

Our attitudes toward other sources of satisfaction are very different,

however. Feelings about other people are the most obvious case. If people enrich my life experience, I may feel love, affection, gratitude, respect, or even reverence for them. Though my valuing of them is instrumental in the technical sense, it is quite different from that associated with tools and utensils. This is so even if the purpose of a relationship is to provide pleasure. People often choose to marry, form friendships, or have children because they believe it will make them happy. This motive, however, need not prevent them from developing deep emotional ties to others or sacrificing their own satisfaction in order to benefit those they love. None of this is incompatible with a hedonistic theory of value.

Given the satisfactions of love and friendship, people often count the welfare of others as equal to their own. If they feel this way, their judgments about which acts have the best foreseeable consequences will be based in part on the effects of acting on people they care for, as well as themselves. Since hedonism places intrinsic value in the satisfying experiences of people and other conscious beings, there is nothing in the hedonistic theory of value that prevents this extension beyond the self. Hedonists need not be egoists.

Finally, the misleading connotations of the phrase "instrumental value" can be seen in relation to things other than personal relationships. Objects of natural beauty and artistic creations are things we cherish in quite special ways, even though hedonists would describe them, in the technical sense, as instrumentally valuable. Wiggins, in his protest against hedonism, writes,

> The theory says that the whole actual value of the beauty of the valley and mountains is dependent upon arranging for the full exploitation of the capacity of these things to produce such states [of pleasure or satisfaction] in human beings. (105–106, n. 2)

He believes that thinking of these objects as, so to speak, made-to-order for human sensitivities reduces their value.[14]

Yet, people who believe in God have long regarded the natural order in this way without regarding either nature itself or its Creator as a mere tool. Likewise, paintings, novels, and symphonies are indisputable instances of things whose parts are deliberately arranged to produce aesthetic responses in human beings. That they succeed is our reason for valuing them and does not diminish them in our eyes.

My conclusion is that Wiggins does not refute hedonism. A hedonistic theory of value can go quite far toward satisfying his own aim of

giving weight both to the contribution of human nature and the contribution of the world in generating values.

Beyond the Pleasure Principle

I have gone to some lengths to defend hedonism because its power and plausibility are often denied. There is, however, an objection to hedonism that succeeds in showing that things can possess value independently of their effects on our conscious experiences and thus independently of their ability to produce pleasure.

Robert Nozick develops this antihedonist argument very effectively by asking us to consider a hypothetical choice. Imagine, first, what an ideal life might be, and include in it everything that would bring satisfaction, not only a rich array of pleasurable sensations but the deepest satisfactions of aesthetic experience, intellectual achievement, friendship, and love. Second, imagine that one could be attached to a machine that would stimulate one's brain to produce experiences identical to what one would undergo in actually doing all the things that make up this ideal life. A person attached to the machine would have the illusion of eating sumptuous meals, gazing at the Mona Lisa, writing monumental classics of thought, and would experience the very same feelings of satisfaction that would be enjoyed by someone who actually does all of these things. Now imagine choosing between the two of these.

Robert Nozick argues that hedonists are committed to saying that each of these lives is equally valuable and that it does not matter which one a person chooses. Neither is preferable to the other because both produce the same amount of satisfaction.[15] However, Nozick insists, the actual life is far superior to the simulated one, and rational persons would not choose to plug into such a machine. If this is so, then something other than satisfactory experiences is valuable in itself, and hedonism is false.

The argument can be made more embarrassing to the hedonist by supposing that the machine-generated life slightly exceeds the "lived" life in amount of experienced satisfaction, for in this case, hedonists will have to agree that reason requires choosing the life simulation. Nozick claims that this is obviously less desirable, in spite of the greater yield in satisfaction.

Nonexperiential Values

In reflecting on the machine example, Nozick writes,

> We learn that something matters to us in addition to experience by imagining an experience machine and then realizing that we would not use it. (44)

Though Nozick develops no systematic answer to the question of what it is besides experience that matters to us, he makes some interesting suggestions. One is that "we want to *be* a certain way, to be a certain sort of person." What can we say of the person attached to the machine? "Is he courageous, kind, intelligent, witty, loving? It's not merely that it's difficult to tell; there's no way he is" (43). This answer recalls a traditional objection to hedonism, that it does not account for the intrinsic value of virtuous traits of character. Without limiting ourselves to specifically moral traits, we can agree that it does not seem irrational to be concerned about the kind of person one is, and this concern could lead one to feel that he had suffered a loss of personal value in living attached to the machine.

Hedonists, however, are committed to holding that nothing matters (even the kind of people we are) unless it somehow impinges on experience by producing pleasure or pain. Nozick's rhetorical reply has some force. He asks, "But should it be surprising that what *we are* is important to us?" (43). Clearly, it does matter to us, and it is hard to believe that our concern about this is irrational. The hedonist's criterion of what counts as a rational consideration seems to be too narrow.

A second suggestion from Nozick is: "Perhaps what we desire is to live (an active verb) ourselves, in contact with reality. (And this, machines cannot do *for us*)" (45). What we value is not simply the psychological result of engaging or seeming to engage in particular activities. We want actually to stand in a certain relationship to the world, actually to be in contact with the world and to exercise our will in it. While simulated satisfactions might feel the same as actual ones, they remain significantly different.

One need not introduce as extreme a case as the experience simulator to see this point. Contrast the situation of a person who is loved and admired by his friends and family with that of someone who is despised by all but never knows it because everyone treats him as if they loved and

admired him. One person has the pleasures of true love and friendship, while the other has the illusion of love and friendship. For most of us, these situations are far from equivalent in value, and we would be repelled by the idea of being the recipient of false professions of affection and respect.[16]

These arguments are supposed to show that it is rational to value certain states of being apart from whatever satisfaction they produce and that rational persons would choose those states, even if doing so meant sacrificing some experiences of satisfaction. According to Nozick, the hedonistic picture of value is incomplete. It fails to recognize the genuine value that belongs to things outside our psychological experience.

Hedonism as One Rational Option

While I think that Nozick succeeds in showing that it is rational to care about things other than amounts of satisfaction, the situation is not as simple as his discussion suggests. He seems to think that any rational person would refuse the machine simulation and choose a truly active life. I believe, however, that a rational person could choose the machine life. While reason allows choosing real over simulated living, it does not require this choice.

In order to see this, imagine the choice between a blissful life attached to the machine and an actual life of torture and deprivation. Even if one believes that a person who chooses the simulation is losing something of great importance, it would certainly not be irrational to prefer it to an actual life of great suffering. If this is true, we cannot assume that actual lives will always be superior to life simulations.

Moreover, even if the real and simulated lives are of equal value in terms of satisfaction, a person could choose the simulated life without calling her rationality into question. Suppose someone actually cares about things only insofar as they impinge on her experience. Although very interested in how things affect her, she is indifferent to whether her satisfactions derive from realities or simulations. Moreover, she does not care what kind of person she is, if that implies wanting to live up to ideals or standards of excellence. For a certain kind of egoist, the only relevant question is "what's in it for me?" and if this person cares only about the quality of her experience, then real life may have nothing in it that the simulation lacks.

The view that it could be rational for a person to prefer the machine simulation over actual life experiences receives support from two previous conclusions. First, I claimed earlier that while rationality permits concern for other people, it requires concern only for oneself. A rational person could view other people and things in the world merely as means for producing her own satisfaction. The person who would opt for the simulated life simply embodies an extreme form of self-concern. She does not care about being part of the world, interacting with others, or being a certain sort of person. All she cares about is whether she is satisfied or dissatisfied. Hence, what repels most of us about the life simulation would not repel her.

Second, I argued earlier that reason requires an interest in truth only insofar as knowing the truth contributes to producing a better life. While many of us are disturbed by the fact that the simulated existence requires a constant delusion and totally false beliefs about our nature and situation, this need not disturb every rational being. A rational person must be concerned with truth and falsity only insofar as they affect him in noticeable ways, and if what he does not know will not hurt him (as it will not in this case), he will attach no special value to knowing. For him, truth has instrumental value only, and given the satisfactoriness of his grand illusion, he would not be compelled by reason to reject it because of its illusory nature.

Hedonism and Ideal Goods

For most of us, actually engaging in activities, actually possessing certain traits of character, and knowing the nature of our situation are things of value. Likewise, we believe that other people, works of art, and natural objects have value apart from the pleasure they produce. Because recognition of these goods is not required by reason and in many cases is related to our commitment to particular ideals, I will call these "ideal goods." They are things we believe are valuable independently of the satisfaction they produce. Under normal circumstances, ideal goods contribute to satisfaction with one's life, but there can be conflicts between satisfaction and particular ideals, too. The simulation machine is only an extreme case of a kind of conflict that occurs in actual life.

One reason that hedonism is such a resilient theory is that it tells an important part of the truth. No rational person can be indifferent to pleasure and pain, and a person could be rational without caring about

other things of value. Thus, if we are looking for a way to prove value judgments, we are led to hedonism because hedonic values are rationally compelling. Having arrived at this view, however, we become dissatisfied with it because we see that there are other non-hedonic values. While these ideal values are rationally permissible, however, they are not rationally required.

In an otherwise perceptive and valuable discussion of reason and value, Hilary Putnam mistakenly tries to show that a purely hedonistic life is irrational. He begins by describing a group of what he calls "pig-men," people who are content with the simple pleasures of food, shelter, and drunkenness and have no interest in the "artistic, scientific, and spiritual aspects of life."[17] Putnam believes that a more richly human life is better than the more animal-like life of the pig-men, and this leads him to want to say that the pig-men are irrational. Nonetheless, he sees that the more plausible judgment is that "while the lives of the pig-men are not as *good* as they might be . . . they are not *irrational*" (171).

One reason they don't seem irrational is that they are unaware of the option of living the kind of life Putnam values. Thus, they cannot foresee that the consequences of such a life would make them better off. But what if we could acquaint them with this possibility and they simply refused it? Putnam wants to say that this would be irrational, and he laments our reluctance to say this, explaining it as "the product of the recent vicissitudes of the notion of reason in our culture." He continues:

> For neither ancient philosophers nor the medievals saw anything strange about saying that if A is a *better* life than B then that fact is a *reason,* the best possible reason, for *choosing* A over B. We have lost the ability to see how the goodness of an end can make it *rational* to choose that end. (173)

Clearly, Putnam thinks we have become disabled in our ability to make certain kinds of judgments. In contrast, my view is that the judgment he wants to make about the pig-men is simply mistaken. If the life of the pig-men is as satisfying to them as would be a life of high culture, then we, as valuers of high culture, may lament their contentment with "lower" pleasures. Nonetheless, our assessment, while based on reasons, is one that rational people can reject. Unless the pig-men can be expected to see that they are missing out on a better life, then they cannot be judged to be irrational in contenting themselves with bodily pleasures.[18]

Putnam is correct in thinking that a theory of value that does not

allow for ideal (i.e., higher) goods fails to allow for values that rational persons often regard as the highest and most ennobling. At the same time, a theory of value that fails to acknowledge that reason does not require the pursuit of ideal goods has an implausible ring to it; it cannot withstand the skeptical charge that one is simply equating one's own values with the requirements of reason. Reason does not require preferring a life of high culture to a life of low culture.

Summing Up

In this chapter, I have explored some of the strengths and weaknesses of hedonism. Although hedonism is not, after all, true, it is capable of being developed in ways that enable it to stand up to numerous objections. Since the arguments against other theories pointed in the direction of hedonism, it appeared to be a promising answer to questions about the nature of the good.

If I am correct, part of the appeal of hedonism consists in the fact that, all things being equal, it is rational to make choices on hedonic grounds. A person would be irrational not to consider matters of satisfaction at all, and someone could be interested only in hedonic goods without being irrational.

Nonetheless, there are sometimes good reasons for choosing options at the sacrifice of pleasure and satisfaction, and these reasons derive from an interest in certain "ideal" goods, such as truth or the nature of one's own character. We need to consider these ideal goods and see if there is any way they can be rationally assessed.

12
Evaluating Ideals

> *No one has insight into all the ideals. No one should presume to judge them offhand. The pretension to dogmatize about them in each other is the root of most human injustices and cruelties, and the trait in human character most likely to make the angels weep.*
> —William James

The reflections of the last chapter show that hedonism does not provide a complete account of what it is to "act for the best." An adequate theory of the goals of rational action must recognize numerous ideal goods in addition to the value of pleasure. In moving to a pluralist theory, we sacrifice two apparent advantages of hedonism. We sacrifice the idea that what is good is rationally required, since ideal goods are allowed but not required by reason, and we sacrifice the idea that everything of value can be measured on a unitary scale. If there is a plurality of valuable ends and no fundamental value that underlies them, then there is no single measure for evaluating them.

These sacrifices are significant, but they may be less distressing than it first appears. Even for hedonists, there are well-known problems concerning the use of a single scale to measure very disparate sorts of pleasures, as well as problems in comparing the pleasures experienced by different people. These problems are sufficient to take the glow off the hedonic model of decision-making, even though a crude version of these procedures is often useful to employ. Nonetheless, given the difficulties of applying a hedonistic calculus, the problems of dealing with plural values are not unique.[1]

Likewise, while we may hope to show that what we value most is rationally required, the fact that we cannot is no cause for discouragement. Value claims are not the only beliefs which cannot be proved from self-evident premises. This is true of virtually everything we believe

about ourselves and the world. While some may be driven to skepticism or nihilism by an inability to find self-evident value premises and derive other values from them, there is no need to take this step. We can have justified beliefs about values in the same way that we can have justified beliefs about facts. Indeed, as Hilary Putnam has argued, if we cannot make any value judgments, we cannot judge that factual beliefs are justified or unjustified.[2] Even skeptics are committed to evaluative beliefs, since their claim that certain beliefs are not worthy of our acceptance is itself a value judgment.

Patterns of Plural Values

In considering the implications of Nozick's experience machine, I argued that he correctly infers that there are things other than pleasure that are rational to desire. Nonetheless, neither Nozick nor Putnam succeeds in showing that a purely hedonistic way of life is irrational. Rational people may differ over the question of what is valuable, some desiring pleasure alone while others seek ideal (non-hedonic) goods. One important distinction among value systems, then, is between hedonistic systems that only recognize pleasure as a good and non-hedonistic ones that recognize other goods in addition to pleasure.

Just as rational people may differ over *what* is valuable, so may they differ over the question of *which* people (or other beings) they want to benefit. While many philosophers since Plato have tried to show that reason requires a degree of altruism, egoists have stubbornly defended the claim that it is rational to care only about oneself. Here again, reason permits different views. As I have already indicated, there is nothing irrational about the egoist limiting concern for himself and wanting to produce good results for himself. In fact, reason requires some degree of concern for oneself since, as Gert argues, being rational requires avoiding harms to oneself unless there is a special reason to undergo them. Nonetheless, reason does not require that we seek good results only for ourselves. It permits us to seek the good for others as well, including those we know and care about, as well as those who are strangers to us.

Using these distinctions, we can say that there are four different types of rational life plan, each defined by a different view of what it means to "act for the best." These are:

1. egoistic, hedonistic
2. egoistic, ideal (non-hedonistic)
3. non-egoistic, hedonistic
4. non-egoistic, ideal (non-hedonistic)

Rational people may pursue pleasure alone, and they may do so either for themselves alone or for others, too. Likewise, they may pursue non-hedonistic goals either for themselves alone or for others as well. So, for example, while a person who pursues only his own pleasure would be an egoistic hedonist, someone whose goal is his own self-actualization (i.e., the development of his talents, abilities, and best traits of character) is a non-hedonic egoist. A person whose goal is pleasure for others would be a non-egoistic hedonist, while one who seeks to develop talents and virtues in others would have non-hedonic, non-egoistic goals.

In fact, the situation is more complicated because there are both many different non-hedonic goods and many different groups that non-egoists may be interested in benefiting. Among non-egoists, there are people who care only about their families, their friends, members of their own race, religion, or nation, while others care about all humanity. Reason does not itself require any particular view about the scope of our concerns. It can range from ourselves to all creatures.

Likewise, there is a vast array of nonhedonic values and ideals. Virtue, truth, fame, patriotism, autonomy, wealth, and religious devotion are but a few of the more common ideals. Likewise, there are personal ideals, the desire to be a good parent, spouse, teacher, citizen, or artist. Finally, there are traits that people want to possess, qualities like courage or honesty, manliness, feminity, independence, or distinctness. Qualities like objectivity, deliberateness, knowledge, and intellectual integrity—key components of the classical ideal of rationality—are among the traits that people aspire to exhibit in themselves or develop in others. The result of this is a dizzying multiplicity of different types of lives that rational people may pursue.

While this pluralistic view may strike us as awkward and unwieldy from a theoretical perspective, it is confirmed by common experience. This kind of pluralism is in fact more attractive than unitary views that seek to impose a single way of life on all. Indeed, the classical ideal fails in large part because it does not recognize that there is no single form of life that reason requires. Means/end theorists and hedonists do recognize the plurality of values but think that they share a common

essence—that they satisfy desires or bring pleasure. The pluralism I have described is more radical than this because there is no unity underlying the diversity. Pluralism is not merely a surface phenomenon.

Faced with this plurality, we may accept it grudgingly, wishing that there were some way to show that our own ideals are required by reason. Or, if we are like William James and John Stuart Mill, we may take pleasure from diversity and find the multiplicity of ideals among human beings to be a source of pride and delight.[3]

Faced with this plurality, however, we may also come to think that all value is simply a matter of taste and that no rational assessment or argument about ideals is possible. Bertrand Russell seemed to express such a view when he wrote,

> I cannot . . . prove that my view of the good life is right; I can only state my view, and hope that as many as possible will agree.[4]

If any assessment of ideals is impossible, however, my criticisms of the classical ideal of rationality must be defective. Moreover, if the value of an ideal to a person is simply a function of whether that person *wants* to pursue it, then the kind of desire-based theories of value I have opposed would appear to be correct after all.

In order to avoid these conclusions, I need to show that it is possible to hold a pluralistic view of ideals without accepting the view that ideals cannot be rationally assessed and criticized. This is especially important to my inquiry here, since I have criticized various ideals of rationality. If it is impossible to assess ideals rationally, then none of my previous arguments can have any substance to them.

Assessing Ideals

In retrospect, it might appear that my criticisms of classical rationalism presupposed the truth of hedonism, since I argued that there are cases in which pursuit of classical rationalist ideals would be irrational because it would cause suffering or otherwise diminish a person's well-being. This criticism seems to appeal to hedonistic premises. Now, however, I have claimed that there are ideal goods (states of character, truth, etc.) for which it is rational to make sacrifices in pleasure. Can I admit ideal goods without undermining my objections to classical rationality?

This criticism rests on two assumptions. The first is that my previous

arguments appealed solely to hedonistic values. The second is that once one rejects hedonism, arguments concerning pleasures and pains are no longer relevant to assessing ideals. Both of these assumptions are mistaken.

First, my arguments against the classical ideal of rationality did not presuppose the truth of hedonism. In criticizing the classical ideal, I argued that this ideal conflicts with other ideals such as friendship, benevolence, and spontaneity. Recall Joe Morgan's attempt to understand his wife's adultery and his pursuit of this inquiry even when it threatens his wife's well-being and life. Morgan's quest for knowledge leads him to callous and insensitive behavior, which would be undesirable toward anyone, but which is especially undesirable when directed at the person whom he allegedly loves most.

True, the fact of Rennie's pain is central here, and this is something that hedonists would emphasize. It is not the only factor, however, and my criticisms of the classical ideal assumed not only that pleasure and pain are important but also that there are other ideals which sometimes should take precedence over the pursuit of rationality. Anyone who finds the single-minded pursuit of rational ideals inconsistent with other ideals will take this to be a negative feature of the classical ideal, with its exclusive emphasis on the quest to be as deliberate, objective, and knowledgeable as possible.

The second assumption involved in this objection is also false. One need not be a hedonist to recognize that the pursuit of an ideal can be too costly, that it can require sacrifices of well-being that are not justified by the attainment of the ideal. Jacob Horner's life shows us what the cost of acting only after due deliberation might be. William James suggests the benefits of making assumptions not justified by evidence, as in the case where assuming the trustworthiness of strangers increases the possibility of establishing trusting relations with them. The cost of rejecting these assumptions and upholding the "ethics of belief" may be loneliness and isolation. This is not the place to restate all of the arguments against the classical ideal. My point is that they do not presuppose the truth of hedonism.

I take it, too, that my arguments show that it is possible to criticize ideals. Nonetheless, there are difficult questions about how we should understand such criticism. While I criticized means/end theories for leaving entirely open the ends a person might pursue, if I am unable to distinguish rational from irrational ideals, much of the point of those criticisms will be undermined.

I want, therefore, to indicate some of the ways ideals can be rationally assessed and some of the factors that make the pursuit of an ideal irrational. Even if we cannot provide proofs of the validity of particular ideals, we may still be able to establish some criteria for weeding out those that are defective.

Inconsistent Ideals

If someone is committed to two or more ideals that are inconsistent with one another and if the inconsistency should be evident, then her pursuit of those ideals is irrational. One cannot, for example, combine such ideals as patriotism and internationalism, asceticism and sensationalism, solitary contemplation and community involvement, sobriety and exuberance. The pursuit of each would nullify one's efforts to realize its opposite.

Of course, competing ideals are sometimes attractive to us, and there are ways to try to make them consistent with one another. One way is to establish priorities between them and pursue the lesser ideal only when it does not interfere with the more important one. Or, one could reinterpret the ideal so as to combine elements of it with that of its competitor in a new, consistent synthesis.

That opposing ideals may be combined with one another shows that they are not strictly contradictory. We have already seen that an egoist might behave altruistically in order to further his own goals, and I noted Sidgwick's claim that intelligent hedonists will best obtain pleasure by pursuing things other than pleasure itself. In the same way, patriots may gain honor for their country by promoting internationalism.[5] Sensationalists may enhance their pleasures through periodic abstinence. In each of these cases, there will be a clear set of priorities, however, and when the lesser ideal conflicts with the more important, its pursuit ought to be stopped. In addition, the lesser of the pair in each of these cases might be valued instrumentally rather than for its intrinsic worth. The sensationalist may not value abstinence itself and would not practice it if he found that it did not enhance his pleasures. Likewise, if a patriot promotes internationalist goals only because she believes it will bring honor to her own country, then she will cease to promote internationalism if this expectation proves false.

To be inconsistent, then, a person must value two competing ideals

both equally with one another and intrinsically, rather than instrumentally. It is this kind of inconsistent commitment that is irrational.

Most of us have many goals and ideals, and we generally do not have clearly drawn priorities among them. Perhaps we hope that we will be fortunate and never have to choose between the various things we value. Given the multiplicity of our goals and ideals, it is unlikely that one of them is absolutely predominant, and this is the reason most people find the single-minded pursuit of a particular goal unattractive. To pursue some one thing single-mindedly is to ignore other things of importance and to risk fanaticism. For a vivid illustration of this problem, consider the following quotation from Angela of Foligno, a religious mystic whose entire family died within a brief time.

> In that time, and by God's will, there died my mother, who was a great hindrance to me in following the way of God; my husband died likewise, and in a short time there also died all my children. And because I had begun to follow the [mystical] way, and had prayed to God to rid me of them, I had great consolation of their deaths, although I also felt some grief.[6]

Because most of us find many things to be valuable and important and because other human beings are so important to us, this attempt to realize but one ideal is highly unattractive. It is inconsistent with too much that we value. Given our broad range of values, we cannot accept that pursuit of some one value is the best thing for us to do, and we therefore reject such exclusive ideals as irrational to pursue.[7]

This is not to say that the same ideal need be irrational for every person. Another person with a narrower range of values may find that pursuing some single ideal is best for her. For most of us, however, any ideal that presents itself as the sole end for which we live will be inconsistent with so much that we value that we will reject it.

Even if two ideals are not inherently inconsistent, they may conflict with each other in particular circumstances. We hope that we can allot our time and energy to the different things we value and pursue some of them to a satisfactory degree. We may find, however, that we lack the time and energy for everything we value and that some goals must be sacrificed. There is no *a priori* test for such practical inconsistencies. Nonetheless, if someone pursues several ideal goods and should be able to see that success in all of them is not possible, that person's set of ideals is irrational to pursue.

Harmful Ideals

As human beings, we all have certain fundamental biological, psychological, and social interests, and pursuing an ideal may be irrational because it damages these interests. I have criticized the classical ideal for being "too costly" in this sense. If someone pursues a career, seeks to develop a talent, or strives for fame or fortune in ways that damage his health, psychological well-being, or relations with people he cares about, we would judge that he is acting in ways that are injurious to himself. If he sees this occurring, then continuing to act in this way may be irrational. Even if he himself claims not to care about the injurious effects of his behavior or says that his only interest is in realizing his ideal, we *might* nonetheless judge him to be irrational in this pursuit.

I stress the word "might" here because the person's goals may be so valuable that we might believe his sacrifices to be worthwhile. As I have argued before, it can be rational to make sacrifices of one's well-being for the sake of one's ideals. At least, this is what we must believe if we hold it to be rational to reject a simulated life of greater pleasure because we want to have a real life, even if it contains less satisfaction. Even if we believe, however, that such sacrifices in well-being can be rationally justified, we need not accept a particular person's stated aims as definitive of his good. People can make mistaken judgments about what is most important, and a person may come to regret the injuries that he brought on himself. As both Rawls and Gert emphasize, maintaining one's physical and psychological health are preconditions for so many values that a person's lack of attention to them casts doubt on the rationality of his pursuits.

There are other cases in which people make substantial sacrifices without calling into question their rationality. We sometimes greatly admire people who maintain ideals of truthfulness in the face of political pressure or who endure privation in pursuit of humanitarian or artistic activities. It may be important that in such cases, the hardships are forced upon them.

Deciding whether sacrifices are rational or irrational in particular cases may be difficult, and I have no formula to determine when the harms incurred on behalf of an ideal become too costly. My main point is that we do assess ideals in terms of their costs. While rational people may be willing to suffer for their ideals, no rational person will ignore

these costs, and if we judge the costs to be excessive, we imply that the pursuit of this particular good is irrational.

Immoral Ideals

Ideals and their pursuit can be criticized not only for being irrational but also for being immoral. A person's goals can be inconsistent not only with her own other goals but also with moral rules or ideals that we take to apply to everyone, whether or not they themselves embrace them. Likewise, when we talk about the costliness of pursuing particular ideals, the relevant injuries may involve damage either to the agent herself or to other people. In such cases, pursuit of the ideal is immoral.

In thinking about immoral ideals, we need to distinguish between inherently immoral ideals and those that are contingently immoral. On the one hand, an ideal that necessarily requires subjugating others to someone's will and damaging their interests is inherently immoral. On the other hand, someone's pursuit of artistic excellence, though in no way inherently immoral, may nonetheless lead her to violate obligations she has to family or friends. Likewise, as I argued earlier, while the pursuit of knowledge is not inherently immoral, the pursuit of knowledge about someone's personal life may violate their rights and hence be an immoral activity.

Immoral actions need not be irrational. While I argued earlier against Harman's view that moral principles do not apply to people who reject them, I do not deny that it can be rational for Harman's "amoral gangster" to use people for his own ends. As many philosophers have argued (including Brandt, Fingarette, Gert, and Sidgwick), the rational person need not be moral. This is because acting morally can require sacrifices of one's own welfare, and it is never irrational to act on behalf of one's own well-being. As we have seen, reason permits people to pursue either egoistic or non-egoistic goals, and among non-egoists, the range of concern for other people can vary in both strength and scope. Some people are only concerned about their friends or immediate families, while others care about their countrymen, or members of their own religious group, culture, or social class. Likewise, one's degree of concern for these various groups may range from tepid to passionate.

The point of view of morality, however, is inclusive of all human beings. When we evaluate actions and ideals from a moral point of view,

we evaluate the way they affect other people, whether or not the agent cares about them. There are good moral reasons why an "amoral gangster" should not harm innocent people, even though he does not care about them and even though his harming them is not irrational. When we evaluate ideals from the point of view of rationality, the scope of the agent's concerns is relevant because it partly determines what the good is for him and hence what act is (rationally) best for him to perform.[8] In this sense judgments about the rational are more highly relativized than judgments about the moral.

That it can be rational to act immorally in no way detracts from the importance of the moral point of view as a perspective from which to evaluate actions and ideals. The moral point of view is an independent framework for evaluation, and actions may be negatively evaluated morally even though one could not criticize them for being irrational.[9]

Bizarre Ideals

There are times when someone's aims strike us as so strange or outlandish that we do not see how those aims could possibly be pursued by rational persons. We judge the person to be irrational because our most vigorous efforts of thought, imagination, and empathy fail to make comprehensible how that person's aim could possibly constitute anyone's good.

Suppose, for example, that someone wants to be an invalid. He wants to pursue the goal of his own disablement and believes that being disabled is better than having one's physical capacities intact. We might be able to imagine some circumstance in which being an invalid would bring advantages we could understand, but if someone simply wants to be in a disabled state, we would, I think, find the notion that this is a worthwhile goal beyond our comprehension.

While this is an extreme case, there are related ones that are not imaginary. Consider, for example, members of religious groups whose ideals require them not to use medical techniques for curing diseases. While they do not seek out ill health, they avoid using available methods for promoting good health. Such practices may strike one as totally bizarre. We may not understand why abstaining from medical care would be regarded as ideal behavior.

In cases like this, closer acquaintance with people who follow these practices might change one's view. It might be that persons who

embrace this ideal tend to have particularly admirable traits of character or live especially fruitful lives. We might think, of course, that whatever goods are part of such traditions are attainable without abstaining from medical treatment, making such sacrifices of health and life seem totally unnecessary. This might not be true, however. Familiarity with these people might make one doubt that one could alter this particular practice without changing the entire way of life clustered around it. I do not claim that this is so, but I think we would be less likely to call the practice irrational if it seemed inextricably bound up with other practices or traits that are particularly laudable.

In some traditions, the goal is withdrawal from the world of activity and the attainment of a state of complete mental tranquility. If we imagine this state as one of great pleasure, such withdrawal would be on a par with hooking oneself up to the life simulator. I have said that we cannot rule that out as necessarily irrational. If we imagine, however, that the goal is a "blank" state of mind, a condition of nonawareness, then the evaluation may be different. We might find that there is no understandable good to be achieved by this, that it is a quest for a kind of mental incapacitation. In this case, if we believe that adhering to this goal is not what is best for someone and that he himself should know this, we would judge his activities to be irrational.

Sometimes an ideal strikes us as irrational because it is grossly immoral. Imagine someone whose goal involves behaving cruelly to others, perhaps killing or torturing them. Or he has such great a hatred of others that he simply wishes to destroy them. We often feel a sense of incomprehension at such behavior. I have said, however, that we cannot judge behavior to be irrational simply because it is immoral. What about such cases?

There are, I think, two ways of looking at them. First, we may find such behavior hard to understand because we tend to think that harming others requires some special justification. This point is correct, but it is made from the moral perspective. If we assume that someone has normal moral motivations and some concern for others, such callous behavior is incomprehensible. If, however, someone has no concern for others and need not fear punishment, we can "make sense" of their behavior. We can do this because we understand that people frequently find the exercise of power and control over others gratifying. We can understand it because we know that hatred involves a desire to harm others. Natural human motivations can give rise to such behavior when they are particularly strong and unchecked by benevolence. When we see the

connection between such actions and natural emotions and motives, we can comprehend the person's ideal, even though it remains incomprehensible within a framework of other assumptions about normal behavior.

Ideals Based on False Beliefs

In discussing the assessment of ideals, my aim has been to acknowledge the difficulty of making such assessments without joining those who say that ideals cannot be rationally assessed at all. Many thinkers, of course, would simply reject my predicament by arguing that value judgments in general are not capable of rational justification or refutation. Such thinkers should take no solace from the predicaments involved in assessing ideals, however, for one of the key sources of uncertainty in evaluating ideals is the difficulty in assessing the factual presuppositions of ideals.

In some of the cases I have discussed, I have omitted the fact that the ideal is based on particular religious or metaphysical doctrines. For example, a person might avoid medical treatment because he believes that an omniscient deity has commanded him to do so. Or a person may seek a life of contemplative withdrawal because he believes in transmigration of souls after death and thinks that failure to live contemplatively will result in a less desirable life in his next existence.

People who reject these ideals often do so because they regard such beliefs about the nature of the world as false. Holding false beliefs is not always irrational, however. In order for these ideals to be irrational, they must be held by people who are in a position to know that the beliefs they rest on are false. It is unclear, however, that anyone is in a position to demonstrate that beliefs about God's commandments or existence after death are false. As anyone familiar with the history of metaphysical disputes knows, it is extremely difficult to produce knockdown refutations of such beliefs. Indeed, the history of such disputes suggests that they are no more easily resolvable than are disputes about values themselves.

This is not the place to enter into a full-scale discussion of issues concerning the verification of factual beliefs and hypotheses. Contemporary writings in the philosophy of science have certainly shown, however, that it is extremely difficult to provide proofs or conclusive verifications of scientific theories.[10] Moreover, the wider the divergence

between those who disagree, the harder it is to find common ground upon which to adjudicate disagreements. The disagreements among those who hold a scientific naturalistic view and those who believe in things like transmigration of souls and divine commands are very acute indeed. If we could resolve such issues about the nature of the world, many of our problems with value questions would be solved.

In spite of the difficulties I have mentioned, criticism of the factual presuppositions of ideals is one way in which we assess them. If a person holds an ideal that rests on beliefs we think he should know to be false, we will view his adherence to the ideal as irrational. Criticism of factual beliefs, then, is one way in which ideals can be rationally assessed. The beliefs in question need not be grandiose metaphysical schemes. They may simply be factual predictions about what a person can achieve. It would be irrational for me to adopt the goal of winning the world heavyweight boxing title. I lack both the physical frame and the combative spirit necessary for this accomplishment. In this instance and generally, the facts of the world place objective constraints on the range of choices it would be rational for a person to choose. Since ignorance can lead us to adopt ideals that have no chance of succeeding, having knowledge of ourselves and the world is necessary if we are to adopt rational goals.

Summing Up

Having forsaken hedonism's use of pleasure as a universal criterion of evaluation, I have tried to make some constructive (though admittedly sketchy) remarks about the ways we can evaluate ideals. I have tried to argue for a form of critical pluralism, a view that avoids both the idea that one ideal is best for all and the idea that there is no such thing as an irrational ideal. While we ought not to be too quick to reject the ideals of others, we need not be tolerant or accepting of every ideal. Since the choice of ideals is so fundamental to the value of a person's life, the question of the worth of ideals is one where the use of reasoning, criticism, and other rational procedures is useful and appropriate. While reflecting on our lives is not a necessary requirement for worthwhile living and while critical examination does not guarantee a happy result, an examined life may be more likely to be worth living.

13
Rationality Within Reason

> *Desires and impulses are as much a part of a perfect human being as beliefs and restraints: and strong impulses are only perilous when not properly balanced; when one set of aims and inclinations is developed into strength, while others, which ought to co-exist with them, remain weak and inactive.*
> —J. S. Mill

The ideal of rationality has inspired praise and provoked denunciations. For many, rationality promises the only way of attaining worthwhile goals, while for others it is a deadening, life-denying force that has helped produce the evils of modern civilization. My approach to this debate and the form my discussion has taken derive from a motive, a methodological belief, and what I hope is an insight. My motive was to resolve a tension created in my own mind by the divergent claims of rationalists and antirationalists and to try to clarify for others the issues involved in this disagreement. My methodological belief was that the only way to resolve this dispute was to isolate the assumptions made by rationalists and their critics about the nature of rationality. While this procedure itself implies a bias toward rational methods, it is hard to see how one could possibly decide about the value of rationality without first knowing what rationality is and why people have thought it good or bad. Finally, the insight (for which I claim no originality) is the idea that there is an essential connection between something's being good and its being rational to choose or prefer. When we apply this idea to the arguments of antirationalists, we see that whenever a criticism of rationality succeeds in showing some "rational" ideal to be harmful, destructive, or otherwise undesirable, it also shows it to be a mistaken or

incomplete conception of rationality. A proper conception of rationality is one that necessarily shows itself to be desirable.

This strategy is double-edged. While it succeeds in taking the sting out of wholesale attacks on rationality, it also calls into question a number of traditional rationalist values. In particular, it requires a reexamination of the nature and value of deliberation, objectivity, knowledge, and truth. This reexamination has led me to a number of departures from classical rationalism, and these departures may lead some to classify my views as antirationalist. That is not how I see them, but I admit that some of my conclusions have surprised me and caused me some discomfort.

I have a high regard for truth, clear thinking, and the ethics of inquiry, and I have no wish to undermine rational values that still need to be encouraged and promoted. The situation poses a dilemma for me, but the dilemma serves to reinforce my earlier point about the tension between practical and evidential rationality. Given my understanding of the issues, my commitment to principles of evidential rationality requires that I assert views that might be damaging to the values associated with truth and honest inquiry. On the other hand, to assert contrary views in order to promote the values of evidential rationality would be to violate those very values. While propagandizing on behalf of rational inquiry might be rational (as a means to a laudable goal), it would nonetheless be a violation of obligations and ideals that I have as a philosopher and a seeker after truth.

While speaking the truth is important, there are other things of importance, too. What one feels called upon to say often results from one's perception of what needs to be said and not just one's sense of what is accurate. William James makes this point in the introduction to the volume containing "The Will to Believe." "I admit," he wrote,

> that were I addressing the Salvation Army or a miscellaneous popular crowd it would be a misuse of opportunity to preach the liberty of believing as I have in these pages preached it. What such audiences most need is that their faiths should be broken up and ventilated, that the north-west wind of science should get into them and blow their sickliness and barbarism away. But academic audiences, fed already on science, have a very different need.[1]

James, like some contemporary critics of theoretical reason, saw a need to redress the balance between reason and the passions, to argue for

weaker evidential constraints on belief in order to promote what he took to be a healthier form of life.

Karl Popper, writing under the shadow of Nazism and war, saw the matter differently. For Popper, the greatest need was for a resurgence of the values of classical rationalism. In his words,

> It is my firm conviction that this irrational emphasis upon emotion and passion leads ultimately to what I can only describe as crime. One reason for this opinion is that this attitude [antirationalism] . . . must lead to an appeal to violence and brutal force as the ultimate arbiter in any dispute.[2]

For Popper, the commitment to impartial reasoning is the most effective barrier to violence and barbarism. Moreover, in his view, even an excessive commitment to rationalism is harmless. As he wrote,

> The only way in which excessive rationalism is likely to prove harmful is that it tends to undermine its own position and thus to further an irrationalist reaction.[3]

Popper's views suffer badly from overstatement, for an excessive commitment to certain rationalist values can be harmful. Moreover, since reason by itself is frequently unable to settle disputes between people with differing interests or values, one wants to be able to appeal to emotions such as sympathy and benevolence. While Popper sees this, he understates the importance of these "constructive emotions" in his attempt to glorify reasoning.

My inquiry has led me to conclude that one can do harm to important human values by overemphasizing the values of theorizing and cognition, that intellectual traits are as capable of excess as they are of defect, and that their development may sometimes be undesirable and thus irrational to pursue.

Some of the defects of classical rationalism are avoided by means/end theories, since they highlight the plurality of worthwhile aims in life and thus make clear that we should not evaluate actions simply by reference to cognitive ideals. In addition, means/end theories properly stress the constructive role of our emotional responses to the world in determining what our goals should be. Finally, while they are too permissive in calling everything that we desire good, they nonetheless rightly suggest that we should evaluate our actions by their success in achieving valuable goals at the least cost.

Just as my rejection of classical rationality does not imply that I deny the value of deliberation, truth, or objectivity, so my rejection of

means/end rationality as a theory is not meant to demean the importance of efficacy and efficiency in action. The costs of neglecting these are failure to bring about desired results and acceptance of unnecessary sacrifices. These are serious losses.

Means/end theories are defective in part because they allow anything to be a legitimate goal and thus fail to recognize irrational goals. This mistake is avoided both by hedonists, who specify satisfaction as the only goal of rational action, and by Gert, who emphasizes that certain kinds of harms cannot be rational goals. While I agree with much that is contained in each of these views, both of them limit too narrowly the range of rational goals. Gert sees the goal required by reason to be entirely negative, while hedonists cannot allow sacrifices of pleasure for the sake of ideal (non-hedonic) goods.

Acting for the Best

My conclusion has been that to act rationally is to act for the best. While others (such as Kurt Baier and Richard Brandt) have made this same claim, they differ from me in their understanding of what "acting for the best" means.[4] The rational action in any situation is the one with the best foreseeable consequences. While this view differs from the other conceptions of rationality I have discussed, it allows us to see what is plausible in them. It affirms that our cognitive abilities greatly enhance our ability to act effectively. It grants that if our desires and life plans are not defective, actions that tend to satisfy our desires and advance our aims will be rational to perform. Finally, it acknowledges that acting in ways that diminish our well-being will always be irrational unless these negative results are offset by significant goods. At the same time that it accepts these points, however, it does not equate rationality with cognitive activities, desire satisfaction, the avoidance of evil, or the maximizing of pleasure.

In saying that it is rational to act for *the* best, I do not mean that there is some single mode of behavior that is best for everyone. Since people differ in innumerable and significant ways, what is best for them will often differ. Even a particular individual changes through life, so that what is best for her to pursue while young may be foolish when she is older. External circumstances—both natural and social—also vary, both for different people and for individuals at different points in their

lives. A rational person will be sensitive to changes and variations in assessing what is best for him or others to do.

Moreover, in order to be relevant in assessing an agent's rationality, the good to come of actions must be foreseeable by the agent himself. Foreseeability is important in two ways. First, the agent must have factual information about the likely effects of actions. As I stressed earlier, rational actions can have unfortunate results that no one could be expected to know in advance. When this occurs, it is a reflection on a person's luck rather than on his rationality. Second, the goods we take to be foreseeable must be ones that the agent is in a position to appreciate. It would be foolish to criticize the goals of aboriginal tribe members as irrational because they do not include such things as winning a Nobel prize or beatification by the Catholic church. Given that such goals are no part of the cultural tradition to which they belong, the knowledge of whatever value they might possess is not available to them. They cannot be expected to know about these goals or to recognize their value. If one is trying to determine whether they are acting rationally, one must look both at the evidence and the values they are in a position to know and understand.

Many disputes about the rationality of beliefs and actions among so-called primitive peoples would not have arisen if theorists had kept in mind that criteria of rationality are always relative to information available to particular persons. One cannot, for example, dismiss the use of witch doctors or amulets to ward off disease as irrational simply because they fail to accord with the practices of modern medical science. The people who use these techniques do not have evidence to indicate that Western medical methods might be superior to their traditional tribal practices. It is no more fitting to condemn their beliefs or actions as irrational than it would be to condemn our own current practices as irrational on the grounds that they do not accord with what medical research will discover in the next two hundred years. There is nothing inherently irrational in false beliefs or ineffective actions.[5]

Even among people in the same culture with similar beliefs about facts and values, there will be divergent ideals that are equally rational. As I argued earlier, these can be broadly classified as egoistic and non-egoistic, hedonic and non-hedonic. In addition, the class of people about whom nonegoists care differ, as do the goods valued by nonhedonists. Thus, quite divergent conceptions of the good must be

considered in evaluating whether a particular person's actions are rational. This pluralism may make it look impossible to criticize anyone's goals, but I have argued that there are limits to the goals one can rationally seek, and I have described some of the criteria by which ideals can be evaluated.

Part of what makes means/end theories plausible is that our most common evaluations of the rationality of actions have to do with efficacy. We assume that people have certain practical needs, desires, and goals, and we judge their behavior to be irrational when they fail to do what will obviously promote the attainment of their own goals. Of course, we do not always use the word "irrational" in such evaluations. We are more likely to describe such actions as silly, stupid, or foolish.

It is less common for us to view others' actions as irrational because we think their goals are irrational. This may be because we share so many values with the people we commonly interact with. We can see some value in their goals, even when the goals are ones we would reject for ourselves. Where there are greater cultural differences between us and others, it is often harder to see their ideals as good at all, and we may think of them as irrational. Such judgments frequently reflect no more than narrowness and lack of imagination in the person judging. Nonetheless, it is no accident that when ideals are rejected as valueless, people who pursue those ideals are thought to be irrational. There is a necessary link between the rational and the good that even false and unfair judgments may reveal.

In cases where we view people's actions as irrational because we think their goals are irrational, we are apt to use stronger language, describing their actions as crazy or insane. The same is true of cases where a person brings great harm upon herself or people she cares about for no good reason. Impulsive actions with serious negative effects are often described as crazy.

Ultimately, we must believe that people's goals are rational if we are to consider their actions rational, but in practice, our judgments will most often concern the means they choose for acting. This may reflect a certain tolerance and willingness to give the benefit of the doubt. If someone who appears to be normal pursues some goal, we assume it brings some good to her or others and only judge otherwise with reluctance. Respect for the autonomy of others makes this the best policy.

Practical Reason

Rationality is often identified with theoretical reason, and one might expect a book about rationality to have more to say about logic, assessments of evidence, and criteria of rational belief. I agree that these are important matters. Nonetheless, theorizing and the judicious weighing of evidence are activities carried out by human beings, and I have stressed questions about practical reason because it seemed to me important to solve some problems about the place of cognitive activities in human life. The great figures of the rationalist tradition have not simply wanted to promote techniques of inquiry. As Werner Jaeger has written,

> It was precisely its services to actual living that had given the theoretic life according to Plato its moral dignity and its sacred rights.[6]

The notion that good theorizing and good living are inextricably bound up with each other is the most powerful idea of the Socratic legacy.

While I have criticized the classical rationalists for overstating the value of cognitive virtues, I share their view that "how shall I live?" is one of the central questions philosophy should address. This is clearly a question for practical reason, and the ideal of rationality has been a practical ideal. Nonetheless, a complete theory of rationality must deal with theorizing and inquiry as activities in their own right, apart from the relation of such activities to other aspects of human life.[7] My discussion of rationality is in this respect incomplete because it assumes that we have ways of determining facts and assessing theories. My justification for emphasizing the practical side of rationality is that the practical side is primary.

In discussing how we ought to live, traditional rationalists have made the mistake of equating the rational life with the life of reason. They have thought that a rational life must be one in which intellectual and cognitive values predominate over all others. Ironically, antirationalists have accepted this assumption, but it has led them to deplore rationality as an enemy of variation, emotion, and individuality.

Both have been mistaken. Since people vary in their natures and find themselves in different situations, there is no single manner of living that is rational for all to pursue. There is no such thing as *the* good life or *the* meaning of life. All of us need to discover enough about our nature

and enough about the world to make our lives worthwhile. Relativists are correct in their emphasis on diversity, though they are wrong in thinking that there are no limits to the values one may rationally pursue.

Some critics of rationality have recognized that rational people need not be good. They need not be moral, sensitive, or compassionate. This is correct, and rationalists from Plato onward were wrong to think that development of one's rational capacities was sufficient for the creation of virtue. Nonetheless, it is equally true that sensitivity and compassion are not sufficient for enabling people to benefit themselves and people they care about. If romantics and other antirationalists forsake rationality, they will be forsaking a commitment to seek the best and giving up the ability to draw on their own cognitive powers to produce worthwhile goals. It should be clear on reflection that the ideals of human goodness that motivate many antirationalists can be realized only if an appropriate role is given to both the cognitive and the emotional components of our nature. One of the chief defects of classical rationalism is that it appears to force a choice between these components of ourselves. One of my central contentions has been that no reasonable form of rationalism will force such a choice upon us.

Rationality, as I have described it, is an inclusive rather than an exclusive ideal. Though reason may not require a respect for all the things we regard as valuable, there is no good that rationality forbids or puts out of reach. Likewise, there is no valuable part of our nature that it disparages. There is no reason why T. H. Huxley's description of an ideally educated person could not serve to depict an ideally rational person as well. Such a person, Huxley wrote, is one who

> has been so trained in youth that his body is the ready servant of his will and does with ease and pleasure all the work that, as a mechanism, it is capable of; whose intellect is a clear, cold logic engine, with all its parts of equal strength and in smooth working order, ready like the steam engine to turn to any kind of work, and spin the gossamers as well as forge the anchors of the mind; whose mind is stored with the great and fundamental truths of nature and of the laws of her operations; one who, no stunted ascetic, is full of life and fire, but whose passions are trained to come to heel by a vigorous will, the servant of a tender conscience, who has learned to love all beauty, whether of nature or of art, to hate all vileness and to respect others as himself.[8]

PART V

AFTERWORDS

Afterword I
Rationality Revisited

I wrote the original version of *The Ideal of Rationality* between 1979 and 1983. The impetus to write the book grew from tensions within my own beliefs and values. On the one hand, I was drawn to the philosophical ideal of rationality, the idea that deliberation and the examination of beliefs are activities that both possess extreme (perhaps even preeminent) value and provide the measure for the value of other aspects of life. On the other hand, I was aware that the search for rational justifications of beliefs was not always successful. Problems of skepticism seemed to plague philosophy, leading to the worry that a rational justification of beliefs might not be possible. Worse yet, my reading of novels and social criticism suggested that rational ideals might themselves be at the root of important personal and social problems. These works suggested that deliberating about how to live, imposing standards of efficiency on our actions, and subjecting beliefs and values to objective examination lead to alienation, the stultifying of the emotions, and callous indifference to other people and the natural environment. In short, they suggested that rationality was a vice rather than a virtue.

It is instructive, looking back, to think about the broader sources of disillusionment with rationality. If one identifies reason with science and technology, then the building and use of atomic weapons provides a sobering commentary on reason's worth. It is interesting, too, that the discussion of nuclear strategy was carried out in the hyper-rationalistic languages of game theory and geopolitics. Opposition to nuclear weapons policies was seen not merely as mistaken but as emotional, hysterical, irrational. Likewise, during the Vietnam war, science, technology, law, and bureaucratic procedures were combined for destructive purposes. It is no accident that opposition to the war and the government that promoted it led to the development of a counterculture that rejected the trappings of reason, orderliness, intellectual detachment, and social respectability.

While this disillusionment was voiced in popular works by writers like Philip Slater and Theodore Roszak, it seldom found direct

expression among academic philosophers. Nonetheless, Stuart Hampshire raises these issues forcefully in his 1972 essay, "Morality and Pessimism." While Hampshire's specific target of criticism is utilitarian morality, it is particularly the alleged rationality of this approach that he condemns. He writes:

> The utilitarian habit of mind has brought with it a new abstract cruelty in politics, a dull, destructive political righteousness: mechanical, quantitative thinking, leaden academic minds setting out their moral calculations in leaden abstract prose, and more civilised and more superstitious people destroyed because of enlightened calculations that have proved wrong.[1]

Expressing his sympathy with the counterculture, Hampshire continues:

> To [some people,] and particularly to many of the young in America and in Europe, . . . it seems now obvious that the large-scale computations in modern politics and social planning bring with them a coarseness of moral feeling, a blunting of sensibility, and a suppression of individual discrimination and gentleness which are a price that they will not pay for the benefits of clear calculation. Their point is worth considering: perhaps it can be given a philosophical basis.[2]

Hampshire's point is sobering and important. Suppose that the cultivation of rationality does lead to a loss of moral feeling, to a weakening of sensitivities and discriminative powers. Suppose it does suppress qualities like gentleness and moral sensitivity. Is the triumph of reason worth the cost? Might not the triumph of reason bring with it the destruction of human life itself, a possibility rendered realistic by the ongoing development of the nuclear arsenals after World War II? For if we simply reason about life and do not cherish it, then nothing seems to stand in the way of our reasoning on behalf of destructive ends.

Perhaps the most powerful expression of Hampshire's protest comes in his reference to the destruction of people who are both "more civilized" and "more superstitious." While rationalists have always linked civilization with the growth of knowledge and the overcoming of superstition, Hampshire repudiates this too easy identification. His comment recalls the poet Kenneth Rexroth's remark that "Since Hiroshima, . . . [s]ome of our best people prefer alchemy to physics. . . ."[3]

The idea that reason has destructive effects is, of course, not new. It lies at the heart of the various romantic revolts against reason. It can be found in Rousseau's warnings about the growth of science and knowl-

edge in his "Discourse on the Arts and Sciences." "Let men learn," he says,

> that nature would have preserved them from science, as a mother snatches a dangerous weapon from the hands of her child. Let them know that all the secrets she hides are so many evils from which she protects them. . . . Men are perverse; but they would have been far worse, if they had had the misfortune to be born learned.[4]

Rousseau goes on to condemn the "vain and futile declaimers" whose writings employ paradoxes to destroy faith and virtue.

> They smile contemptuously at such old names as patriotism and religion, and consecrate their talents and philosophy to the destruction and defamation of all that men hold sacred.[5]

While defenders of reason pride themselves on challenging traditional values, Rousseau condemns what he sees as a destructive process. He even laments the invention of the printing press, noting that because of it "the pernicious reflections of Hobbes and Spinoza will last for ever."[6]

One could multiply examples: Wordsworth, in his poem "The Tables Turned," rejects books as "a dull and endless strife" and urges us to open our "minds and hearts" to the "sweet lore" of Nature itself. Reason will not lead to truth. Instead, he tells us,

> Our meddling intellect
> Mis-shapes the beauteous forms of things:—
> We murder to dissect.

Dickens tries to show us in *Hard Times* how people are damaged by the narrowly rationalist, utilitarian, fact-based education promulgated by Mr. Gradgrind. We see the genuinely destructive effects of Gradgrind's hostility to play and spontaneous emotions in the damage they do to the emotional powers of Elisa. Or think of e.e. cummings's pithy proclamation that "life is more true than reason will deceive."[7]

Yet, the worries expressed in these voices seldom made it onto the intellectual agenda of analytic philosophical thinking. A discipline that prided itself on sparing nothing from reason's scrutiny appeared to spare reason itself. Questions about the value of reason or the life of reason were simply not debated. Their value was presupposed. Philosophy, as I learned it, was dedicated to the pursuit of truth, and this was assumed to be a significant value, perhaps the most significant one. That is why, for much of this century, philosophers have praised the natural sciences,

since the sciences have appeared to be the most successful at discovering truth. Many philosophers sought to emulate the sciences, even going so far as refusing to discuss serious moral and political issues because doing so would violate (what they took to be) the essential command of science: thou shalt be value neutral. It is instructive to recall that issues in "applied ethics" that are now the ordinary fare of academic philosophers were scarcely recognized as legitimate areas of inquiry before the 1970s. Early work on problems of war and peace or medical ethics was done by theologians rather than academic philosophers. Philosophers aspired to a detachment that did not permit active engagement with the issues of the day.

Nonetheless, there was a kind of disingenuousness about this, for the impersonal quest for truth was itself assumed to be something of great personal value, and for those of us who aspired to be philosophers and teachers of philosophy, there had to be a belief that this was a worthwhile form of life. And, indeed, to the extent that philosophy existed as a profession, it had its values and its exemplary heroes. At a time when many philosophers thought that there were no justified beliefs about values, they also believed that philosophy itself was a noble profession.

Fortunately, things have changed significantly within the discipline of philosophy. The range of subjects considered to be legitimate topics of inquiry has expanded considerably. At the time I wrote, however, I felt that there were no serious philosophical discussions of challenges to rational ideals. Wanting to know whether it was good to be rational, I found philosophical books that contained relevant material but none that I felt addressed the question directly and satisfactorily.

My aim, then, was to write a book that took as its central topic the question "why be rational?" I wanted to take seriously the challenge to the notion that rationality was a good thing and to try to see what merit that challenge had. In the course of considering that question, I came to see that many of the traits and practices associated with rationality did not have the unconditional value that often seemed to be attributed to them. Nonetheless, I came to believe that rationality is worth defending, and I tried to articulate the form in which it is defensible.

The passage of time and continued reading and reflection about these matters have left me reasonably content with the positions and arguments I originally put forward. Still, my book was never meant to be the last word about these problems, and I knew that it left many important questions untouched. In particular, it avoided epistemological questions, just the ones that philosophers had mostly focused on. In

addition, new challenges to rationality have taken shape. Some of these, in particular many of the criticisms that originate in feminist thought, are in harmony with my own attack on excessive rationalism. Others go farther toward forms of antirationalism that I reject.

While I cannot give any of these issues their due here, I hope that the framework of thinking worked out in this book can be helpful in working through these important problems. In the rest of these additional sections, I will try to fill in some of the gaps in my original discussion and make comments that I hope are pertinent toward more recent work as well.

Afterword II
An Interview with the Author

Q. I enjoyed your book, but I'm still puzzled about whether the question "why be rational?" makes sense. After all, in seeking to answer it, you either have to proceed rationally or nonrationally. The first approach begs the question against antirationalists, while the second begs the question against rationalists. Since you used reasons and arguments in your book, didn't you assume that we ought to be rational?

A. That's a good question. It reminds me of Raymond Smullyan's description of a debate between advocates of reason and those who believe in intuition. People "on the side of reason . . . give *reasons* to support their belief," he says, while those "on the side of intuition claim their intuition tells them that intuition is superior to reason."[1] Such an exchange seems doomed to failure.

Smullyan, by the way, thinks that advocates of reasoning cannot prove their view is correct, but he adds, in characteristic fashion, that he "would not be surprised" if they recognize the truth of their view by "some valid mystical intuition"!

The impasse that you and Smullyan describe may not be as complete as it appears. Whether it is depends on how we think of the participants in such debates. If someone is both absolutely committed to a particular view and sufficiently clever, that person can probably find ways to dodge the force of whatever arguments and objections the opposition produces. Given a resolute enough will to maintain belief and a bit of intelligence, people can keep from altering a view they want to hold.

Not every participant in a debate is like this, however. In the first place, all of our views are more complex than the theories we articulate to express them. For this reason, while the "ideal type" irrationalist has no truck with reasons and arguments, people who express antirationalist views in fact use arguments and appeal to reasons to support their antirationalism. And, most people who think of reason as a good thing can also recognize that there are other things that we value and that in some situations, reasoning would be out of place. It is possible to

reason about the place of reason, then, because most of us are not so committed to our theoretical views that we are unable to feel the force of arguments against them.

In addition, while authors and public debaters have a certain commitment to a view, readers and listeners may not have formed their views yet. Even if two debaters fail to convince one another, onlookers to the debate may be helped by it to form their own conclusions.

In an interesting passage in *Whose Justice? Which Rationality?* Alasdair MacIntyre describes the person to whom his book "is primarily addressed" as

> someone who [has not yet] given . . . allegiance to some coherent tradition of enquiry . . . [and who] is besieged by disputes over what is just and about how it is reasonable to act, both at the level of particular immediate issues . . . and at the level at which rival systematic tradition-informed conceptions contend.[2]

The existence of people who are undecided about which tradition to embrace represents something of a problem for MacIntyre, since he also argues that there is no such thing as inquiry or judgment that is not tradition-based.[3] Nonetheless, his description of the imagined reader of his book is interesting and suggestive. Much philosophical writing appears to be directed toward a reader with well-worked-out views that differ from those of the author. At a surface level, the aim of the book is to bring readers around from whatever opposing views they begin with and have them embrace the view of the author. A good book of this genre is a kind of debate in which one party speaks for both sides. The best books of this type present the opposing views as well as their proponents would have presented them and then show why a better case can be made for the author's own view.

Even for authors and public spokespeople for various views, nothing is totally fixed, however. As I argued in chapter 1, every rational discussion is both an opportunity and a risk. While one may aim to convert one's opponent, one may also find one's own confidence shaken and end up changing one's mind. And, even if the actual debaters do not shift ground, others may find their exchange instructive.

In the course of writing this book, my views changed in a number of ways. I rejected some previously held ideas, made beliefs that were vague more determinate, and resolved some areas of uncertainty. I assume that most readers, even if they are not as undecided as the one MacIntyre

imagines, find their beliefs being altered in these several ways as a result of reading and hearing the views of others.

Q. Excuse me. Have you really answered my question? Have you really said why your rational methods don't simply beg the question against antirationalists?

A. I was just about to get there. I don't think I've begged the question against them by using rational methods because I've tried to take what they say seriously, give it a fair representation in this book, and say why I agree or disagree. Beyond that, I can do no more. The verdict is in the hands of the reader, who can decide both whether my arguments are convincing or not and whether they are relevant to the concerns expressed by antirationalists. For those who are not convinced and who believe that other, less rationalistic approaches should be used, they are free to use them.

I can even recommend a few of the many nonrational sources of antirationalist thinking: Wordsworth's poems, Raymond Smullyan's jokes and stories, Nietzsche's insults and snide remarks, the Barth novels I've discussed, and the musical "Hair."

Q. Let me ask you a different sort of question. Haven't you really caricatured the classical rationalist position? It's hard to imagine anyone believing in things that are as silly as some of the things you criticize. Has anyone ever thought that we should deliberate as much as possible, try to be totally objective and detached, or put the pursuit of knowledge above all else? Haven't you really attacked a straw man in the opening chapters of the book?

A. Again, that's a good question, and again, ultimately, it's up to the reader to decide whether I've portrayed the views I criticize fairly or not. If some readers think I've been unfair, then the best thing they can do is to describe a version of the classical ideal that does not have the defects I described.

It's worth recalling, however, that the fact that a view is extreme or implausible does not mean that it hasn't been stated or implied by some great thinker. Remember Descartes' comment that

> there is nothing imaginable so strange or so little credible that it has not been maintained by one philosopher or other.[4]

It's also worth noting that this comment itself comes from a great thinker who set out not simply to doubt this or that but rather to doubt *everything* and who entertained the hypothesis that all of our experiences

may be either a dream or the product of an omnipotent, evil deceiver. Being aware of the extravagance of other people's thought evidently provides no immunity against engaging in similar extravagances oneself.

More important, as I argued in chapter 3, there are special reasons why philosophers are drawn to extreme views. The extreme views that make up the classical ideal of rationality are just one instance of this more general tendency.

Q. But what's the matter with placing a very high value on the quest for truth or a striving to be objective or valuing reasoning? Why are those absurd or unreasonable?

A. There is nothing absurd or unreasonable about placing a high value on these things. Personally, I value them a lot. What is extravagant, however, is placing so high a value on them that the value of everything else is eclipsed or denied. What is absurd is thinking that these values always outweigh other concerns or interests, and that absurdity is at least suggested in many philosophical writings. In trying to glorify the philosophical life in the *Phaedo*, Plato slips into just these errors. The result is an extreme form of rationalism that calls into question the value of the rationality Plato seeks to promote.

One of the things philosophers often do is take something that is valuable and try to turn it into *the fundamental thing*. They turn a value into an "ism." In this way, Plato, who valued rationality, turned his belief in its value into rational*ism*, thereby heightening the value of reason but exposing it to the kind of extremity I have attacked.

In making the distinction between rationality and rationalism, I'm drawing on an insightful point by Max Deutscher. He writes,

> [F]or every attitude, there is a debased form of it described as an "ism". For liberality, liberalism; for intellectuality, intellectualism, . . . for objectivity, objectivism.[5] (29)

Deutscher goes on to explain why he calls these "isms" debased. "In general," he writes,

> values are debased to the degree to which they are treated as absolutes. . . . Any value has its base in the variety of values and forms of life and interests which surround it. Within this context, it is just "one among many". Therefore, no matter how valuable, from time to time it must give way to other values. . . . To treat something as an absolute, is to absolve it of the ordinary everyday demands of experience and reason.[6]

I find what Deutscher says to be very relevant to classical rationalism. It takes rationality, something of great value in the context of our lives, and elevates it into an absolute that overwhelms other important features of our lives. Once this occurs, then we do have an extreme and implausible view.

Q. Does the fact that a view is extreme show that it's wrong? How can we tell whether an extreme view is "debased" or whether it is simply a radical but correct extrapolation of some valid insight?

A. You're right. Extreme views have a lot of appeal, and people who are deeply committed to some one thing often make a powerful impression on others. Socrates stood out as an extraordinary person because he carried the ideal of rational inquiry to an extreme. Likewise, as Plato portrays him in the *Crito,* Socrates carries the ideal of the good citizen to an extreme, since he is willing to accept a legal sentence of death, even though he believes he is not guilty of any crime. Other major figures like Jesus and Gandhi are similarly striking and influential because of their extremity.

How these people strike us, however, depends a lot on how they are portrayed and even on what mood we are in. In some moods, we find the notion that we ought to respond to assault by "turning the other cheek" as profound and insightful, while at other times it may just appear silly and unrealistic. Likewise, the willingness to die for his country that Socrates expresses in the *Crito* may strike us as noble and inspiring. In other moods we may think it merely stupid.

In any case, when we think about extreme views, we need to consider what forms of action they encourage or require. As I noted in my discussion of the evaluation of ideals, when we assess any one ideal, we need to consider what other goods would be sacrificed by adhering to it. Given the plurality of important things in life, it's unlikely that any single ideal can be defended as the only thing of importance. Any view that is committed to the pursuit of a single ideal will lead to the kinds of problems I raised about the classical ideal.

That brings me back to the question of caricature. When you suggested that I had caricatured the classical ideal, you implied that a caricature must always be wrong or misleading. In fact, however, caricatures can be quite revealing. They show us what is implicit in a person or ideal by exaggerating certain features of it. Some philosophies are themselves caricatures in this sense, since they place an exaggerated value on something or draw out a general principle to extremes.

Philosophers often caricature the views of others by taking what they

say literally and drawing out its logical implications, knowing in advance that the person didn't mean *that!* More sympathetic hearers don't take things so literally and give others the benefit of the doubt rather than imputing to them the absurd implications of the words they speak.

So, perhaps I have caricatured classical rationalism, but that doesn't mean that my objections have no force. And, as I've said before, people who want to defend some form of classical rationalism can respond to my arguments by offering a better description of rationalist values. If I've oversimplified, they can produce a more accurate and subtle account.

Q. Okay, suppose you've been more or less fair—or at least as fair as philosophers can be—toward both classical rationalists and antirationalists. I'm still troubled by a certain naive optimism that runs through your thinking. You seem to believe that we can have secure knowledge about the nature of the world and the problems that face us, about the likely effects of our actions, and about the value of these effects. Surely you're aware that many thinkers have doubted that we could have factual knowledge about the world and that many others deny that there can be knowledge of values. Yet, you've completely ignored these very deep skeptical problems. How can we be rational if we cannot have genuine knowledge? Do you have anything to say to people who take skepticism, whether about facts or about values, seriously?

A. Well . . . that's quite a big question! Answering it would really require another book, and I doubt that either of us is up to that right now. So, let me give you a sketch of an answer.

Do you remember Socrates' discussion with Euthyphro? In that discussion, Socrates appeared to show that Euthyphro did not know that prosecuting his father was the pious thing to do. Socrates did this by revealing that Euthyphro could not define "piety" and thus could not say what makes a thing pious.

Behind this procedure lies a general test for knowledge: A person who knows that something has a certain feature must be able to give a definition of the word that designates that feature. Let's call that the "definition test" for knowledge. This test is absolutely essential to Socrates' arguments. If we can have knowledge without being able to define general terms like "piety," then Euthyphro may know what piety is, even though he can't define it.

Suppose we become convinced that Socrates' definition test is a valid criterion for determining whether someone knows something. Suppose

further that most of us cannot pass the definition test, that we cannot define many of the general terms we use, ranging from words like "desk" and "game" to "piety" and "justice." Then, we will conclude that we do not know that any particular thing is a desk, a game, pious, or just. We will be skeptics about such knowledge. And, the more things we are unable to define, the less we can claim to know.

This form of reasoning actually led Socrates in the direction of a general skeptical position. Remember his telling the jury that he himself knew nothing and that when the oracle proclaimed him the wisest man in Athens, that simply meant that he alone was aware of his own ignorance. Everyone else falsely believed they knew a lot.

Socrates, of course, did not become a skeptic. He pushed onward, hoping that through continued inquiry he would gain knowledge. Others are not so persevering, however, or they come to believe that no one can possibly satisfy what seems like a reasonable test of knowledge. They become skeptics, moving from the hope of finding certain knowledge to despair about finding any knowledge at all.

Q. That's right, and you haven't shown that they are mistaken in thinking this. After all, here we are thousands of years later, and philosophers are still debating the same issues that Socrates raised.

A. Okay, but notice that there is a contradiction in the views of a person who says that we cannot know anything *because* we cannot define the general terms we use. Actually, there are two contradictions. First, such a skeptical person seems to be claiming to know that we can't know anything. Second, the skeptic's claim is only plausible if there is reason to believe that the definition test is the correct criterion of knowledge. Unless the skeptic knows this, he or she cannot know that we lack knowledge generally.

When skeptics argue that we lack knowledge, they must be relying on a criterion for knowledge. If we *cannot* know this criterion to be correct, then we have no reason to accept their view. But if we *can* know their criterion to be correct, then we must possess some knowledge after all.

Pressing this further, though, we can see that the fact that a criterion of knowledge leads us to the conclusion that we know nothing at all may cast doubt upon the criterion itself. Just as an IQ test that revealed Einstein to be minimally intelligent would show itself to be an invalid measure of intelligence, so a test for knowledge that implies universal ignorance may well reveal its own defects rather than the defects of our knowledge.[7]

Q. I see your point here, and I think that it works against a total

skeptic, a person who claims that we know nothing. I don't see, however, that your argument has any force against more selective forms of skepticism, for example, a value skepticism that holds that we can have scientific knowledge but not knowledge of what is good or bad, right or wrong. How do you answer that kind of view?

A. Again, this is a big issue, but I'll try to give you a brief answer. As I said earlier, every form of skepticism presupposes a criterion of knowledge. Some people, like the logical positivists, for example, claimed that we can have scientific knowledge but no knowledge of values because scientific claims can be empirically verified or falsified, while there is no empirical verification for beliefs about values.

This view, however, is untenable for two important reasons. It turns out to be much harder to verify and falsify scientific beliefs than people had thought. The history of philosophy from Descartes to Kant to Russell and the positivists is dominated by the difficulties of verifying our most basic factual beliefs about the world. In the last twenty-five years or so, many of these problems have been discussed in terms of the issues raised by Thomas Kuhn in *The Structure of Scientific Revolutions*.

Even if one could show that factual beliefs satisfied a criterion of knowledge, however, that would not undermine value beliefs because a criterion of knowledge is itself a criterion of value. To call some belief knowledge implies that it is justified, that it has some value as a belief that other beliefs lack. There is no way to make a pronouncement about the general possibility of knowledge without making some value claims. So, people who want to say that we can know facts but can't know values run into contradictions of the sort I described earlier.[8]

Q. Aren't you overworking this sort of argument? And besides, even if you're right, that seems to lead to a deeper skepticism. If we can't know the truth of value judgments and if any criterion of knowledge involves value claims, then perhaps we just don't have that kind of knowledge either. All you seem to be showing is that it's hard to justify any view, including skepticism, but you haven't really shown that we have knowledge.

A. Let's be careful here. Grant me for a second the idea that the burden of proof is on skeptics to show that we have no knowledge in general or no knowledge of particular sorts. If that is true and if I can show that skeptical views contain serious contradictions, that in fact they presuppose the very sorts of judgments they attempt to undermine, then that refutes these views.

Q. But why think that the burden of proof is on skeptics? Isn't it up to people who think they have knowledge to prove what they claim to know? If they can't, then maybe that would show that skeptics are right after all.

A. Okay, but there's one more crucial point, one that John Dewey stressed very effectively. Even if someone could offer a proof of skepticism and could demonstrate that we have no knowledge or no knowledge of a particular sort, their proof would be irrelevant from a practical point of view. We would still have to live, and that means that we would still have to make judgments about the nature of the world, the probable effects of our actions, and the value of various ends that we seek. What Dewey and James both stressed is the centrality of our practical needs. Recall John Kekes's nice point that "problems of life" are unavoidable.

Dewey argued that the quest for theoretical certainty was irrelevant because action in the world is always *un*certain, and we need to do the best we can in a world of uncertainty. That means that we need to devise ways of testing beliefs even though there is no guarantee that they will provide true answers. We need to learn to live with fallibility and uncertainty. That is not the same as being a skeptic, however.[9]

For Dewey, the test of a belief is its role in solving our problems. How do we identify our problems? This presupposes certain beliefs about the nature of the world, about ourselves, about our needs and the dangers we face. In addition, it presupposes certain value judgments— that life is generally better than death, that health is better than illness, that food is better than hunger, companionship better than loneliness, etc.

We also know that we have minds, that we can discover things about the world, that we can think about our problems and improve our responses to them. To be rational is to make the best use of our cognitive powers in striving for things we take to be good.

In the end, perhaps skepticism's greatest problem comes after the alleged proof that we have no knowledge. For at that point, we must turn to the skeptic and ask what difference skepticism should make to our lives. Should we not have beliefs or take action? And if we must both believe and act, then shouldn't we do these things as well as possible, even if some high ideal of successful inquiry cannot be met?

I'm reminded of the fact that for many years, under the influence of logical positivism and the emotive theory of ethics, eminent

philosophers believed that there could be no rational, philosophical discussion of ethical and political issues. Political philosophy was thought by many to be a thing of the past. Then, in the late 1960s, burning controversies arose out of the civil rights movement and the debates about the Vietnam war. In the wake of these events, ethics and political philosophy came to life again, and philosophers began to debate and theorize about issues that had been ruled out as mere matters of feeling and not fit subjects for the profession of philosophy.

Why did the change occur? I think there are two crucial reasons. First, the issues of the 1960s—racial injustice, civil disobedience, the legitimacy of war, the duty to fight for one's country—all of these issues were too important to ignore. Second, no matter what philosophers might have said about the absence of rationality in disputes about value, it became clear that people did *argue* about these things. People on all sides put forward the pros and cons of racial segregation, civil disobedience, the justice and injustice of war, the duty to fight or to resist military service. Philosophers could see that expertise in analyzing arguments was relevant in assessing what people were saying. Even if the most rigorous standards of proof could not be met, still some arguments were better than others, and there were ways of pointing this out.

Q. Okay, but how does this bear on the general problem of skepticism that I began with?

A. My point is this. If issues and problems are important enough, then we need to form beliefs about them and about how to respond to them. And, even if one could prove skepticism to be true, we would still need to do these things.

If someone proves some form of skepticism to be correct, the next question is "what do we do now?" Do we cease to reason? Do we stop trying to form better rather than worse beliefs about the world, the goals we seek, and the means we use to attain them? If skeptics say we should stop, then they need to show us how this would improve our lives. If they do not say we should stop, then skepticism is irrelevant, since it tells us nothing about how we should think and act.

Q. Isn't that just a pragmatic argument?

A. Of course it's a pragmatic argument, but at this point, I'd hope you would not see that as a weakness. Remember, the great advocates of the classical ideal of rationality tried to justify it pragmatically—that is, by considering the effects of its adoption on the value of people's lives. I'm simply using the same criterion for thinking about how seriously we should take skepticism.

Q. I see. Well, since we're being pragmatic, perhaps we should stop now so I don't miss my train.

A. Fine. We can continue another time.

Afterword III
Rationality: Doubts and Theories

In recent years, questions and doubts about the nature and value of rationality have been expressed in many works by diverse authors. The spirit of them is perhaps best captured in the title of Alasdair MacIntyre's book, *Whose Justice? Which Rationality?* MacIntyre's title calls into question any attempt to clarify the nature of rationality and to evaluate competing standards of rationality. It suggests that there are many rationalities and that questions about their relative worth are not rationally decidable. Early in the book, he writes that "rationality itself, whether theoretical or practical, is a concept with a history," and because this history contains "a diversity of traditions of enquiry," there is no such thing as *the* nature of rationality. There are, he writes, "rationalities rather than rationality."[1] Much of the historical analysis in his book appears designed to support a kind of skeptical relativist view of rationality, even though MacIntyre himself finally rejects such a view.[2]

Similar doubts about rationality have been raised by feminist philosophers, many of whom have argued that our ideals of rationality are not general human ideals but are instead idealizations of masculine traits. In *The Man of Reason: "Male" and "Female" in Western Thought,* Genevieve Lloyd calls attention to the gender specific connotations of a phrase ("man of reason") that might in the past have seemed quite neutral. "Our trust in a Reason that knows no sex," she writes, "has been largely self-deceiving."[3] Instead of being neutral with respect to the sexes, rational ideals have incorporated traits specifically identified with men. According to some feminists, rationality has not only failed to be neutral but has been an ideal that has been used against women. As Sara Ruddick writes,

> Reason, at least as Western philosophers had imagined Him, was infected by—and contributed to—the pervasive disrespect for women's minds and lives.... For a woman to love Reason was to risk both self-contempt and a self-alienating misogyny.[4]

Even though Ruddick wants to salvage or reconstruct rationality, she stresses that rational ideals have not been an unalloyed good for women and that it remains difficult for women to embrace rational ideals.[5]

Feminist discussions of rationality give added force to questions like MacIntyre's "Which Rationality?" and reinforce both doubts about the worth of rationality and questions about whether we ought to be skeptical or relativistic about rationality.

These questions and the existence of a widespread, skeptical attitude about reason may make one wonder how any author can be presumptuous enough to support any particular view of rationality as *the* correct one. Isn't the moral of the story that there is no single criterion and that rationality is relative to many different things?

Theories of Rationality

Many of these questions are addressed in earlier chapters of this book. To the extent that they are rejections of the classical ideal of rationality, I agree with them. In many cases, however, they go beyond this and appear to undermine the idea that there could be an acceptable rational ideal.

I want to approach this more general challenge by trying to get an overview of the nature of the theory of rationality as an area of philosophical inquiry. Without a clearer understanding of the questions that competing theories of rationality are addressing and the nature of diverse answers to them, it is hard to come to terms with the challenges of skepticism and relativism.

In discussing the aims of theories of rationality, I will draw on the many parallels that exist between rationality as a subject of inquiry and moral philosophy. In describing the subject matter of moral philosophy, it is helpful to divide it into three somewhat distinct (but nonetheless interrelated) areas: applied ethics, normative ethics, and theoretical ethics (sometimes called "meta-ethics").[6] *Applied ethics* deals with questions about how to behave in specific cases or with respect to relatively specific types of actions. Am I morally obligated to keep an appointment that I was roped into if my absence is unlikely to make a difference? Should I fight in a war if I have doubts that my country's position is justified? Are actions like capital punishment, abortion, and euthanasia morally permissible? These are the sorts of practical questions that constitute "applied ethics."

In approaching such practical questions, philosophers and other thinkers often look for general rules or principles that would answer specific questions like these. In its most ambitious form, the area of *normative ethics* is the search for the true moral code, a set of moral norms or principles that could be applied to specific cases to tell us how we ought to act. Examples of moral codes that are sometimes described in this way are the Ten Commandments, the Golden Rule, utilitarianism, and Kant's categorical imperative.

Finally, the area of *moral theory,* or *meta-ethics,* deals with questions about the nature and justification of morality. Someone who attempts to provide a justification for a particular moral code is engaged in moral theory. She is no longer describing the norms of behavior (the various "thou shalts" and "thou shalt nots") that make up the code. Instead, she is trying to show why this set of moral norms is the correct one.[7]

The contrast between moral theory and normative ethics is perhaps clearest when we consider those views that reject the idea that there is a moral code that we can know to be true. It is obvious that such theories do not aim to provide norms of behavior. Emotivists, for example, believe that no moral code can be true because moral "judgments" are simply expressions of feeling or emotion. Extreme relativists deny that there is any single true moral code because there are no absolute values, principles, or judgments. Rather, different moral codes are valid for particular groups or individuals. Finally, moral skeptics believe that even if there is a true moral code, we have no way to know what it is. Debates about these various positions make up much of moral theory. Unlike normative ethics and applied ethics, these debates do not directly concern how we ought to act. Nonetheless, their outcome often suggests normative implications. How we answer these theoretical questions affects the degree to which we think particular moral norms or moral norms in general can be justified.

One task of moral theory is to describe the nature of morality. What makes something a moral rule or a moral code? What does it mean to describe an act or person as "moral" or "immoral"? Even skeptics and emotivists, people who reject any particular norms as fully justified, have some concept of morality. Otherwise, they would not understand their own claims about the impossibility of justifying claims to moral knowledge. So, questions about the nature of morality are central questions in theoretical ethics.

The philosophical study of rationality can likewise be divided into three areas, which I will call applied rationality, normative rationality,

and rational theory (or metarationality). "Applied rationality" aims to tell us what it is rational to do in particular cases or whether certain types of action can be rational. Discussions, for example, of whether suicide or masochistic acts can be rational would fall into this category, as would questions about the rationality of behaving morally. "Normative rationality" consists of the attempt to state general principles or norms for determining what actions are rational. An egoistic normative theory, for example, tells us "always do what is in your own best interest," while a means/end theory tells us "act so as to achieve your goals as effectively as possible." Advocates of objective deliberation tell us "do whatever seems best after careful, detached consideration of the available options."

Finally, "rational theory" consists of attempts to justify particular norms of rationality, inquiry into the nature of rationality, and discussions of the status of normative rational principles. Because there is often a close relationship between particular views of normative rationality and "metatheories" about the nature of rationality, it is easy to confuse the two. Consider an egoistic theory of the nature of rationality. According to this view, to act rationally just is to act so as to advance one's own interests. Since this view says that acting to maximize benefits to oneself is rational and that acting otherwise is irrational, it appears to imply the normative principle that everyone ought to act egoistically.

This is a mistake, however. This normative implication only follows if we assume that calling something "rational" necessarily endorses it. In fact, this is normally true, but "rationality" might be defined in such a way that one does not want to endorse behavior that qualifies as rational. If the egoist view about the nature of rationality is correct and self-interested actions are the only rational actions, then people who value altruistic behavior may come to see rationality as an obstacle to virtuous behavior. Even if they accept the metatheory that defines rationality in terms of self-interested behavior, they would still reject the rational norm that tells us to behave in this way.

This relates to a point I discussed earlier. (See the Introduction, part II.) Advocates and opponents of rationality often accept the same metatheories, describing rationality in the same way but supporting quite different normative judgments about how we should behave. Both rationalists and romantics, for example, could agree that being rational requires being objective, logical, detached, and deliberate. Yet they differ sharply about whether these are good traits or not. When they do this, they are agreeing on a metatheoretical thesis about the nature of

rationality but disagreeing about whether to endorse norms that tell us to be objective, logical, detached, and so on.

The simplest way to prevent confusion between metatheories about the nature of rationality and norms of rational behavior is to keep in mind that norms can always be expressed as rules or imperatives.

In concluding this sketch of different aspects of the philosophy of rationality, let me point out that the issues of skepticism and relativism mentioned at the outset are part of the theoretical discussion of rationality. They are concerned with whether we can know what is rational, as well as whether the criteria apply universally or are limited to people or groups that accept them. Before turning to these issues, it will be helpful to consider one more feature of competing attempts to state the norms of rational behavior.

Generality Versus Specificity

When we consider the various attempts to state norms of rational behavior, it is evident that there are wide variations in the degree of specificity of these norms. An egoistic norm of rationality, for example, says that each of us should act so as to maximize our own interests. This view is quite general insofar as it does not say what those interests are. By contrast, a norm that combines egoism and hedonism tells each of us to maximize our own pleasure or happiness. This hedonistic version of egoism is more specific in its normative import. Still, by itself it implies no specific behavior since it does not say how to go about producing pleasure for oneself. A theory that endorses specific routes to pleasure as the most reliable (e.g., the acquisition of money, power, friendship, or knowledge) would be more specific still.

Some theories of rationality, including the "acting for the best" view, are pluralistic. They recognize many distinct ends as rational to seek. Such pluralist theories also vary in their specificity. Some might specify a limited list of valuable ends and claim that these alone are worthy of pursuit. Others are more general, perhaps giving some examples of worthwhile ends but not endorsing any list as complete or exhaustive of all that is worthwhile. Both would be pluralistic, but one would be more general and the other more specific in its normative content.

If our inquiries about rationality are motivated by practical concerns, we may be dissatisfied with highly general norms. We may want more

specific norms that can provide practical advice in concrete situations. This desire is satirized by John Barth in *The End of the Road* when he has Jacob Horner tell us

> I read Sartre but had difficulty deciding how to apply him to specific situations (How did existentialism help one decide whether to carry one's lunch to work or buy it in the factory cafeteria? I had no head for philosophy). (86)

What Horner's remark brings out, of course, is the foolishness of expecting general norms to have such specific implications. If differences between people and facts about their immediate circumstances are important in determining what it is rational to do, then one should not expect an abstract norm of rationality to tell a person how to behave. It will offer general guidelines and constraints, but it will not by itself issue specific directives for action. The failure of theory to provide specific advice is not necessarily a fault then. Indeed, specificity can be a vice. By overlooking relevant differences among people, a highly specific norm that is put forward in universal form can generate inappropriate advice about how individuals ought to act.

Relativism and Rationality

Relativism enters into views about rationality in different ways. At the level of theory, a relativist view might say that no norms of rationality apply universally. Or, relativism could be incorporated into the norms of rationality themselves. The saying "when in Rome, do as the Romans do," is a normative principle, a directive about how to behave. It says to follow Roman rules while in Rome and presupposes that there is a set of specific norms that constitutes the rules of behavior for Romans. The saying suggests a metatheoretical view as well, namely, that rules of behavior only apply locally so that no norms have universal or absolute status.

MacIntyre's rhetorical question "which rationality?" inspires similar thoughts. It suggests that one ought not to be troubled if one's actions are called irrational when they are judged by any particular rational norm. This is because there may be alternative norms with respect to which one's actions are quite rational.

Both relativism and its opposite, absolutism, are unattractive in certain ways. Each is associated with a different philosophical specter.

Relativism suggests an overly permissive, "anything goes" attitude and the undermining of all standards. Absolutism, by contrast, suggests a presumptuous tendency to judge everyone by one's own purely personal standards. It smacks of a kind of philosophical rigidity and narrow-mindedness that equates one's own judgments with the voice of Reason itself. Because neither of these views is especially attractive, the choice between them is quite difficult.

In my view, we need not succumb to either specter because this picture of the choice that faces us is misleading. We can see why by noticing that the terms "relativist" and "absolutist" are quite unclear. It is natural, for example, to think of means/end theories as relativistic because they make the rationality of actions relative to the desires of the agent. They neither require nor forbid any particular desires. Hence, what is rational for one person to do need not be rational for another. While skydiving may be a rational activity for you because you desire the feeling of free fall, it is irrational for me because I regard that feeling with terror. The means/end theory says that the action is neither inherently rational nor irrational and that there is no absolute standard of rationality by which to judge it.

Because the means/end theory places no limits on the aims that people may (rationally) pursue or the desires they may seek to satisfy, it appears to be an extreme form of relativism. Notice, however, that means/end views affirm that all rational actions have something in common: they all are means to attain the aims of the agent. Hence, there is an important respect in which the means/end theory is absolutist. Understood as a norm of rational action, it addresses a categorical imperative to all agents: "do what will attain your ends." That is the one absolute principle of rational action for means/end theorists. It is the sole standard of rational evaluation of actions, and it applies universally to all actions of all persons in all times and places.

Described in this way, the means/end theory does not appear to be relativist at all. Yet, when we focus on the unlimited range of desires and the fact that the rationality of actions is relative to the desires of the agent, the theory seems radically relativistic. Which is it, relativist or absolutist?

The answer is that it is both, and this is an extremely important point because it shows that the simple opposition between relativism and absolutism is a mistake. A theory can be absolutist in some respects and relativist in others. The means/end theory illustrates this. It is absolutist because it affirms a single universal norm of rational action, but it is

relativist because it accepts each person's desires as the standard for evaluating goals.

The sharp dichotomy between relativism and absolutism also breaks down because views can exhibit different degrees of relativism (and, conversely, of absolutism). For example, the basic means/end theory is a fairly extreme version of relativism insofar as it imposes no constraints at all on what a person may desire. Brandt's version of the means/end theory is also relativistic with respect to evaluating goals, but it is less relativistic than other means/end theories because it places limits on the types of desires that qualify as rational for a person to act on. For Brandt, acting to satisfy a desire is rational only if that desire can survive cognitive psychotherapy. If it cannot, then acting to satisfy it is irrational. There is, then, an important respect in which Brandt's view is absolutist. It (rationally) forbids acting on desires that would not survive cognitive psychotherapy. Even if a person wants to act on these desires, that does not matter, for Brandt's "extinguishability" criterion applies independently of whether a person accepts it or not. While his view is still quite permissive (since it does not rule out any specific desires as inherently irrational), it is a far cry from the "anything goes" attitude that characterizes the most extreme types of relativism.

We can further see how views exhibit different degrees of relativism by considering a norm that combines Brandt's "extinguishability" criterion with Gert's "evil avoidance" norm. Like Gert's view, this combined view would rule out certain desires as inherently irrational; unlike Gert's, it would not permit acting on all other desires. Instead, it would add Brandt's criterion as an additional constraint on other desires. On this view, acting to satisfy a desire is rational when a) the agent does not desire death, pain, disablement, etc., and b) the desires the agent acts on would survive cognitive psychotherapy. This two-part criterion is more restrictive and hence less relativistic than either Gert's or Brandt's original views. It is absolutist to some degree because it imposes "absolute" constraints on acceptable desires, but it is relativistic to some degree because the rationality of actions still depends on the desires of the person acting.

My point in describing these different views is not to advocate them. Rather, I want to show that the question of whether a theory is a form of relativism or absolutism need not have a simple "yes" or "no" answer. This means that the various specters associated with different types of theories may be irrelevant. As I have just shown, not every theory with absolutist features implies rigidity or intolerance. It may be quite

sensitive to individual differences among people and their desires. Likewise, not every relativist theory implies complete permissiveness or a rejection of all rational standards. Hence a theory's being relativistic or absolutist does not by itself show that it has any particular flaws or virtues. In order to tell whether it is acceptable, we must look at the degree of relativism it embodies and the respects in which it is or is not relativist. It is not enough just to react to competing specters.[8]

Hedonism is a good example of an absolutist theory that accomplishes much that is appealing to relativists. The theory is absolutist because it says that in acting rationally, we should always act so as to produce the most pleasure or happiness. Nonetheless, hedonism combines this single value absolutism in theory with a radical pluralism in practice. Because different people experience pleasure from different things, hedonism implies that it is rational for different people to pursue different (sub)goals, even though all rational people have the same ultimate goal. A theory, then, can affirm unity at the theoretical level with diversity at the level of practice.[9]

Consequentialism Versus Deontology

In comparing differing views about rationality, it is helpful to use another distinction from moral philosophy, the distinction between consequentialist and deontological theories. In moral philosophy, consequentialist views tell us that the rightness and wrongness of actions depend on their results, while deontological theories describe right and wrong by reference to features other than results. Utilitarianism is an example of a consequentialist view, since it tells us that an action is right if, among all the actions possible, it is the one with the most positive effects on the well-being of everyone affected by it. A religious ethic is an example of a deontological theory, since it tells us that right acts are those that are commanded by God. Such a view evaluates actions by looking at their conformity with God's wishes rather than their results.

Theories of rational action fall into both categories. Among consequentialist theories, some classify actions as rational if they maximize pleasure or increase knowledge. The "acting for the best" criterion is a consequentialist theory. Without specifying particular goods, it says that it is rational for a person to perform the action with the best foreseeable consequences.

In contrast, what I called "method-based" criteria of rational action

(in chapter 3) are deontological theories. They tell us that an action is rational if, for example, it is done after full deliberation or in the light of full knowledge or is chosen from an objective perspective. According to these views, the rationality of actions is not directly related to their consequences. So long as the action is chosen as the result of a "rational" procedure, then it is rational, no matter what its result might be.

Classical Rationality Revisited

The classical view can be expressed either in consequentialist or deontological form. In its consequentialist form, it says that such things as having knowledge, being objective, and deliberating carefully are things of great value. Hence, the end that is rational to seek in life is the maximization of knowledge, objectivity, and deliberation. Actions are rational if they further these ends. Alternatively, in its deontological form, the classical ideal tells us that actions are rational if they are chosen from a perspective that is objective, informed by knowledge, and the result of careful deliberation. According to this view, it is the fact of being chosen from a favored perspective that makes actions rational.

Finally, we can combine these two views and see each one as a component of the classical ideal. According to this interpretation, classical rationalists claim both: 1) that goals or ends are rationally desirable if they are chosen on the basis of objective, informed deliberations, and 2) that when we evaluate various ends from this perspective, we find that the only rationally desirable end is a life in which there is as much knowledge, objectivity, and deliberation as possible. In Socratic terms, the "examined life" is the only worthwhile life because when we deliberate in an objective, fully informed manner about the variety of possible ends, we see that the process of engaging in objective, informed deliberation is the only thing of intrinsic value. By rationally examining possible forms of life, we come to see that a life of examining life is the only genuinely good life. This combined interpretation seems best to capture the spirit of the classical ideal of rationality.

If a view can combine both consequentialist and deontological aspects, one might wonder whether the distinction between these types of views is helpful here. The reason is that it enables us to ask which of these components is more fundamental. If the consequentialist part (the assertion that cognitive activities alone have intrinsic value) is funda-

mental, then the classical ideal is committed to the extreme intellectualism I have criticized. If the deontological component is more basic, however, then it remains an open question what sorts of states or activities might be chosen on the basis of objective, fully informed deliberations. If other ends that are not fundamentally cognitive would be chosen from this perspective, then one could be a deontological rationalist without embracing the exclusively intellectualist goals of the classical tradition.

Beginning with this deontological perspective and applying it to the examination of various types of lives, one need not arrive at the conclusion that the examined life is the only form of good life. Rather than concluding with Socrates that the examined life is the only valuable life, one could hold that lives are valuable if they would appear valuable on the basis of informed, objective evaluation. On this view, an unexamined life might well be worth living if it included other elements of value, such as great zest and vigor, close personal relationships, or a healthy balance of pleasurable over painful experiences. In addition, applying this method to different people need not yield the same answer about what each ought to pursue. Indeed, as I argued earlier, this sort of evaluation could even support the conclusion that a particular person would be better off not engaging in this sort of evaluation.

Emphasizing the deontological or method component of the classical ideal, one could end up with a different and more plausible set of evaluations than one gets if one begins with the consequentialist version of classical rationality. Such a view could allow that the examined life might have been best for Socrates, for example, but not for Jacob Horner. It need not condemn cognitive or reflective ends, but neither must it recommend or require them for everyone.

Of course, the specific method of rational, informed deliberation that classical rationalism promotes is also defective in a number of ways. For example, it appears to require perfect objectivity and detachment and thus no attention to emotions or desires. I argued in chapter 4 that these stringent requirements are both impossible to meet and undesirable. Perfect objectivity might lead to nihilism and indifference rather than the recognition of genuine values. We need something that is both more and less perfect—that is, less perfect in the sense of less extreme, but more perfect in the sense of better suited to informing human beings about the constituents of good lives.[10]

It is worth noting that feminist criticisms of rationality have been

directed against both components of the classical ideal. Feminists have criticized the deontological aspect of the classical ideal for its emphasis on detachment and objectivity, seeing these as ruling out caring, concern, involvement, and other forms of emotional attachment that have traditionally been associated with women. Similarly, feminists have objected to classical rationalist claims that a life of intellectual pursuits is the only form of worthwhile living. For some feminists, this ideal is objectionable because it excludes activities, such as raising children, that are associated with women and that have great value.[11] Since these points are closely related to criticisms that I raised against the classical ideal, I see no tension between my own discussion and that of many feminists. Their critiques provide additional confirmation to claims I have made about the negative aspects of the classical ideal.

I differ with those feminists who want to dispense with rationality because I deny that the classical ideal is either the only or the best conception of rationality we possess.[12] Several of the theories I have discussed, including the "acting for the best" criterion, are capable of recognizing the genuine value of many goals and activities that have traditionally been associated with women. They do this not because such goals are rooted in tradition but rather because reflection shows them to be genuinely valuable. If other traditional goals and activities associated with women require subservience or the acceptance of diminished status, then they lack genuine value and can be rejected as unworthy ideals.[13]

"Acting for the Best" Revisited

Where does the "acting for the best" criterion of rationality fit into the various classifications I have described?

First, as a definition or analysis of what it is to be a rational action, the "acting for the best" view is a metatheory. I offer it as the closest approximation to what we mean in calling an action rational.[14] It can also be seen as the fundamental norm of rationality: "act for the best." Other rational norms are more specific but are also subservient to this fundamental one.

Second, "acting for the best" is a consequentialist view. It says that it is rational to perform the action with the best foreseeable consequences. As such, it states a certain goal for rational action. Nonetheless, like most

other consequentialist theories, it describes that goal only in general terms. The "acting for the best" view takes a pluralistic view of the goals of rational action. Unlike the classical ideal, it does not restrict all legitimate goals to one thing (like knowledge). Nor does it reduce them all to one type of thing (source of pleasurable experiences or means of satisfying desires). While it recognizes the importance of people's desires, it does not see desires themselves as the source of value and is willing to rule out goals, even if they are deemed desirable by the person who seeks them. In this sense, the view is absolutist rather than relativist. Nonetheless, like other forms of pluralism, it recognizes a wide variety of ends as having value and thus lacks the rigidity that often pushes people from absolutism toward relativism.

Third, while the theory is consequentialist, it evaluates actions in terms of their foreseeable results and relativizes foreseeability to specific agents. An action with bad consequences is not irrational if the agent could not be expected to foresee its bad results. Moreover, just as there are limits on the factual knowledge available to people, so too are there limits on the goods that a person can be expected to appreciate. Failure to act so as to produce a valuable result is not irrational if that value is so culturally remote from a person that she could not be expected to appreciate its value. All of us are limited by our place in history and society. We are fortunate if our culture attunes us to things of value and unfortunate if its tendencies misdirect us away from what is genuinely good and toward things of little consequence.

Fourth, in assessing what is best, the theory takes the agent's point of view as its starting point. To act rationally is to act for the best, as "the best" could be expected to be understood by the agent. A pure egoist, from this perspective, could act for the best from the rational perspective and yet act in a way that is grossly immoral. This is because, as I have argued earlier, the moral perspective and the rational perspective are not identical. Hence, actions that are morally wrong may be rationally permissible. This is a distasteful point, but it was recognized as at least plausible by Plato in his telling of the Gyges story in *The Republic*. This does not mean that being moral is irrational, but it does mean that the rational perspective does not invariably require morally right actions.

Common sense seems to support this judgment. We seldom think that people who lead exemplary moral lives are stupid, crazy, or irrational. Nonetheless, we do not generally think that those who act abominably necessarily act contrary to reason. Though there are always

good reasons for acting well, it is an unfortunate fact of life that there are often good reasons for acting badly. The "acting for the best" view does not deny or gloss over this fact.

Summing Up

In this section, I have tried to address some of the questions and doubts that have been raised in recent years about rationality and rational ideals. I have also suggested that we might better understand some of these challenges by trying to get a more systematic view of the "philosophy of rationality" as a field of inquiry, and I have borrowed concepts from moral philosophy to begin sketching a framework of understanding.

One problem, of course, is that the concept of rationality plays such a central role in so many areas of philosophy. This makes it more difficult to get a good overview, but it also makes the attempt to achieve it even more important.

Afterword IV
Final Thoughts

I closed the original version of this book with the quote from T. H. Huxley that still concludes chapter 13. Huxley, speaking about the ideally educated person, seemed to me to summarize nicely a list of attractive traits that I thought were compatible with rationality. I liked the quote because it contrasted so nicely with the classical ideal. While it includes elements of the classical ideal (a clear intellect and a mind stored with truths about nature), it also stresses a "tender conscience," strong passions, "a love of all beauty," a hatred of "vileness," and a respect for other persons.

My point in quoting Huxley was to show that there was no genuine good that rationality excludes. That remains true and worth remembering. Many of reason's critics have mistakenly thought that rational ideals necessarily denigrate or omit things of significant value.

Nonetheless, the critics of reason are correct if their point is that rationality is compatible with an absence of other central values. Reason does not require a tender conscience, a love of natural or artistic beauty, or a respect for others. Because there are many significant virtues that a rational person need not possess, it is not enough for people who support humane values to be advocates and champions of rationality. We need to strengthen and promote all those elements of human life and human nature that are life-enhancing. This involves strengthening much that is not required by reason or essential to being rational.

It is worth recalling one of Jacob Horner's critical remarks about Joe Morgan. Morgan, Jacob says, is "just insane, a monomaniac: he's fixed in the delusion that intelligence will solve all our problems" (23). Horner is right. This is a delusion. Intelligence is a valuable trait of human beings, and we certainly have not fully realized the contribution it can make to human good. Nonetheless, intelligence has also contributed to the creation of death camps and weapons capable of destroying everything of human value. While the use of our intelligence and the enlargement of our knowledge are crucial to any efforts to improve human life, intelligence alone will not solve our problems. For this

reason, we need to honor and cultivate every feature of ourselves that can contribute to making the world a more just, more peaceful setting for people's lives.

To recognize this is in no way to reject rational ideals and values. It is only to point out that they are not the only ones that are worthy of our allegiance.

NOTES

CHAPTER 1: THE CLASSICAL IDEAL

1. Plato, *Apology* 38a.
2. Plato, *Euthyphro* 4e, trans. Lane Cooper, in *Plato: The Collected Dialogues*, ed. E. Hamilton and H. Cairns (New York: Pantheon Books, 1961).
3. Ibid., 15d.
4. M. Black, "Reasonableness," in *Reason*, ed. R. F. Dearden, P. H. Hirst, and R. S. Peters (London: Routledge and Kegan Paul, 1972), 55.
5. K. Popper, *The Open Society and Its Enemies*, 5th rev. ed. (Princeton, N. J.: Princeton University Press, 1966), 2: 238.
6. Plato, *Crito* 46b, trans. Hugh Tredennick, in *Collected Dialogues*, ed. Hamilton and Cairns.
7. Ibid., 48b.
8. I discuss Socrates' actual arguments about the morality of escape in *Should We Consent to be Governed?—A Short Introduction to Political Philosophy* (Belmont, Ca.: Wadsworth, 1992), chs. 1 and 2.
9. *Crito*, 46c.
10. R. Descartes, *The Principles of Philosophy*, Part I, Section LXXI.
11. Richard Rorty appeals to the "contingency" of our beliefs as part of an argument to undermine classical ideals of rationality. Unlike Socrates, he believes that this contingency is not something we can escape and therefore that the ideal of objectivity is an illusion. For this argument, see his *Contingency, Irony, and Solidarity* (Cambridge: Cambridge University Press, 1989).
12. Cf. R. S. Peters, "Reason and Passion," in *Reason*, ed. Dearden, Hirst, and Peters, 58–79.
13. For the concept of an ideal observer, see R. Firth, "Ethical Absolutism and the Ideal Observer," *Philosophy and Phenomenological Research* 12 (1952): 317–45.

14. For the story of Gyges, see Plato, *Republic* 2: 359d–360b.

15. For a variety of responses to the problem of egoism, see D. Gauthier, ed., *Morality and Rational Self Interest* (Englewood Cliffs, N.J.: Prentice-Hall, 1970).

16. Plato, *Republic* 9: 589a–b, trans. Paul Shorey, in *Collected Dialogues*, ed. Hamilton and Cairns.

CHAPTER 2: JOHN BARTH'S CRITIQUE OF PURE REASON

1. Cf. the conclusion to Ernest Gellner's *Words and Things* (Harmondsworth, England: Penguin, 1968), 296: "Philosophy is explicitness, generality, orientation, and assessment. That which one would insinuate, thereof one must speak."

2. For a somewhat different defense of the philosophical importance of fiction, see Martha Nussbaum, *Love's Knowledge: Essays on Philosophy and Literature* (New York: Oxford University Press, 1990), ch. 1.

3. John Barth, *The Floating Opera*, rev. ed. (New York: Bantam Books, 1972; orig. ed. 1956), 1. Subsequent page references are in the text. Readers should note that there are two versions of the novel. I discuss the "revised" edition, which (somewhat paradoxically) contains Barth's original ending.

4. For more about Todd's history and character, see my "Nihilism, Reason, and Death: Reflections on John Barth's *Floating Opera*" in *The Philosophical Reflection of Man in Literature*, ed. A. T. Tymieniecka (Dordrecht, Holland: Reidel, 1982).

5. John Barth, *The End of the Road* (New York: Bantam Books, 1969; orig. ed. 1958), 3. Subsequent page references are in the text.

6. It is worth noting that while the ideas in this passage are related to existentialist worries about the absurdity of existence, Barth's book differs significantly from those of Camus or Sartre. Barth's often bleak vision is saturated in a grim but genuine humor which is evidenced in this passage by his use of the word "cosmopsis." Barth himself called his first three novels an "amusing nihilistic trilogy." For this and other interesting comments, see "John Barth: An Interview," *Wisconsin Studies in Contemporary Literature*, no. 6 (Winter-Spring 1965): 3–14.

7. D. Hume, *A Treatise of Human Nature*, ed. L. A. Selby-Bigge (Great Britain: Oxford University Press, 1888), 415.

8. Barth himself saw his novels as nihilistic. For his comments, see "John Barth: An Interview," *Wisconsin Studies in Contemporary Literature*, no. 6 (Winter-Spring 1965): 3–14. I have tried to show that the novels do not establish nihilism in "Nihilism, Reason, and Death: Reflections on John Barth's *Floating Opera*" in *The Philosophical Reflection of Man in Literature*, ed. A. T. Tymieniecka (Dordrecht, Holland: Reidel, 1982), and in "Nihilism, Reason,

and the Value of Life," in *Infanticide and the Value of Life,* ed. M. Kohl (Buffalo: Prometheus Books, 1978).

INTRODUCTION TO PART II: DEFECTS OF THE CLASSICAL IDEAL

1. M. Black, "Reasonableness," in *Reason,* ed. R. F. Dearden, P. H. Hirst, and R. S. Peters (London: Routledge and Kegan Paul, 1972), 53.
2. Ibid., 44.
3. For two examples, see Philip Slater, *Earthwalk* (Garden City, N.Y.: Anchor Press/Doubleday, 1974), and *The Wayward Gate* (Boston: Beacon Press, 1977), as well as Theodore Roszak, *The Making of a Counter-Culture* (Garden City, N.Y.: Anchor Press/Doubleday, 1969).
4. For a brief discussion that brings out why women might be ambivalent about rational ideals, see Sara Ruddick, *Maternal Thinking* (Boston: Beacon Press, 1989), 3-12. For a survey of feminist thinking about rationality, see Susan Hekman, *Gender and Knowledge: Elements of a Postmodern Feminism* (Boston: Northeastern University Press, 1990), 30-47. For feminist discussions of rational ideals in traditional philosophical thought, see Elizabeth Spelman, "Woman as Body," *Feminist Studies* 8 (1982), 109-31, and Genevieve Lloyd, *The Man of Reason* (Minneapolis: University of Minnesota Press, 1984).

CHAPTER 3: REASON AND DELIBERATION

1. J. Barnes, ed., *The Ethics of Aristotle* (Harmondsworth: Penguin Books, 1976), 37.
2. M. Black, "Reasonableness," in *Reason,* ed. R. F. Dearden, P. H. Hirst, and R. S. Peters (London: Routledge and Kegan Paul, 1972), 55.
3. Aristotle, *Nichomachean Ethics* 10, 1178b, trans. J. A. K. Thomson with revisions by Hugh Tredennick in Barnes, ed. *The Ethics of Aristotle,* 334.
4. In other passages, Aristotle's views seem less extreme and less intellectualist. For interesting discussions and debate about Aristotle's view of the place of contemplation in human life, see the following, all of which appear in A. Rorty, ed., *Essays on Aristotle's Ethics* (Berkeley: University of California Press, 1980): T. Nagel, "Aristotle on *Eudaimonia*"; J. L. Ackrill, "Aristotle on *Eudaimonia*"; K. V. Wilkes, "The Good Man and the Good for Man in Aristotle's Ethics"; and A. Rorty, "The Place of Contemplation in Aristotle's *Nichomachean Ethics.*"
5. W. James, *The Principles of Psychology* (New York: Dover Publications, 1950; orig. ed. 1890), 1: 122.
6. J. Rawls, *A Theory of Justice* (Cambridge, Mass.: Harvard University Press, 1971), 418.

7. H. Sidgwick, *The Methods of Ethics,* 7th ed. (New York: Dover Publications, 1966; orig. ed. 1907), 345.

8. For discussions of the place of rational ideals in Greek thought, see John Passmore, *The Perfectability of Man* (New York: Charles Scribner's Sons, 1970), chs. 2–3; Henry Sidgwick, *Outline of the History of Ethics* (London: Macmillan, 1967; orig. ed. 1886), ch. 2; Werner Jaeger, "On the Origin and Cycle of the Philosophic Ideal of Life," app. 2 in *Aristotle,* 2d ed. (Oxford: Oxford University Press, 1934), 426–61. On Socrates in particular, see Gregory Vlastos' interesting essay, "The Paradox of Socrates," in G. Vlastos, ed., *The Philosophy of Socrates* (Notre Dame: Notre Dame University Press), 1–21.

9. John Passmore, *The Perfectability of Man* (New York: Charles Scribner's Sons, 1970), 152.

10. For further confirmation of this point, see Derek Parfit's discussion of what he calls "rational irrationality" in *Reasons and Persons* (New York: Oxford University Press, 1984), 12–13.

11. The classic sources for the utilitarian method are Jeremy Benthan, *Introduction to the Principles of Morals and Legislation* and John Stuart Mill, *Utilitarianism.* Mill's work and excerpts from Bentham are collected in Mary Warnock, ed., *Utilitarianism and Other Writings* (Cleveland: Meridian Books, 1962). For a discussion of the objection that utilitarian calculations have bad effects, see J. J. C. Smart in J. J. C. Smart and Bernard Williams, *Utilitarianism: For and Against* (Cambridge: Cambridge University Press, 1973), 43–46.

12. Lawrence Blum appeals to the importance of spontaneous acts of friendship and compassion in developing his critique of moral rationalism in *Friendship, Altruism, and Morality* (London: Routledge and Kegan Paul, 1980).

13. D. Hume, *A Treatise of Human Nature,* ed. L. A. Selby-Bigge (Great Britain: Oxford University Press, 1888), 416.

14. Rawls, *A Theory of Justice,* 417.

15. For defense of a similar point, see Allan Gibbard, *Wise Choices, Apt Feelings* (Cambridge: Harvard University Press, 1990), 18–19.

16. For an indication of some of the difficulties concerning rational explanations, see William Dray, *Laws and Explanation in History* (Oxford: Oxford University Press, 1957), ch. 5, and Carl Hempel, "Rational Action," in *Proceedings and Addresses of the American Philosophical Association* 35 (1962): 10–16. For a discussion of related points concerning moral deliberation, see Samuel Scheffler, *Human Morality* (New York: Oxford University Press, 1992), ch. 3.

17. On this point, see Herbert Fingarette, *The Meaning of Criminal Insanity* (Berkeley and Los Angeles: University of California Press, 1972), 190–91.

18. For a related point, see J. Raz, in "Reasons for Action, Decisions, and Norms," in J. Raz, ed., *Practical Reasoning* (Oxford: Oxford University Press, 1978), especially 133–38. Also relevant is Michael Bratman's discussion of

plans in *Intention, Plans, and Practical Reason* (Cambridge, Mass.: Harvard University Press, 1987).

19. For discussion of a similar point, see Scheffler, *Human Morality*, 36.

CHAPTER 4: REASON, NIHILISM, AND OBJECTIVITY

1. Henry Sidgwick, *The Methods of Ethics*, 7th ed. (New York: Dover Publications, 1966), 382, 420. Thomas Nagel, *The View From Nowhere* (New York: Oxford University Press, 1986), especially chs. 1 and 2.

2. J. J. C. Smart, "My Semantic Ascents and Descents," in *The Owl of Minerva: Philosophers on Philosophy*, ed. C. J. Bontempo and S. J. Odell (New York: McGraw Hill, 1975), 67–68. The classic attempt to describe reality *sub specie aeternitatis* is to be found in Spinoza's *Ethics*. For an important twentieth century philosopher's endorsement of this ideal, see Bertrand Russell, "The Place of Science in a Liberal Education," and "On Scientific Method in Philosophy," both reprinted in *Mysticism and Logic* (London: Allen and Unwin, 1964; orig. ed. 1917).

3. For interesting discussions of the implications of taking the objective standpoint, see Thomas Nagel, "The Absurd" and "Subjective and Objective," both reprinted in *Mortal Questions* (Cambridge: Cambridge University Press, 1979).

4. Plato, *Republic* 486a, trans. Paul Shorey in *Collected Dialogues*, ed. E. Hamilton and H. Cairns (New York: Pantheon Books, 1961).

5. Descartes, *Discourse on Method* in *Philosophical Works of Descartes*, ed. E. Haldane and G. Ross (New York: Dover Books, 1955), I, 87.

6. The classic discussion of primary and secondary qualities is Locke's *Essay Concerning Human Understanding*, Bk. 2, ch. 8. For discussions of Locke's account, see M. Mandelbaum, *Philosophy, Science and Sense Perception* (Baltimore: Johns Hopkins Press, 1964), ch. 1, and my "Locke's Uses of the Theory of Ideas," *The Personalist* 59 (1978): 241–56. For an excellent account of the historical background, see E. A. Burtt, *The Metaphysical Foundations of Modern Science* (Garden City, N.Y.: Doubleday, 1954; orig. ed. 1924).

7. For a powerful expression of this type of argument, see L. Tolstoy, *A Confession* (London: Penguin Books, 1987), 43–44. Tolstoy concluded that reason could not provide a basis for values and that religious faith alone could carry out this function.

8. In saying this, I do not mean that preferences and desires are either entirely out of our control or that they cannot be evaluated. I discuss irrational desires in chapters 9 and 10.

9. For Edwards, see "Life, Meaning and Value of," in *The Encyclopedia of Philosophy*, ed. Paul Edwards (New York: Macmillan, 1967), 4: 467–77. Interesting discussions can also be found in Kurt Baier, *The Meaning of Life*

(Canberra: Australian National University, 1957), and David Wiggins, "Truth, Invention and the Meaning of Life," *Proceedings of the British Academy* 62(1976): 331–78. For the kind of view Edwards criticizes, see Tolsoy, *op. cit.*

10. Edwards, "Life," 472.

11. J Rawls, *A Theory of Justice* (Cambridge, Mass.: Harvard University Press, 1971), 399.

12. Deutscher, *Subjecting and Objecting* (Oxford: Blackwell, 1983), 46.

13. Deutscher, 50.

14. For an insightful discussion of related issues, see Allison Jaggar, "Love and Knowledge: Emotion in Feminist Epistemology," in E. Harvey and K. Okrulik, eds., *Women and Reason* (Ann Arbor, Mich.: University of Michigan Press, 1990), 115–41.

15. Smart, 67–68.

16. Borges, "Of Exactitude in Science," in *A Universal History of Infamy*, translated by Norman Thomas DiGiovanni (New York: Dutton, 1972), 141.

17. In a similar spirit, Hilary Putnam rejects the idea that there is "One True Theory" of the world in *Reason, Truth, and History* (Cambridge: Cambridge University Press, 1981). Thomas Nagel is similarly critical of this form of reductionism. While he holds that a perfectly objective perspective would be incomplete, he does not seem to see it as empty. See *The View from Nowhere*, 4–5, 25. For other attacks on defining reality from the perspective of perfect objectivity, see John Dewey, *The Quest for Certainty* (Carbondale, Ill.: Southern Illinois University Press, 1984); Max Deutscher, *Subjecting and Objecting*, 200–206, 221–25; and Sandra Harding, *Whose Science? Whose Knowledge?* (Ithaca: Cornell University Press, 1991).

CHAPTER 5: REASON, KNOWLEDGE, AND TRUTH

1. W. K. Clifford, "The Ethics of Belief," in *Lectures and Essays* (London: Macmillan, 1879), 2:185.

2. Plato, *Phaedo* 66b–e, trans. Hugh Tredennick, in *Collected Dialogues*, ed. E. Hamilton and H. Cairns (New York: Pantheon Books, 1961).

3. For an effective parody of the extreme mind-body dualism that underlies the views of Socrates and many classical rationalists, see John Barth's brief story, "Petition," in his *Lost in the Funhouse* (New York: Bantam Books, 1969), 55–68. I discuss Barth's story in "The Plight of the Siamese Twin: Mind, Body, and Value in John Barth's 'Petition'," in A.T. Tymieniecka, ed., *The Elemental Passions of the Soul* (Kluwer, 1990), 461–70. Elizabeth Spelman raises related issues from a feminist perspective in "Woman as Body," *Feminist Studies* 8 (1982), 109–31.

4. *Phaedo*, 66e.

5. *Phaedo*, 64a, my italics.

6. The rationalist ideal is not the only one that leads to this devaluation of ordinary life. On this point, see John Passmore, *The Perfectability of Man* (New York: Charles Scribner's Sons, 1970).

7. For a discussion of cases of "bad knowledge" and their relevance to limits on freedom of expression, see Joel Feinberg, "Limits to the Free Expression of Opinion," in J. Feinberg and H. Gross, eds., *Philosophy of Law*, 3rd ed. (Belmont, Ca.: Wadsworth, 1986), 217–32.

8. J. L. Ackrill raises similar concerns about the role of *theoria* in Aristotle's ethical thought. Ackrill argues that Aristotle never faced the conflict between the pursuit of knowledge and other moral virtues. See his "Aristotle on Eudaimonia," in A. Rorty, ed., *Essays on Aristotle's Ethics* (Berkeley: University of California Press, 1980), 30–33.

9. John Kekes, *A Justification of Rationality* (Albany, N.Y.: State University of New York Press, 1976). Page references are in the text.

10. For discussions of the relevance of anthropological evidence to theories of rationality, see the papers collected in Bryan Wilson, ed., *Rationality* (New York: Harper and Row, 1970). These issues are revisited in M. Hollis and S. Lukes, eds., *Rationality and Relativism* (Cambridge: MIT Press, 1982).

11. For an interesting discussion and defense of the view that inconsistent beliefs can be rational to accept, see Nicholas Rescher, *Rationality* (Oxford: Oxford University Press, 1988), ch. 5.

CHAPTER 6: THE ETHICS OF BELIEF: A JAMESIAN VIEW

1. James's essay appears in *The Will to Believe and Other Essays in Popular Philosophy* (New York: Dover Publications, 1956; orig. ed. 1897). Page references are cited in the text.

2. "The Ethics of Belief," in *Lectures and Essays* (London: Macmillan, 1879) 2:183.

3. Quoted by James, "The Will to Believe," 7.

4. J. J. C. Smart uses the phrase "rule worship" to describe the attitude of someone who refuses to break a generally beneficial rule on those occasions when obeying it is clearly counterproductive. For his comment, see J. J. C. Smart and Bernard Williams, *Utilitarianism: For and Against* (Cambridge: Cambridge University Press, 1973), 10.

5. B. Blanshard, *Reason and Belief* (New Haven: Yale University Press, 1975), 401.

6. Ibid., 419.

7. For an interesting discussion of this point, see H. H. Price, "Belief and Will," *Proceedings of the Aristotelian Society,* suppl. vol. 28 (1954); reprinted in *Reason,* ed. R. F. Dearden, P. H. Hirst, and R. S. Peters (London: Routledge and Kegan Paul, 1972), 198–217. For the opposing view, see R. Edgley, *Reason in*

Theory and Practice (London: Hutchinson, 1969), 61–65, and Bernard Williams, "Deciding to Believe," in *Problems of the Self* (Cambridge: Cambridge University Press, 1973), 136–51.

8. For a similar argument, see Jack Meiland, "What Ought We To Believe? or The Ethics of Belief Revisited," *American Philosophical Quarterly* 17 (1980), 15–24.

9. For discussion, see Norman Cousins, *The Anatomy of an Illness* (New York: W. W. Norton, 1979), ch. 2. On some of the dangers involving placebos and medical deceptions, see Sissela Bok, *Lying* (New York: Pantheon Books, 1978), 61ff. For an interesting, more general discussion of the good effects of "upbeat" beliefs, see Martin Seligman, *Learned Optimism* (New York: Pocket Books, 1990).

10. For an interesting discussion of self-deception that draws attention to the positive roles it can play, see Amelie Rorty, "The Deceptive Self: Liars, Layers, and Lairs," in B. McLaughlin and A. Rorty, eds., *Perspectives on Self-Deception* (Berkeley: University of California Press, 1988), 11–28.

11. The charge that James encourages both self-deception and wishful thinking is made by Walter Kaufmann in his *Critique of Religion and Philosophy* (New York: Harper and Row, 1972), 116, 119.

12. The first of these objections is made by Bernard Williams in "Deciding to Believe," 151. I owe the second to William DeAngelis.

13. For one prominent example, see Bertrand Russell's "Pragmatism" and "William James's Conception of Truth," in *Philosophical Essays* (New York: Simon and Schuster, 1966; original ed., 1910).

CHAPTER 7: THE MEANS/END CONCEPTION OF RATIONALITY

1. B. Russell, *Human Society in Ethics and Politics* (New York: New American Library, 1962; orig. ed., 1954), ix.

2. Bernard Gert clarifies these senses of "rational" and "irrational" in *Morality: A New Justification of the Moral Rules* (New York: Oxford University Press, 1988), 21–24.

3. B. Russell, *Human Society in Ethics and Politics*, viii.

4. J. Rawls, *A Theory of Justice* (Cambridge, Mass: Harvard University Press, 1971), 401. Subsequent references are in the text.

5. For this point, see J. D. Mabbott, "Reason and Desire," *Philosophy* 28 (1953); reprinted in *Reason,* ed. R. F. Dearden, P. H. Hirst, and R. S. Peters (London: Routledge and Kegan Paul, 1972), 170–81.

6. D. Hume, *A Treatise of Human Nature,* ed. L. A. Selby-Bigge (Great Britain: Oxford University Press, 1888), 416–17.

7. On the rationality of particular emotional responses, see George Pitcher, "Emotion," *Mind* 74 (1965); reprinted in *Reason,* ed. Dearden, Hirst, and Peters, 218–38.

CHAPTER 8: REASONS, MOTIVES, AND MORALITY

1. The internalist conception of reasons, like the related means/end view of rationality, is a widely held view. For useful discussions and criticisms of internalism, see Stephen Darwall, *Impartial Reason* (Ithaca, N.Y.: Cornell University Press, 1983), Part I; David Brink, *Moral Realism and the Foundations of Ethics* (Cambridge: Cambridge University Press, 1989) ch. 3; and Martin Hollis, *The Cunning of Reason* (Cambridge: Cambridge University Press, 1987), ch. 6.

2. Williams, "Internal and External Reasons," in *Moral Luck* (Cambridge: Cambridge University Press, 1981), 109, 111.

3. Williams, 111.

4. For an excellent defense of coherence as a test of acceptability, see David Brink, *Moral Realism and the Foundations of Ethics,* ch. 5. Also of interest is Morton White, *What Is and What Ought to Be Done: An Essay on Ethics and Epistemology* (New York: Oxford University Press, 1981).

5. G. Harman, *The Nature of Morality* (New York: Oxford University Press 1977), 33. Subsequent references are in the text.

6. For discussions of related issues that stress this distinction, see E. J. Bond, *Reason and Value* (Cambridge: Cambridge University Press, 1983), ch. 2.; and Stephen Darwall, *Impartial Reason* (Ithaca: Cornell University Press, 1983), 28–31.

7. William James, "The Sentiment of Rationality," reprinted in *The Will to Believe and Other Essays in Popular Philosophy* (New York: Dover Publications, 1956; orig. ed., 1897), 63.

8. Whitman, "Starting from Paumanok," Section 51, in *Leaves of Grass* (Garden City, N.Y.: Doubleday, 1926), 76.

9. In *The Nature of Morality,* Harman seems unsure whether to take a purely empirical, motivational approach toward logical reasons or to treat logical reasons as normative. See 128, 131. Similar waverings between descriptive and normative senses of cognitive reasons seem to arise in his earlier book, *Thought* (Princeton, N.J.: Princeton University Press, 1973); see 24–33, 151–54, 163–68.

10. This is a view that I mistakenly asserted in the first edition of this book. See *The Ideal of Rationality,* original edition, 98.

11. For a general discussion of related issues, see Herbert Fingarette, *The Meaning of Criminal Insanity* (Berkeley and Los Angeles: University of California Press, 1972).

12. For a milder version of relativism, see Philippa Foot, "Moral Relativism," in *Relativism: Cognitive and Moral,* ed. J. Meiland and M. Krauz (Notre Dame: University of Notre Dame Press, 1982), esp. 163, or her "Morality and Art," *Proceedings of the British Academy* 56 (London: Oxford University Press, 1970): 1–16. I discuss different versions of relativism in my *Patriotism,*

Morality, and Peace (Lanham, Md.: Rowman and Littlefield, 1993), 97–103.

CHAPTER 9: IRRATIONAL DESIRES

1. D. Hume, *A Treatise of Human Nature,* ed. L. A. Selby-Bigge (Great Britain: Oxford University Press, 1888), 416.
2. K. Baier, *The Moral Point of View* (Ithaca, N.Y.: Cornell University Press, 1958), 91.
3. Bernard Gert, *Morality: A New Justification of the Moral Rules* (New York: Oxford University Press, 1988), 28–34. Subsequent references are in the text.
4. J. Rawls, A *Theory of Justice* (Cambridge, Mass: Harvard University Press, 1971), 92–93. Subsequent references are in the text.
5. H. Sidgwick, *The Methods of Ethics,* 7th ed. (New York: Dover Publications, 1966; orig. ed., 1907), 111–12.
6. Gert develops other criticisms of Rawls in *Morality,* ch. 13.
7. Brandt's theory of rationality occupies the first half of his *A Theory of the Good and the Right* (Oxford: Oxford University Press, 1979). Page references are in the text.
8. For an astonishing list of phobias, see Joy Melville, *Phobias and Obsessions* (New York: Penguin Books, 1978), 196–202.
9. For other criticisms of Brandt's criterion, see Norman Daniels, "Can Cognitive Psychotherapy Reconcile Reason and Desire?" *Ethics* 93 (1983), 772–85; and Noah Lemos, "Brandt on Rationality, Value, and Morality," *Philosophical Studies* 45 (1984), 79–93. Related points are made by Allan Gibbard in *Wise Choices, Apt Feelings* (Cambridge: Harvard University Press, 1990), 165–66. For a general discussion and criticisms that bear on Brandt's theory, see David Brink, *Moral Realism and the Foundations of Ethics* (Cambridge: Cambridge University Press, 1989), ch. 3. I discuss Brandt's theory further in "Brandt on Rationality and Value," in B. Hooker, ed., *Rationality, Rules, Utility* (Boulder, Co.: Westview Press, 1993).
10. For criticisms by Gert of an earlier version of Brandt's theory, see "Irrational Desires," in *Human Nature in Politics,* ed. J. R. Pennock and J. Chapman (New York: New York University Press, 1977), 286–91.

CHAPTER 10: RATIONAL AND IRRATIONAL ENDS

1. Bernard Gert, *Morality: A New Justification of the Moral Rules* (New York: Oxford University Press, 1988), 49. Subsequent references are in the text.

Gert's view was originally developed in *The Moral Rules* (New York: Harper and Row, 1973). It is restated and applied to a variety of medical issues in a book co-authored with Charles Culver, *Philosophy in Medicine* (New York: Oxford University Press, 1982).

2. Herbert Fingarette, *The Meaning of Criminal Insanity* (Berkeley and Los Angeles: University of California Press, 1972), 111 (italics added). A similar conclusion is reached by R. M. Sainsbury in "Rationality and Morality," in *The Manson Murders: A Philosophical Inquiry*, ed. David Cooper (Cambridge, Mass.: Schenkman, 1974), 89–106.

3. In fairness to Brandt, whom I criticized in chapter 9, he also permits benevolent desires to play a role in the lives of rational people. In contrast with Gert, however, Brandt is committed to holding that benevolent desires are irrational if they would extinguish in cognitive psychotherapy. For Gert, benevolent desires are simply allowed by reason and always count as a reason (though not necessarily an overriding reason) for action.

4. Gert defends his method of offering a list (rather than some formal criterion) both in *Morality*, 44–46, and in "Rationality, Human Nature, and Lists," *Ethics* 100 (1990), 279–300.

5. For another discussion that stresses the distinction between interests and desires, see Martin Hollis, *The Cunning of Reason* (Cambridge: Cambridge University Press, 1987), 77ff. See, too, Nicholas Rescher, *Rationality* (Oxford: Oxford University Press, 1988.), ch. 6.

6. For a similar case, see Gert and Culver, *Philosophy in Medicine*, 36.

7. W. James, *The Varieties of Religious Experience* (New York: Collier, 1961; orig. ed., 1902), 127. See, too, R. B. Perry's chapter, "The Pathology of Interest," in *The General Theory of Value* (Cambridge, Mass.: Harvard University Press, 1926), 567ff.

CHAPTER 11: PLEASURES AND VALUES

1. For a brief summary of the hedonism of Epicurus, see Henry Sidgwick, *Outline of the History of Ethics* (London: Macmillan, 1967; orig. ed., 1886), 82–90. Bentham develops his hedonism in his *Introduction to the Principles of Morals and Legislation*, while Mill offers a revision of Bentham's hedonism in *Utilitarianism*, ch. 2. For Sidgwick, see *The Methods of Ethics*, 7th ed. (New York: Dover Publications, 1966; orig. ed., 1907), Bk. 1, ch. 9 and Bk. 3, ch. 14. For Lewis's views, see his *Analysis of Knowledge and Valuation* (LaSalle, Ill.: Open Court, 1946), Bk. 3.

2. For Bentham's views on the measurement of pleasures, see his *Introduction to the Principles of Morals and Legislation*, ch. 4. For a contemporary discussion of the measurement problem, see James Griffin, *Well-Being: Its Meaning, Measurement, and Moral Importance* (Oxford: Oxford University

Press, 1986), Part 2. For an interesting survey of recent research that highlights the difficulties of measuring well-being, see Alvin Goldman, "Ethics and Cognitive Science," *Ethics* 103 (1993), 345–50.

3. For a discussion of these two different conceptions of value, see Richard Brandt, "Two Concepts of Utility," in his *Morality, Utilitarianism, and Rights* (Cambridge: Cambridge University Press, 1992), ch 9.

4. This point is emphasized by E. J. Bond in "Reasons, Wants, and Values," *Canadian Journal of Philosophy* 3 (1974).

5. For further comparison of desire-based theories with hedonism, see my "Brandt on Rationality and Value," in B. Hooker, ed., *Rationality, Rules, Utility* (Boulder, Co.: Westview Press, 1993).

6. For a survey of objections to hedonism, see William Alston, "Pleasure," in *The Encyclopedia of Philosophy,* ed. Paul Edwards (New York: Macmillan, 1967), 6: 341–47.

7. For a recent statement of this objection, see James Griffin, *Well-Being: Its Meaning, Measurement, and Moral Importance,* ch. 1.

8. For a discussion of this issue, see John Stuart Mill, *Utilitarianism* (Meridian ed.), 264.

9. H. Rashdall, *The Theory of Good and Evil* (Oxford: Oxford University Press, 1924), 2: 52.

10. Alston, "Pleasure," 344–46; see, too, Brandt, *A Theory of the Good and the Right* (Oxford: Oxford University Press, 1979), 38–42.

11. D. Wiggins, "Truth, Invention, and the Meaning of Life," in Wiggins, *Needs, Values, and Truth* (Oxford: Blackwell, 1987), 103–104, 106. Subsequent page references are in the text.

12. Sidgwick, *The Methods of Ethics,* 136.

13. For this view, see Lewis, *An Analysis of Knowledge and Valuation,* chs. 12, 13, 17.

14. Given Wiggins's example, it is interesting to consider a remark by Colin Fletcher in his account of his walk through the Grand Canyon. After describing his coming to a place where he began to recognize the "harmony and beauty" of the rocks in a new way, Fletcher adds: "But, after all, what was beauty but some kind of harmony between the rock and my senses?" See *The Man Who Walked Through Time* (New York: Vintage Books, 1989), 106.

15. R. Nozick, *Anarchy, State, and Utopia* (New York: Basic Books, 1974), 42–45. Subsequent references are in the text. A similar argument is discussed and replied to by J. J. C. Smart in J. J. C. Smart and Bernard Williams, *Utilitarianism: For and Against* (Cambridge: Cambridge University Press, 1973), 18–24.

16. Thomas Nagel makes this point as part of a defense of nonexperiential values in his essay "Death"; see his *Mortal Questions* (New York: Cambridge University Press, 1979), 4.

17. Putnam, *Reason, Truth, and History* (New York: Cambridge University Press, 1981), 172.

18. For the classic discussion of this issue and the distinction between higher and lower pleasures, see John Stuart Mill, *Utilitarianism,* ch. 2.

CHAPTER 12: EVALUATING IDEALS

1. For an "ideal utilitarian" attempt to compare hedonic and non-hedonic values, see Hastings Rashdall, *The Theory of Good and Evil* (Oxford: Oxford University Press, 1924), vol. 2, ch. 2.

2. *Reason, Truth, and History* (Cambridge: Cambridge University Press, 1981), ch. 9. On the role of value judgments in science, see, too, Larry Laudan, *Science and Values* (Berkeley: University of California Press, 1984).

3. James defends many forms of pluralism throughout his writings. For Mill, see *On Liberty,* especially ch. 3.

4. B. Russell, "What I Believe," in *Why I Am Not a Christian* (New York: Simon and Schuster, 1956), 56.

5. For an attempt to develop a form of patriotism that is consistent with internationalism, see my *Patriotism, Morality, and Peace* (Lanham, Md.: Rowman and Littlefield, 1993).

6. Quoted in John Passmore, *The Perfectability of Man* (New York: Charles Scribner's Sons, 1970), 120–21.

7. In *Moral Tradition and Individuality* (Princeton, N.J.: Princeton University Press, 1989), 165–73, John Kekes appears to defend the view that while we may value many things, our lives are best when there is some one thing to which we are unconditionally committed.

8. For a discussion of the nature of a person's interests and the ways in which one's interests may include others, see Joel Feinberg, *Harm to Others* (New York: Oxford University Press, 1984), 70–79.

9. For further discussion of the relationship between the moral and rational perspectives, see Bernard Gert, *Morality: A New Justification of the Moral Rules* (New York: Oxford University Press, 1988).

10. There is a vast literature on the subject, much of it stimulated by Thomas Kuhn's *The Structure of Scientific Revolutions* (Chicago: University of Chicago Press, 1962).

CHAPTER 13: RATIONALITY WITHIN REASON

1. William James, *The Will to Believe and Other Essays in Popular Philosophy* (New York: Dover Publications, 1956; orig. ed., 1897), x.

2. K. Popper, *The Open Society and Its Enemies,* 5th rev. ed. (Princeton, N. J.: Princeton University Press, 1966), 2: 234.

3. Ibid., 229.

4. For their views, see K. Baier, *The Moral Point of View* (Ithaca, N.Y.: Cornell University Press, 1958), 85–88; and R. Brandt, *A Theory of the Good and the Right* (Oxford: Oxford University Press, 1979), 14–15.

5. On the rationality of "primitive" people, see the essays collected in Brian Wilson, ed., *Rationality* (New York: Harper and Row, 1970).

6. Werner Jaeger, *Aristotle,* 2nd ed. (Oxford: Oxford University Press, 1934), 435.

7. For worthwhile discussions that focus on both cognitive and practical rationality, see Hilary Putnam, *Reason, Truth and History* (Cambridge: Cambridge University Press, 1981); and Nicholas Rescher, *Rationality* (Oxford: Oxford University Press, 1988).

8. T. H. Huxley, "A Liberal Education," in *The Essence of T. H. Huxley,* ed. Cyril Bibby (London: Macmillian, 1967; orig. ed., 1868), 193–94.

AFTERWORD I: RATIONALITY REVISITED, 1993

1. Stuart Hampshire, "Morality and Pessimism," in S. Hamphire et al., *Public & Private Morality* (Cambridge: Cambridge University Press, 1978), 4.

2. Ibid., 5–6.

3. Rexroth, *Bird in the Bush* (New York: New Directions, 1959), 159.

4. Jean Jacques Rousseau, "Discourse on the Arts and Sciences," in *The Social Contract and Discourses* (New York: Dutton, 1950), 157.

5. Ibid., 160.

6. Ibid., 171.

7. e. e. cummings, *Poems 1923–45* (New York: Harcourt, Brace, 1954), 421.

AFTERWORD II: AN INTERVIEW WITH THE AUTHOR

1. Raymond Smullyan, *This Book Needs No Title* (Englewood Cliffs, N.J.: Prentice-Hall, 1980), 120–21.

2. Alasdair MacIntyre, *Whose Justice? Which Rationality?* (Notre Dame: Notre Dame University Press, 1988), 393.

3. Ibid., 395.

4. René Descartes, *Discourse on Method,* translated by G. Ross and E. Haldane, in *The Philosophical Works of Descartes* (New York: Dover Books, 1955), 1:90.

5. Max Deutscher, *Subjecting and Objecting* (Oxford: Blackwell, 1983), 29.

6. Ibid., 31.

7. For a very good discussion of these issues, see Roderick Chisholm, *Theory of Knowledge,* 2nd ed. (Englewood Cliffs, N.J.: Prentice-Hall, 1977), ch. 7, "The Problem of the Criterion."

8. For discussions of the role of values in scientific theorizing, see Hilary

Putnam, *Reason, Truth and History* (Cambridge: Cambridge University Press, 1981), and Larry Laudan, *Science and Values* (Berkeley: University of California Press, 1984).

9. Dewey develops and defends his views in his 1929 Gifford Lectures, *The Quest for Certainty* (Carbondale: Southern Illinois University Press, 1988).

AFTERWORD III: RATIONALITY: DOUBTS AND THEORIES

1. Alasdair MacIntyre, *Whose Justice? Which Rationality?* (Notre Dame: University of Notre Dame Press, 1988), 9.

2. For MacIntyre's discussion and disavowal of both relativism and "perspectivism," see ch. 18, "The Rationality of Traditions." For further criticisms of relativism about rationality, see Nicholas Rescher, *Rationality* (Oxford: Oxford University Press, 1988), ch. 9. For a defense of a more radically skeptical view, see Richard Rorty, *Contingency, Irony, and Solidarity* (Cambridge: Cambridge University Press, 1989).

3. Genevieve Lloyd, *The Man of Reason: "Male" and "Female" in Western Thought* (Minneapolis: University of Minnesota Press, 1984), x.

4. Sara Ruddick, *Maternal Thinking* (Boston: Beacon Press, 1989), 5.

5. For discussions of these themes, see Elizabeth Spelman, "Woman as Body," *Feminist Studies* 8 (1982), 109–31, and Susan Hekman, *Gender and Knowledge: Elements of a Postmodern Feminism* (Boston: Northeastern University Press, 1990), 30–47. Also relevant is Sandra Harding, *Whose Science? Whose Knowledge?* (Ithaca, N.Y.: Cornell University Press, 1991).

6. In distinguishing these three areas, I do not mean to suggest that they are unrelated to one another. In addition, the terms I use to label each area are sometimes used in other ways by different writers.

7. My account here departs from those accounts that make a radical distinction between normative inquiry and value neutral meta-ethics. I include the justification of moral codes as part of moral theory or meta-ethics, while others would see this as part of normative ethics.

8. Similar points apply to relativism in ethics. Note that the version of ethical relativism I criticized in chapter 8 was an extreme version that did not rule out even genocide. For a discussion of degrees of relativism in ethics, see my *Patriotism, Morality, and Peace* (Rowman and Littlefield, 1993), 96–103.

9. My discussion here has focused on relativism in the theory of practical rationality. I realize that I have not dealt with issues raised by epistemological relativism.

10. Brandt's theory is one version of such a theory. While it is superior to classical rationalist views in a number of ways, it has other defects that I have discussed in ch. 9 and in my "Brandt on Rationality and Value," in B. Hooker, ed., *Rationality, Rules, Utility* (Boulder, Co. Press: Westview Press, 1993).

11. On this point, see especially Carol McMillan, *Women, Reason, and Nature* (Princeton: Princeton University Press, 1982), and Sara Ruddick, *Maternal Thinking* (Boston: Beacon Press, 1989).

12. For a sympathetic discussion of this radical view, see Susan Hekman, *Gender and Knowledge* (Boston: Northeastern University Press, 1990), 39–47.

13. For a discussion of the negative aspects of some traditional roles and "virtues," see Lawrence Blum, "Kant's and Hegel's Moral Rationalism: A Feminist Perspective," *Canadian Journal of Philosophy* XII (1982), 287–302.

14. Cf. Nicholas Rescher, *Rationality* (Oxford: Oxford University Press, 1988), 6: "Rationality is a matter of seeking to do the very best we can (realistically) manage to do in the circumstances."

BIBLIOGRAPHY

Alston, William. "Pleasure." In *The Encyclopedia of Philosophy,* edited by Paul Edwards, vol. 6. New York: Macmillan, 1967.

Aristotle, *Nichomachean Ethics.*

Baier, Kurt. *The Meaning of Life.* Canberra: Australian National University, 1957.

———. *The Moral Point of View.* Ithaca, N.Y.: Cornell University Press, 1958.

Barth, John. *The Floating Opera.* Rev. ed. New York: Bantam Books, 1972.

———. *The End of the Road.* New York: Bantam Books, 1969.

———. "John Barth: An Interview," *Wisconsin Studies in Contemporary Literature,* no. 6 (Winter-Spring 1965): 3–14.

———. "Petition." In *Lost in the Funhouse.* New York: Bantam Books, 1969.

Bartley, W. W., III. *The Retreat to Commitment.* New York: Knopf, 1962.

Bentham, Jeremy. *An Introduction to the Principles of Morals and Legislation.*

Black, Max. "Reasonableness." In *Reason,* edited by R. F. Dearden, P. H. Hirst, and R. S. Peters. London: Routledge and Kegan Paul, 1972.

Blum, Lawrence. *Friendship, Altruism, and Morality.* London: Routledge and Kegan Paul, 1980.

Bond, E. J. "Reasons, Wants, and Values." *Canadian Journal of Philosophy* 3 (1974), 333–47.

———. *Reason and Value.* Cambridge: Cambridge University Press, 1983.

Borges, Jorge Luis. "Of Exactitude in Science." In *A Universal History of Infamy.* Translated by Norman Thomas DiGiovanni. New York: Dutton, 1972.

Brandt, R. B. *A Theory of the Good and the Right.* Oxford: Oxford University Press, 1979.

———. *Morality, Utilitarianism, and Rights.* Cambridge: Cambridge University Press, 1992.

———. "Practical Rationality: A Response," *Philosophy and Phenomenological Research* L (1989).

Bratman, Michael. *Intention, Plans, and Practical Reason.* Cambridge, Mass.: Harvard University Press, 1987.

Brink, David. *Moral Realism and the Foundations of Ethics.* Cambridge: Cambridge University Press, 1989.

Brown, Harold. *Rationality.* London: Routledge, 1988.

Campbell, C. A. "Moral and Non-Moral Values," *Mind* 44 (1935), 279-91.

Chisholm, Roderick. *Theory of Knowledge,* 2nd ed. Englewood Cliffs, N.J.: Prentice-Hall, 1977.

Clifford, W. K. "The Ethics of Belief," in *Lectures and Essays,* vol. 2. London: Macmillan, 1879.

Code, Lorraine. *Epistemic Responsibility.* Hanover, N.H.: University Press of New England, 1987.

Daniels, Norman. "Can Cognitive Psychotherapy Reconcile Reason and Desire?" *Ethics* 93 (1983), 772-85.

Darwall, Stephen. *Impartial Reason.* Ithaca, N.Y.: Cornell University Press, 1983.

Dearden, R. F., P. H. Hirst, and R. S. Peters, eds. *Reason.* London: Routledge and Kegan Paul, 1972. Originally published as part 2 of *Education and the Development of Reason.*

Descartes, Rene. *A Discourse on Method.*

———. *The Principles of Philosophy.*

Deutscher, Max. *Subjecting and Objecting.* Oxford: Blackwell, 1983.

Dewey, John. *The Quest for Certainty.* Carbondale: Southern Illinois University Press, 1988.

Edwards, Paul. "Life, Meaning and Value of." In *The Encyclopedia of Philosophy,* edited by P. Edwards, vol. 4. New York: Macmillan, 1967.

Feinberg, Joel. *Harm to Others.* New York: Oxford University Press, 1984.

———. "Limits to the Free Expression of Opinion." In J. Feinberg and H. Gross, eds. *Philosophy of Law,* 3rd ed. Belmont, Ca.: Wadsworth, 1986, 217-32.

Feyerabend, Paul. *Farewell to Reason.* London: Verso, 1987.

Fingarette, Herbert. *The Meaning of Criminal Insanity.* Berkeley and Los Angeles: The University of California Press, 1972.

Firth, Roderick. "Ethical Absolutism and the Ideal Observer." *Philosophy and Phenomenological Research* 12 (1952), 317-45.

Gauthier, David, ed. *Morality and Rational Self Interest.* Englewood Cliffs, N.J.: Prentice Hall, 1970.

Gert, Bernard. *The Moral Rules.* New York: Harper and Row, 1973.

———. "Irrational Desires." In *Human Nature in Politics,* edited by J. R. Pennock and J. Chapman. New York: New York University Press, 1977.

———. *Morality: A New Justification of the Moral Rules.* New York: Oxford University Press, 1988.

———. "Rationality, Human Nature, and Lists," *Ethics* 100 (1990), 279–300.

Gert, Bernard, and Charles Culver. *Philosophy in Medicine.* New York: Oxford University Press, 1982.

Goldman, Alvin. "Ethics and Cognitive Science," *Ethics* 103 (1993), 345–50.

Griffin, James. *Well-Being: Its Meaning, Measurement, and Moral Importance.* Oxford: Oxford University Press, 1986.

Grimshaw, Jean. *Philosophy and Feminist Thinking.* Minneapolis: University of Minnesota Press, 1986.

Hampshire, Stuart. "Morality and Pessimism." In S. Hamphire et al., *Public & Private Morality.* Cambridge: Cambridge University Press, 1978.

Harding, Sandra. *Whose Science? Whose Knowledge?* Ithaca, N.Y.: Cornell University Press, 1991.

Harman, Gilbert. *The Nature of Morality.* New York: Oxford University Press, 1977.

———. "Relativistic Ethics: Morality as Politics," *Midwest Studies in Philosophy* 3 (1978), 109–21.

Harrison, Jonathan. *Hume's Moral Epistemology.* Oxford: Oxford University Press, 1976.

Hekman, Susan. *Gender and Knowledge.* Boston: Northeastern University Press, 1990.

Hempel, Carl G. "Rational Action." *Proceedings and Addresses of the American Philosophical Association* 35 (1962), 5–23.

Hollis, Martin. *The Cunning of Reason.* Cambridge: Cambridge University Press, 1987.

Hollis, M. and S. Lukes, eds. *Rationality and Relativism.* Cambridge: MIT Press, 1982.

Hume, David. *A Treatise of Human Nature.* Edited by L. A. Selby-Bigge. Great Britain: Oxford University Press, 1888.

Jaeger, Werner. "On the Origin and Cycle of the Philosophic Ideal of Life." App. 2 in *Aristotle.* 2d ed. Oxford: Oxford University Press, 1934.

Jaggar, Alison. "Love and Knowledge: Emotion in Feminist Epistemology." In E. Harvey and K. Okrulik, eds., *Women and Reason.* Ann Arbor, Mich.: University of Michigan Press, 1990.

James, William. *The Will to Believe and Other Essays in Popular Philosophy.* New York: Dover Publications, 1956.

———. *The Principles of Psychology.* New York: Dover Publications, 1950.

———. *The Varieties of Religious Experience.* New York: Collier, 1961.

———. *Pragmatism.* New York: Longmans, Green and Co., 1907.

Kekes, John. *A Justification of Rationality*. Albany: SUNY Press, 1976.

———. *Moral Tradition and Individuality*. Princeton: Princeton University Press, 1989.

Kuhn, Thomas. *The Structure of Scientific Revolutions*. Chicago: University of Chicago Press, 1962.

Laudan, Larry. *Science and Values*. Berkeley: University of California Press, 1984.

Lemos, Noah. "Brandt on Rationality, Value, and Morality," *Philosophical Studies* 45 (1984), 79–93.

Lewis, C. I. *An Analysis of Knowledge and Valuation*. LaSalle, Ill.: Open Court, 1946.

Lloyd, Genevieve. *The Man of Reason: "Male" and "Female" in Western Thought*. Minneapolis: University of Minnesota Press, 1984.

MacIntyre, Alasdair. *Whose Justice? Which Rationality?* Notre Dame: Notre Dame University Press, 1988.

McMillan, Carol. *Women, Reason, and Nature*. Princeton: Princeton University Press, 1982.

Meiland, Jack. "What Ought We To Believe? or The Ethics of Belief Revisited." *American Philosophical Quarterly* 17 (1980), 15–24.

Meiland, J. and M. Krauz, eds. *Relativism: Cognitive and Moral*. Notre Dame: University of Notre Dame Press, 1982.

Mill, J. S. *Utilitarianism*.

———. *On Liberty*.

Nagel, Thomas. *Mortal Questions*. Cambridge: Cambridge University Press, 1979.

———. *The View From Nowhere*. New York: Oxford University Press, 1986.

Nathanson, Stephen. "Nihilism, Reason, and the Value of Life." In M. Kohl, ed., *Infanticide and the Value of Life*. Prometheus Books, 1978, 192–205.

———. "Nihilism, Reason, and Death: Reflections on John Barth's *Floating Opera*." In A.T. Tymieniecka, ed., *The Philosophical Reflection of Man in Literature* (Reidel, 1982), 137–51.

———. Review of *What Is and What Ought To Be Done* by Morton White. *International Philosophical Quarterly*, XXII (1982), 211–12.

———. Review of *Reason, Truth and History* by Hilary Putnam. *International Philosophical Quarterly*, XXIII (1983), 211–15.

———. "Russell's Scientific Mysticism," in *Russell: The Journal of the Bertrand Russell Archives*, 5 (1985), 14–25.

———. "The Plight of the Siamese Twin: Mind, Body, and Value in John Barth's 'Petition'," in A.T. Tymieniecka, ed., *The Elemental Passions of the Soul* (Kluwer, 1990), 461–70.

———. Review of *Rationality* by Harold Brown, *Philosophy and Phenomenological Research* LI (1991), 448–51.

———. *Patriotism, Morality, and Peace.* Rowman and Littlefield, 1993.

———. "Brandt on Rationality and Value." In B. Hooker, ed., *Rationality, Rules, Utility* (Boulder, Co.: Westview Press, 1993).

Norman, Richard. *Reasons for Action.* Oxford: Blackwell, 1971.

Nozick, Robert. *Anarchy, State and Utopia.* New York: Basic Books, 1974.

Nussbaum, Martha. *Love's Knowledge: Essays on Philosophy and Literature.* New York: Oxford University Press, 1990.

Olson, R. G. "Nihilism." In *The Encyclopedia of Philosophy,* Vol V. Edited by P. Edwards. New York: Macmillan, 1967.

Parfit, Derek. *Reasons and Persons.* Oxford: Oxford University Press, 1984.

Passmore, John. *The Perfectability of Man.* New York: Charles Scribner's Sons, 1970.

Plato. *Plato: The Collected Dialogues.* Edited by E. Hamilton and H. Cairns. New York: Pantheon Books, 1961.

Popper, Karl. *The Open Society and Its Enemies.* 5th rev. ed. Princeton N.J.: Princeton University Press, 1966.

Putnam, Hilary. *Reason, Truth and History.* Cambridge: Cambridge University Press, 1981.

Rawls, John. *A Theory of Justice.* Cambridge, Mass.: Harvard University Press, 1971.

Raz, Joseph, ed. *Practical Reasoning.* Oxford: Oxford University Press, 1978.

Rescher, Nicholas. "Pragmatic Justification (A Cautionary Tale)," *Philosophy* 39 (1964), 346–48.

———. *The Primacy of Practice.* Oxford: Blackwell, 1973.

———. *Methodological Pragmatism.* New York: New York University Press, 1977.

———. *Rationality.* Oxford: Oxford University Press, 1988.

Rorty, Amelie, ed. *Essays on Aristotle's Ethics.* Berkeley: University of California Press, 1980.

———. "The Deceptive Self: Liars, Layers, and Lairs" In B. McLaughlin and A. Rorty, eds., *Perspectives on Self-Deception.* Berkeley: University of California Press, 1988, 11–28.

Rorty, Richard. *Contingency, Irony, and Solidarity.* Cambridge: Cambridge University Press, 1989.

Rousseau, Jean Jacques. "Discourse on the Arts and Sciences." In *The Social Contract and Discourses.* New York: Dutton, 1950.

Ruddick, Sara. *Maternal Thinking.* Boston: Beacon Press, 1989.

Russell, Bertrand. *Mysticism and Logic.* London: Allen and Unwin, 1964; original ed., 1917.

Sainsbury, R. M. "Rationality and Morality." In *The Manson Murders: A Philosophical Inquiry,* edited by David Cooper. Cambridge, Mass: Schenkman, 1974.

Scheffler, Samuel. *Human Morality.* New York: Oxford University Press, 1992.

Seligman, Martin. *Learned Optimism.* New York: Pocket Books, 1990.

Sidgwick, Henry. *The Methods of Ethics.* 7th ed. New York: Dover Publications, 1966.

———. *History of Ethics.* 6th ed. London: Macmillan, 1931.

Slater, Philip. *Earthwalk.* Garden City, N.Y.: Anchor/Doubleday, 1974.

———. *The Wayward Gate.* Boston: Beacon Press, 1977.

Smart, J. J. C., and Bernard Williams. *Utilitarianism: For and Against.* Cambridge: Cambridge University Press, 1973.

Smullyan, Raymond. *This Book Needs No Title.* Englewood Cliffs, N.J.: Prentice-Hall, 1980.

Spelman, Elizabeth. "Woman as Body." *Feminist Studies* 8 (1982), 109–31.

Spinoza, Baruch. *On the Improvement of the Understanding.*

———. *The Ethics.*

Stevenson, C. L. *Ethics and Language.* New Haven: Yale University Press, 1944.

———. *Facts and Values.* New Haven: Yale University Press, 1966.

Tolstoy, Leo. *A Confession.* London: Penguin Books, 1987.

Toulmin, Stephen. *The Place of Reason in Ethics.* Cambridge: Cambridge University Press, 1950.

Trigg, Roger. *Reason and Commitment.* Cambridge: Cambridge University Press, 1973.

Wallace, G., and A. D. M. Walker, eds. *The Definition of Morality.* London: Methuen, 1970.

Warnock, G. J. *Contemporary Moral Philosophy.* London: Macmillan, 1967.

White, Morton. *What Is and What Ought to Be Done: An Essay on Ethics and Epistemology.* New York: Oxford University Press, 1981.

Wiggins, David. "Truth, Invention, and the Meaning of Life." In *Needs, Values, Truth.* Oxford: Blackwell, 1987.

Williams, Bernard. *Morality: An Introduction to Ethics.* New York: Harper and Row, 1972.

———, and J. J. C. Smart. *Utilitarianism: For and Against.* Cambridge: Cambridge University Press, 1973.

———. *Problems of the Self.* Cambridge: Cambridge University Press, 1973.

———. *Moral Luck.* Cambridge: Cambridge University Press, 1981.

Wilson, Bryan, ed. *Rationality.* New York: Harper and Row, 1970.

INDEX

Ackrill, J. L., 233, 237
Acting for the best, 149, 153, 174, 190, 219, 223, 226–28
Alston, William, 162, 242
Angela of Foligno, 179
Anhedonia, 147–50
Antirationalism, xi–xiii, 73, 75, 82–83, 100–02, 194, 203–05
Aristotle, 3, 43–44, 57, 139, 233, 237
Autonomy, 9–12, 192
Avoidance of evil. *See* Gert

Baier, Kurt, 124, 137, 153, 190, 235–36, 240, 244
Barnes, Jonathan, 43, 233
Barth, John, xi, 17–35, 56–57, 92–93, 109, 113, 177, 205, 220, 229, 232, 236
Belief(s)
 false, as basis of ideals, 184
 rational, as necessary for rational action, 49–51
 true belief, as necessary for rational action, 49–51
 See also ethics of belief, knowledge, reasons, truth
Benevolence, rationality of, 135, 140
Bentham, Jeremy, 155, 157, 234, 241
Black, Max, 8, 39–40, 43–44, 231, 233
Blanshard, Brand, 86, 88, 237
Blum, Lawrence, 234, 246
Bok, Sissela, 238
Bond, E. J., 239, 242
Borges, Jorge Luis, 66–67, 236
Brandt, Richard, 130–37, 140, 142, 146–47, 181, 190, 222, 240, 241, 242, 245
Bratman, Michael, 234
Brink, David, 239, 240
Buridan's ass, 24, 109
Burtt, E. A., 235

Chisholm, Roderick, 244
Classical ideal of rationality, 3–15, 30–35, 39–79, 93, 139, 175–77, 188, 194, 205–08, 224–27, 229
Clifford, W. K., 70, 81–92, 236
Cognitive dissonance, 118–19
Cognitive psychotherapy, 130–37, 222
Cool moment theories, 129, 134, 145
Cosmic point of view, 20, 23, 56–68, 93
Cousins, Norman, 238
Cummings, e.e., 199, 244

Daniels, Norman, 240
Darwell, Stephen, 239
DeAngelis, William, 238
Deliberation, 43–54, 93, 127–29, 197, 218, 224–26
Descartes, René, 10, 59, 205, 231, 235, 244
Desire(s), 97, 107, 121–22, 128, 130–37, 157–58, 222, 227
 irrational, 123–150
 See also desire-based theories, emotions, passions
Desire-based theories, 142–43, 157
 See also Brandt, Hume, Rawls, Russell
Deutscher, Max, 65, 206–07, 236, 244
Dewey, John, 75, 211, 236, 245
Dickens, Charles, 199
Dray, William, 234

Edgley, Roy, 237
Edwards, Paul, 63–64, 235, 236
Egoism, 12–14, 91, 168–69, 175, 181, 218–19, 227
 See also benevolence, self-interest
Emotions, 97
 as obstacles to rationality, 10, 13–14, 58, 64–65
 rationality of, 107–08
 See also desire(s), passions, preferences
Ends, evaluation of, 139–150
 See also means/end theory
Ethics of belief, 70, 79, 81–92, 177, 188

See also knowledge, truth
Evans-Pritchard, E. E., 77
Evil(s), 124–25, 140, 222
Externalism, 112
Extinguishability criterion, 133–37, 146

Feinberg, Joel, 237, 243
Feminism, 41, 201, 215–16, 225–26, 233 n4
Fingarette, Herbert, 141, 181, 234, 239, 241
Firth, Roderick, 231
Fletcher, Colin, 242
Foot, Philippa, 239

Gandhi, Mohandas K., 207
Gellner, Ernest, 232
Gert, Bernard, 124–26, 129, 137, 139–150, 180–81, 190, 222, 238, 240, 241, 243
Gibbard, Allan, 234, 240
God, as necessary for values, 57
Goldman, Alvin, 242
Good(s), 64, 104, 126
 ideal, 169–171
 See also hedonism, ideals, nihilism, primary goods, value
Griffin, James, 241, 242
Gyges, 13, 113, 227, 232

Hampshire, Stuart, 198, 244
Happiness, 44, 161
 See also hedonism
Harding, Sandra, 236, 245
Harman, Gilbert, 111, 113–16, 120, 122, 141–42, 181, 239
Hedonism, 153, 155–171, 173–78, 185, 190, 219, 223, 241 n1
Hekman, Susan, 233, 245, 246
Hempel, Carl, 234
Hitler, Adolf, 115, 120–21
Hollis, Martin, 239, 241
Hume, David, xi, 17, 33, 49, 99–100, 107, 122, 131, 232, 234, 238, 240
Huxley, T. H., 81, 88, 194, 229, 244

Ideals, 48, 102–03
 evaluation of, 173–185
 See also acting for the best, good(s)
Impartiality, *See* objectivity
Insanity, 52, 141
Interests, as basis of value, 142–43
Internalism, 112–17, 239 n1
Irrational(ity), *See* desires, emotions, insanity, rational, rationality, Brandt, Gert

Jaeger, Werner, 193, 234
Jaggar, Allison, 236, 244
James, William, 44–45, 47–48, 75, 78, 81–92, 101, 118, 123, 147, 173, 176–77, 188, 211, 233, 237, 238, 239, 241, 243
Justification
 and knowledge, 4–5
 pragmatic theory of, 91
 relation to rationality, 4–5
 See also ethics of belief, reasons, skepticism

Kaufman, Walter, 238
Kekes, John, 73–79, 101, 103, 211, 243
Knowledge, 69–79, 93, 208–213
 vs. reasonable belief, 49–51
 See also skepticism, truth
Kuhn, T. S., 210, 243

Laudan, Larry, 245
Lemos, Noah, 240
Lewis, C. I., 155, 164, 241, 242
Literature, philosophical ideas in, 17, 30–31, 232 n2
Lloyd, Genevieve, 215, 245

Mabbott, J. D., 238
MacIntyre, Alasdair, 204, 215–16, 220, 244, 245
Mandelbaum, M., 235
Masochism, 143–46
McMillan, Carol, 246
Meaning of life, 63–64, 193

INDEX

Means/end theory of rationality, 91, 94, 97, 99–150, 175, 177, 189–190, 192, 218, 221
 See also desire-based theories, reasons-as-motivators view, Brandt, Harman, Hume, Rawls, Russell
Meiland, Jack, 238
Mill, J. S., 155, 176, 187, 241, 242, 243
Morality, 11–14, 111–16, 120–22, 181–82, 216–17

Nagel, Thomas, 55, 233, 235, 236, 242
Nihilism, 19–22, 55–68, 103–05, 232 n6, 232 n8
Nonmotivating reasons, 116–120
Nozick, Robert, 166–68, 174, 242
Nuer, 77
Nussbaum, Martha, 232

Objectivity, 7–9, 20, 55–68, 206, 225–26

Parfit, Derek, 234
Passions, 64–65, 67, 82–83, 97
 See also desires, emotions, preferences
Passmore, John, 46, 234, 236, 243
Peirce, C. S., 75
Perry, R. B., 241
Peters, R. S., 231
Phobias, 136, 240 n8
Pitcher, George, 238
Plato, 3–15, 69–71, 139, 206–07, 227, 231, 232, 235, 236
 See also Socrates
Pleasure, 153, 155–171
 See also hedonism
Pluralism, 173–76, 185, 192, 207, 219
 critical, 185
Popper, Karl, 8, 189, 231, 243
Pragmatism, 72–79, 81–92, 212
Preferences, 61–63
 See also desires, emotions

Price, H. H., 237
Primary goods, 104, 126–29, 147
Putnam, Hilary, 170, 174, 236, 242, 243, 244, 245
Pythagoras of Samos, 69

Rashdall, Hastings, 161, 243
Rational
 actions, 49–54, 105–06
 as allowed vs. required by reason, 85, 102
 discussion, 7
 evaluative vs. nonevaluative senses of, 42
 persons, 42
 plan of life, 106
 See also desires, emotions, rationality
Rationality, xi–xiii
 consequentialist vs. deontological theories of, 223–28
 evidential vs. practical, 75–78, 80–92
 feminist criticisms of, 41, 201, 215–16, 225–26, 233 n4
 general vs. specific conceptions of, 40–41
 internal vs. external criteria of, 73–78, 141
 method vs. result criteria of, 45, 47, 74, 223–28
 relativist view of, 215–16, 219–223
 responsiveness to evidence, 48–52
 theories of, 216–228
 See also acting for the best, avoidance of evil, classical ideal of, deliberation, egoism, hedonism, means/end theory, objectivity, utilitarianism, Black, Brandt, Gert, Harman, Hume, Kekes, Rawls, Russell
Rawls, John, 45, 50, 64, 104, 106, 126–29, 133, 137, 142, 147, 180, 233, 234, 236, 238, 240

256 INDEX

Raz, Joseph, 234
Reality, criteria of, 59
Reason(s)
 and motivation, 111–16
 evidential vs. practical, 75–78, 80–92
 explanatory vs. evaluative, 117
 internal vs. external, 112
 nonevidential, 84–86
 nonmotivating, 116–120
Reasoning, 3, 6, 47–48, 206
 See also deliberation
Reasons-as-motivators view, 111–122
Reid, Thomas, 139
Relativism
 and rationality, 215–16, 219–223, 227
 and values, 105
 ethical, 113–16, 122, 245 n8
Rescher, Nicholas, 237, 241, 244, 245, 246
Results, actual vs. foreseeable, 49–51
 as criterion of rational action, 45, 47
Rexroth, Kenneth, 198, 244
Ribot, Theodule, 147
Rorty, Amelie, 233, 238
Rorty, Richard, 231, 245
Roszak, Theodore, 197, 233
Rousseau, J. J., 198–99, 244
Ruddick, Sara, 215–16, 233, 245, 246
Russell, Bertrand, 43, 99, 103, 176, 235, 238, 243

Satisfaction, 157–160
 See also hedonism, pleasure
Scheffler, Samuel, 235
Secondary qualities, 59, 235 n6
Self-deception 32, 90, 238 n10
Self-interest, 11, 42
 See also benevolence, egoism
Seligman, Martin, 238
Sidgwick, Henry, 45, 55, 81, 128, 155, 163, 178, 181, 234, 235, 240, 241, 242

Skepticism, xii, 174, 197, 208–213, 219
 See also antirationalism
Slater, Philip, xii, 39, 55, 197, 233
Smart, J. J. C., 55–56, 65–67, 234, 235, 236, 237, 242
Smullyan, Raymond, 203, 205, 244
Socrates, 3–15, 34, 46, 57, 65, 69–71, 125, 193, 207–09, 224–25, 236
Spelman, Elizabeth, 233, 236, 245
Spinoza, Baruch, 235
Suicide, 144–49

Technology, 40–41
Tolstoy, Leo, 235
Truth, 5, 6, 11, 29–30, 75–79, 93, 169, 188, 199–200, 206
 See also knowledge

Usefulness
 vs. truth, 75–79, 81–92
Utilitarianism, 198, 234 n11
 applied to belief choice, 91
 as a theory of rationality, 156
 See also hedonism

Value(s)
 instrumental, 164–65
 nonexperiential, 167
 See also good(s), hedonism, ideals, nihilism
Vlastos, Gregory, 234

Weakness of will, 136
White, Morton, 239
Whitman, Walt, 119, 239
Wiggins, David, 162–65, 236, 242
Wilkes, K. V., 233
Williams, Bernard, 112, 114, 234, 237, 239
Wisdom, 6
Wittgenstein, Ludwig, 93
Wordsworth, William, 199, 205